IDIOT'S GUIDES
AS EASY AS IT GETS!

Drawing

by David Williams

ALPHA

A member of Penguin Group (USA) Inc.

ALPHA BOOKS

Published by Penguin Group (USA) Inc.

Penguin Group (USA) Inc., 375 Hudson Street, New York, New York 10014, USA • Penguin Group (Canada), 90 Eglinton Avenue East, Suite 700, Toronto, Ontario M4P 2Y3, Canada (a division of Pearson Penguin Canada Inc.) • Penguin Books Ltd., 80 Strand, London WC2R 0RL, England • Penguin Ireland, 25 St. Stephen's Green, Dublin 2, Ireland (a division of Penguin Books Ltd.) • Penguin Group (Australia), 250 Camberwell Road, Camberwell, Victoria 3124, Australia (a division of Pearson Australia Group Pty. Ltd.) • Penguin Books India Pvt. Ltd., 11 Community Centre, Panchsheel Park, New Delhi—110 017, India • Penguin Group (NZ), 67 Apollo Drive, Rosedale, North Shore, Auckland 1311, New Zealand (a division of Pearson New Zealand Ltd.) • Penguin Books (South Africa) (Pty.) Ltd., 24 Sturdee Avenue, Rosebank, Johannesburg 2196, South Africa • Penguin Books Ltd., Registered Offices: 80 Strand, London WC2R 0RL, England

IDIOT'S GUIDES and Design are trademarks of Penguin Group (USA) Inc.

International Standard Book Number: 978-1-61564-414-8
Library of Congress Catalog Card Number: 2013935158

15 14 13 8 7 6 5 4 3 2 1

Interpretation of the printing code: The rightmost number of the first series of numbers is the year of the book's printing; the rightmost number of the second series of numbers is the number of the book's printing. For example, a printing code of 13-1 shows that the first printing occurred in 2013.

Note: This publication contains the opinions and ideas of its author. It is intended to provide helpful and informative material on the subject matter covered. It is sold with the understanding that the author and publisher are not engaged in rendering professional services in the book. If the reader requires personal assistance or advice, a competent professional should be consulted. The author and publisher specifically disclaim any responsibility for any liability, loss, or risk, personal or otherwise, which is incurred as a consequence, directly or indirectly, of the use and application of any of the contents of this book.

Most Alpha books are available at special quantity discounts for bulk purchases for sales promotions, premiums, fund-raising, or educational use. Special books, or book excerpts, can also be created to fit specific needs. For details, write: Special Markets, Alpha Books, 375 Hudson Street, New York, NY 10014.

Publisher: Mike Sanders
Executive Managing Editor: Billy Fields
Executive Acquisitions Editor: Lori Cates Hand

Development Editor: John Etchison
Production Editor/Proofreader: Jana M. Stefanciosa
Book Designer/Layout: Rebecca Batchelor

ALWAYS LEARNING PEARSON

For Stella, Michael, Peg, and Pop.

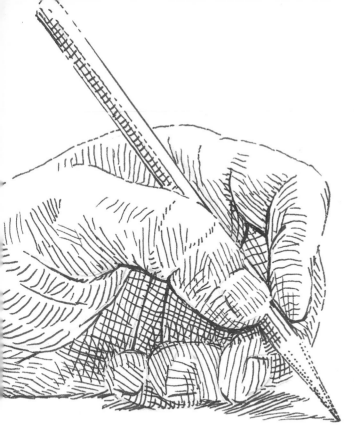

Contents

The Basics 2

The Projects 18

level 1

Introduction

A drawing begins with imagination and a desire to reproduce on paper the way you, the artist, perceive objects. It reveals one's fascination with arranging lines and tones into an illusion. Drawing can be a pastime, a way to relax, or a great workout. Because the tools needed for drawing are few and easy to transport, it can be done in a café, in a museum, out in nature, or even standing at a bus stop.

This book explains how to set up a simple home studio and get started on the path to creating some great sketches. As you complete the lessons in this book, you'll become more aware of the mechanics of observation and drawing. Vital to the drawing process is the way parts of an image relate to each other to create a whole. Drawings are composed of lines and shading, and also relationships of shapes, tone, and proportion. The artist chooses what is relevant to explain the visual idea and edits out the rest. Good drawings use the least effort to say the most.

Learning to draw is strength and endurance training for the mind. Lesson by lesson, you'll improve your ability to recognize more relationships of size and shape and learn ways to guide the pencil to create clear and realistic drawings. Many of the drawings involve a few measurements, but soon you'll be on your way to drawing without a ruler through observation and measuring with a pencil to compare dimensions.

How to Use This Book

The first section of the book describes the basic tools, materials, and techniques you will use to create all the drawings in the following lesson projects. Fifty drawing lessons are organized into five difficulty levels to present a logical progression from the most basic to intermediate to advanced drawing skills.

If you haven't studied the basics of perspective and shading, or you consider yourself a beginner, you'll want to start at Level 1 to learn the fundamental skills and concepts that will prepare you for the more advanced projects. If you've already studied the basics of drawing, you'll probably do fine beginning with Level 2, or even skipping to Level 3 to try drawings as you please. Levels 4 and 5 require an understanding of shading and line drawing that comes through much practice.

Each lesson in the book includes an advanced step in which the drawing is embellished and other creative ideas are suggested. You can take the lesson even further and test your understanding of the techniques learned by composing your own drawing of the subject matter. Each lesson also presents a new concept you can add to your resources to complete future drawing projects. By the end of the book, you will have learned the concepts and techniques to work your way through any problem.

As you progress through the lessons, you will see that drawing is an expression of the hand, eyes, and mind, and requires training them to work together to feel and respond to shapes and tones. As with any training, it's important to proceed slowly through the beginning lessons in order to fully comprehend the instructions. Read through all the steps before you put pencil to paper to get the general idea of how the image takes shape. As you draw, notice your grip on the pencil, and relax it if your hand feels strained. Finally, remember that mastery comes gradually, through perseverance. As much as you can, enjoy all the steps that lead to it.

Acknowledgments

To wordsmiths and editors Lori Cates Hand and John Etchison goes credit for their help in creating a concise text. Thanks also to designer Rebecca Batchelor for crafting pages that are uncluttered, balanced, and user-friendly. Finally, my gratitude goes to Phil Miller and Bill Melvin, my high school art teachers. May your passion for art and compassion for the student live in these lessons.

the basics

Drawing is an expressive activity, whether you draw from imagination or from life. There are many choices you can make before you even put pencil to paper that will ensure better results. It's important to know which tools are effective and how to use them. Your eyes, mind, and hand are your primary tools; however, you need to know about pencil types, erasers, paper, and a few other things that make drawing easier.

Drawing relies heavily on the eyes and mind to recognize shapes and sizes. The artist is aware of the structure and appearance of an object apart from its function in life. When the artist draws, a cup isn't a vessel for holding fluids. A cup is a vertically oriented cylinder with a pattern of light and dark areas. Drawing while you observe an object actually helps you look at things in an active way and prepares you for the task.

The secondary tools of drawing are basic and relatively cheap compared to sports equipment, but they need to be the best quality you can afford.

setting up your drawing area

Before you begin drawing, you should set up a place where you will draw. This area should have enough space, sufficient light, and an optimal setup. The following sections go over the essential elements to consider when setting up your drawing area.

Lighting

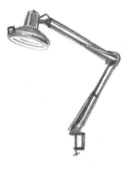

It's important to have enough light to easily see faint measuring marks and subtle transitions of tones. I draw by the light of six 23-watt compact fluorescent lamp (CFL) bulbs, two of them directed at the drawing surface from about 5 feet (1.5m) above and to the left, opposite my drawing hand. The other four are directed at the wall behind and to the right of the desk to create a softer, bounced light. An alternative lighting solution is a drafting light fixture with a flexible arm that can be clamped to a drawing table and its light directed from a few feet away.

Drawing Support

You will need a smooth and solid surface where the paper rests while you draw. Position it so the paper is at about a 90-degree angle to your line of sight.

A field board is a thick piece of compressed wood particles that has a smooth surface, a handle for transporting, and large clips for attaching pads of paper. It's mainly for use outside or indoors leaned against the edge of a table with the bottom edge resting on your legs. More expensive, but well worth the cost, is a drawing desk with a smooth surface that can be adjusted to many angles.

Here are examples of three very different drawing workspaces. The first is an artist standing with a sketchpad, as if walking in nature. The second shows an impromptu drawing session using a portable field board. The third is a more formal, dedicated studio setup for drawing.

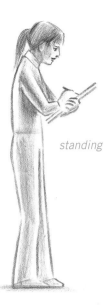

standing

Paper

Your drawing space includes the piece of paper and the space you draw on and in. You should choose it carefully because it's the material that records your lines and shading. Cheap copy paper is acceptable for quick drawings, but the thinness makes it easier to damage when shading and erasing and usually better results can be expected with a better paper. Art papers are thicker with balanced pH to ensure they don't yellow over time.

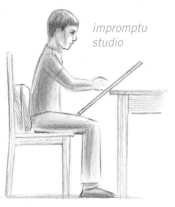

impromptu studio

Paper drawing surfaces are manufactured in thicknesses ranging from very thin tracing paper to 5-ply (layers pressed together) Bristol board. *Printer paper, copier paper, sketch paper, drawing paper*, and *Bristol* are four surfaces ranging from good to great. Each paper has a unique texture, or "tooth," so it's worth trying all kinds, eventually to find one that best fits your drawing style. Bristol paper that is about 96 lb. (260gms), with a slightly textured surface, is heavy enough to withstand erasing and intense shading pressure.

Translucent marker paper, layout paper, or *tracing paper* can be laid over a preliminary drawing to create an *overlay* where the under drawing can be seen through the overlay and is traced and improved upon. These papers usually smear more easily than regular drawing paper.

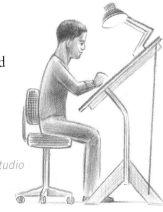

formal studio

tools you will need

Once you have your drawing area set up, you can gather your tools. This book focuses on pencil drawing and some pen drawing in Levels 4 and 5, so the tools needed are minimal. Here are my recommendations.

Pencils

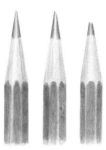

Graphite is combined with clay to make what is called the "lead" of a drawing pencil. Adding more clay to the graphite makes a lead that produces lighter and lighter marks and determines its *grade*.

B (black) grades are better for shading and sketching. If the pencil is sharp and you apply less pressure, a B pencil can make a light line similar to the H (hard) grades. I suggest using mainly 4B and 6B for the lessons in this book. They create subtle light-to-dark gradations and erase well without digging into the paper. Sometimes the harder 2B and HB grades will be helpful to create lighter toned areas, and 8B works for the very darkest tones.

Rulers and Straightedges

A ruler is helpful for measuring, drawing guidelines, and creating grids. A heavy piece of paper or board with a straightedge is a temporary fix. I suggest using an 18-inch metal ruler that includes a 45-centimeter measure. These often have a cork backing. This keeps it from slipping or the edge from touching the paper (which is necessary if you ever use it with an ink pen).

Commonly used for traditional drafting, a T square has a straightedge, or blade, with a shorter perpendicular head (the top of the T) that rests against a table or board and keeps the blade square at a 90-degree angle.

Erasers

The *kneaded eraser* is rubbed across or pressed on a drawing page to take away large or small dark-to-light tone with very little residue. Usually an eraser is regarded as a tool for removing mistakes, but for the artist, a kneaded eraser can be formed to lift off pale shapes within dark tone areas by dry adhesion. The kneaded eraser is a soft rubber material that can be shaped into a small point, dot, blob, or line and can be pressed into, dragged across, or rubbed over the paper. To erase a dark area, press the eraser onto the paper to take off a majority of the graphite. When the outer surface becomes shiny dark, pull and fold the eraser to create a new clean area.

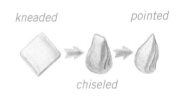

kneaded *pointed*

chiseled

The *white vinyl eraser* is rubbed over or dragged across the drawing surface for erasing light lines and tone, but will smear dark areas. It can be cut into shapes with a craft knife to create smaller erasing tips and edges. These also are manufactured to fit into the ends of mechanical pencils or an eraser tube, or an *electric eraser* that rotates at high speeds.

The *art gum eraser* is a tan block that crumbles as it gently takes off lines and larger areas of tone. It's not as effective for erasing small areas adjacent to other shading.

Erasing roughs up the paper's surface and can leave dust and imbedded eraser particles. Brush off any remaining residue with a wide, soft brush.

Blending Tools

A *blending stump* is a pressed paper stick with pointed ends that can be rubbed across tone. The *tortillion* is a rolled paper blending stick with one pointed end. Chamois leather can also be used on wider areas, as can a paper towel that has been rolled or folded. The side of a small finger that is clean can also be used.

Tape

Drafting tape is used to hold down a loose page to the drawing surface and is less sticky than regular masking tape to avoid tearing the paper.

Pencil Sharpeners

A sharp pencil tip with about 5/16 inch (.75cm) of exposed lead is helpful to achieve a range of effects from tip-end detail to shading with the side. There are many inexpensive handheld designs with openings for various pencil diameters and plastic cases that catch the shavings. Electric sharpeners are convenient for the continual sharpening needed when you're doing lots of shading. However, they are also noisy and can take off more length than you need, although some models are designed to stop when the pencil is sharp.

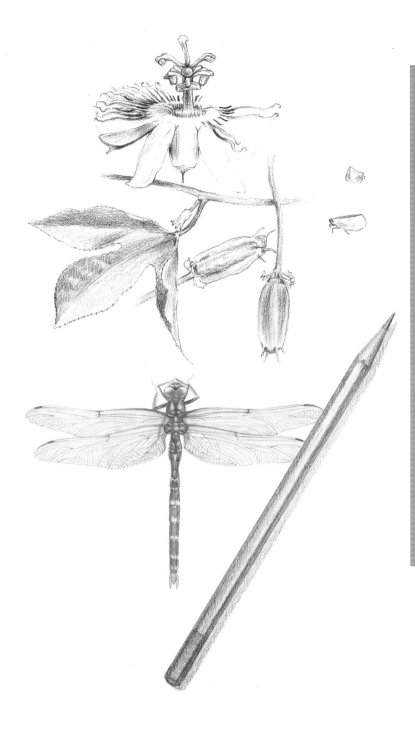

Basic List of Materials

- *Bristol pad: 9 × 12 in. (22.9 × 30.5cm)/96 lb. (260gsm)*

- *Translucent marker paper: 9 x 12 in. (22.9 x 30.5cm/ A4)/13.5 lb. [70gsm])*

- *HB, 2B, 4B, 6B, and 8B graphite drawing pencils*

- *.5mm drawing pen*

- *18-inch (50cm) metal ruler*

- *18-inch (50cm) T square*

- *Kneaded rubber eraser*

- *A few smaller tortillions or blending stumps*

- *Pencil sharpener (electric or manual)*

techniques

The way you hold the pencil when you draw will influence the texture of the lines and shading. Good grip can also relieve hand fatigue and keep you free from chronic wrist and joint pain. Hold the pencil for light to medium dark marks with only enough pressure to keep it from slipping between your fingers. The habit of gripping the pencil too tightly can develop from forcing the pencil when the tip has lost its edge—so remember to keep the tip sharp!

Grips

The first thing to do to improve your drawing grip is to hold the pencil about 3½ inches (9cm) back from the tip and draw with the pencil at about a 30-degree angle. This *basic grip* will position the tip to draw both straighter lines and shade more evenly. This grip will also help to keep your drawing hand farther from the drawing and from smudging the work. This grip is best for drawings 9 × 12 inches (22.9 × 30.5cm) or smaller and is the basic grip for most drawings.

The *distant grip* is best for making soft, light lines and helps the hand pivot for a greater arcing range. Hold the pencil about 3 to 4 inches (7.5cm) back from the tip with the barrel end near or against your palm.

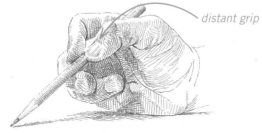

distant grip

Pivoting most grips at the heel of the hand will help improve control, but there are times you will need a more distant pivot, such as from the elbow or shoulder. Gripping the pencil with your hand over the barrel (*overhand grip*) and pivoting at the heel of your hand will help when creating short, textural marks that require more pressure.

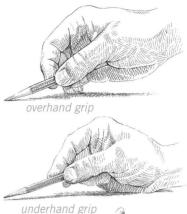

overhand grip

For very loose, expressive lines, the pencil is gripped with the palm facing up. This is called an *underhand grip*. You can make arcing lines this way while pivoting on the knuckles of the small digits.

underhand grip

For the *control grip*, hold the pencil at a steep angle and closer to the tip to create short, sharp, or claw-shaped lines (such as for eyelashes).

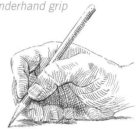

control grip

Types of Lines

Lines drawn with the side of the pencil tip have a softness and variation in thickness. Lifting the pencil tip away from the page at the end of a stroke creates a tapering end that has a dynamic quality.

Factors that change the look of a penciled line are pressure, speed of the stroke, pencil angle, grip, sharpness of the pencil tip, pencil grade, and the drawing surface. Even one's emotional state is recorded by a line.

ruled line

The *ruled line* is exact and useful to draw level, vertical, or precisely angled lines and where a clean edge is required. These lines stand out in a distracting way when isolated in a drawing made mostly with *freehand lines* without a ruler, but are necessary to draw an accurate perspective construction.

freehand line

broken line

The *broken line* is used at the beginning stage of a drawing to rough in the contour without details. It's made of fairly straight lines that simplify a complex shape into sides with small gaps where turns occur. It's much easier to incorporate or change a broken line than a solid one where care has been taken to draw details.

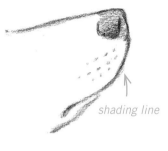

shading line

Often a light, soft line is needed to feel the way to an accurate contour. The *shading line* is made with multiple overlapping light strokes that avoid heaviness.

The *gesture line* is used mainly while making gesture drawings that quickly capture a live subject's pose. It has varying widths and flows with a graceful energy.

gesture line

Unlike other lines that are relatively short strokes, the *continuous line* has few breaks while it records contours and cross contours. It has a fairly consistent width and is best done with a pen where sharpening is not necessary, or with an HB pencil that is harder and requires less sharpening.

continuous line

The *contour line* has a similar look to the continuous line and describes only the edges of a subject.

Construction lines are made at the beginning of a drawing for marking positions, angles, and measurements. They include tick marks, midpoints, roughing-in lines, points, radii, and reference lines.

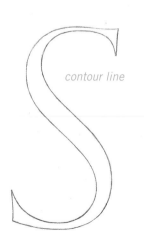

contour line

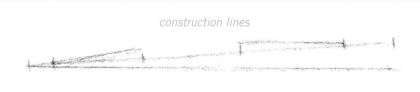

construction lines

The *varied line* changes volume and thickness by you turning the pencil tip and changing pressure while making the line. This line is graceful and can be used to intensify 3D illusion when the contour is emphasized.

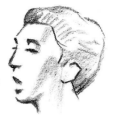
varied lines

Shading

Back-and-forth shading is done with the side of the pencil tip and creates even tone without the texture of individual strokes. It can be layered over previous lined shading to soften and merge tones together.

Stroke shading is done with the tip of the pencil, creating individual strokes that are organized in rows or groups that, en masse, are seen as even tone.

Crosshatching is made with the tip of the pencil by layering rows of short marks at different angles. The result is darker and darker tone with each layer, as well as square-, diamond-, and triangle-shaped texture.

Make *dark tones* in layers by first blocking in the area with even, medium dark tone with the side of the pencil tip, with strokes going in the same direction. Then turn the page and do the same in a different direction. For very dark tones, add a third layer with more pressure and finish with a fourth, softer blending layer using the tip of the pencil to blend and fill in any remaining white flecks of paper that are still showing through.

When the shading hand touches previously shaded areas, it will transfer smudges from the palm. You can avoid this by laying a sheet of paper (a cover sheet) over the area where you rest your

hand while working. You can also use long pencils and grip them farther back so you can rest your hand outside the image area. Sometimes, merely turning the drawing will provide a place in the margin for your hand. As you gain skill, you will be able to shade without resting your hand as it hovers over the page. Some smudges can be cleaned up at the completion of the drawing with a kneaded eraser.

Create *light tones* with the side of the pencil tip, gripping the pencil farther back to lighten the pressure. You can also create light tones with the tip of the pencil and using a 2B, B, or H grade of hardness. Harder grades can dig into the paper and the grooves will show up if dark tones are laid over them.

A *gradation* is tone that softly transitions from light to dark or the reverse. To create a gradation, lay in the lightest tone over the entire area with more pressure applied gradually. But don't create the darkest values yet. After retouching uneven spots, if necessary, go back to the darkest area and darken it more while gradually applying more pressure.

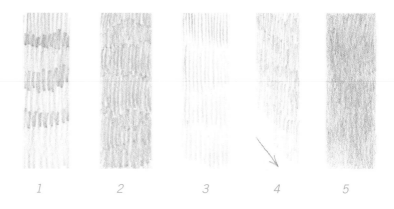

1 2 3 4 5

To create very *smooth tones*, use the side of a 4B pencil for shading the area. Then finish it off with a 2B pencil tip at about a 30-degree angle, applying very little pressure to blend the strokes together. A tortillion of rolled paper can be rubbed over the surface to blend the graphite particles, to fill all the white recesses of the paper texture and blend away all the drawing strokes, if desired.

Examples of Shading Techniques

Following are some different shading effects and how they can be achieved.

1. Rows of overlapping parallel lines.
2. Example #1 with the lighter gaps filled in.
3. Careful rows of parallel lines.
4. The distracting horizontal bands in example 3 are avoided by overlapping and diagonal orientation of rows.
5. Overlapping vertical shading.
6. Careful overlapping vertical shading.
7. Dark value created with four dark layers of crosshatching.
8. Delicate crosshatching using the pencil tip.
9. Crosshatching using the side of the pencil tip.
10. Overlapping shading strokes made with the side of the pencil tip.

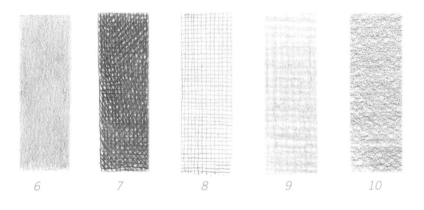

6 7 8 9 10

construction

Construction is the beginning stage of a drawing where sizes and placement of main shapes are marked on the page. These marks include the following:

Level line (horizon, table edge, eyes)

The axis (head, body)

Lines of convergence (road, building)

Basic forms (cube, cylinder, cone, sphere)

Dimensions

Alignment

Because construction lines and marks are used to plan the drawing, these marks are made as light as possible so that they are easy to erase or incorporate into shading. Grip the pencil about 3 inches (7.5cm) back from the tip and draw with the side of the pencil tip to create these soft lines.

Level Lines

Horizontal and vertical level lines can be drawn to create guidelines to align multiple parts of a drawing or can be merely imagined to determine whether one part is aligned with another.

Axis

The axis divides a 2D shape in half or runs the center of a 3D shape. It can help determine the angle of the object, its center, and its length.

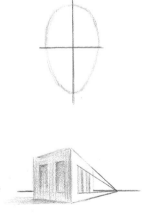

Lines of Convergence

Lines of convergence help determine the angles of edges as they converge at a vanishing point. These are used in one-point and two-point perspective drawings.

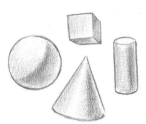

Basic Shapes

The 2D basic shapes are the square, circle, and triangle. The 3D basic shapes are the cube, sphere, cone, and cylinder. These are drawn lightly to determine the orientation of an object or parts of an object in a drawing.

Dimensions

Small marks called tick marks indicate the basic height, width, and length placement of a part of a drawing.

Alignment

These lines are observed to place and orient an object that is level, plumb, or aligned diagonally with another.

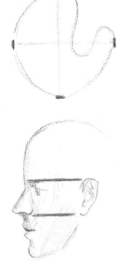

the projects

Following are 50 lesson projects that help you learn the techniques and concepts of drawing while creating satisfying and interesting artworks. The lessons are grouped by difficulty and become more challenging as you progress through the levels:

- **Level 1** introduces the basics of making shapes, how to hold the pencil, and how to draw straight and curved lines. It also introduces how to construct a drawing so all the parts fit together well.

- **Level 2** shows more complex arrangements of the basics. It introduces the human head and how to begin to produce the illusion of texture.

- **Level 3** introduces some full-page compositions. Building on the understanding of human features from level 2, you will apply naturalistic illusion of the anatomy of the head.

- **Level 4** provides subject matter from still life to animal and human. You will investigate how to create realistic textures.

- **Level 5** provides challenging images that build on knowledge of the earlier levels' concepts and prepares you to create satisfying and professional images of your own.

window

Steps: 5 **Difficulty:** ■ ☐ ☐ ☐ ☐

Lines that are parallel to the edges of a page create the feeling of stability in a drawing. As you draw the vertical and horizontal lines of this window, remain aware of the entire page so that you can draw straighter lines that relate to the page.

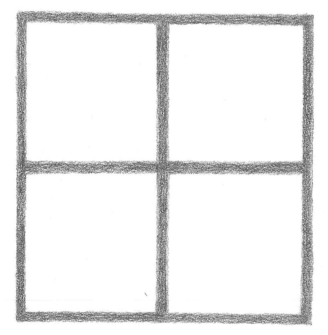

1 Begin the main square of the window by drawing a horizontal top line with a sharp 4B pencil. Draw the line to be parallel to the edge of the paper by glancing at it and then back to the line while moving the pencil. Draw the left side of the square while using the left edge of the paper as a visual reference.

2 Complete the rest of the sides of the square. Check that the sides are the same length by laying your pencil alongside a line with the pencil's tip at one end of the line and then grasping the pencil at the other end of the line. Continue to hold the pencil and turn the paper to compare this measurement to the other sides.

Use your pencil to compare lengths.

CONCEPT

Comparative measurements *are taken by placing the tip of the pencil at one end of a line and then pinching the pencil at the other end.*

A square's four corners should each be 90-degree angles. Check this by drawing light, dashed, diagonal lines connecting opposite corners. If the lines are the same length, the angles are true.

3

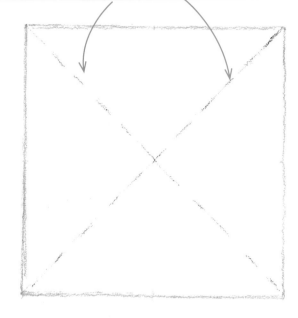

Use diagonals to find the center of a square. Broken lines are easier to erase or revise.

CONCEPT

Be aware of the page *as you draw. Its height and width, edges, and center can be used as visual references to position and draw lines.*

Where the diagonals cross is the center of the square. Draw a horizontal and a vertical line through this point.

4

Light, dashed or "broken" lines are visually weaker, and so they are less distracting and easy to change or erase. Use them whenever you guess at the placement of a line or when the line will be erased. Erase the diagonal lines and then redraw the outer square and interior lines to have an even darkness.

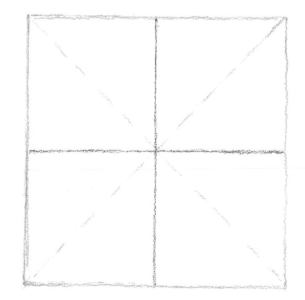

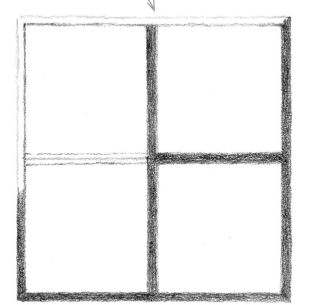

Keep the outlined edges light for a soft, clean look.

5 With light lines and the tip of a sharp pencil, draw a square around the main square and draw guidelines on either side of the interior lines. Shade in the area with short lines that overlap to create an even tone. Clean up any stray marks with a kneaded eraser by dragging it along the edges.

ADVANCED VARIATION

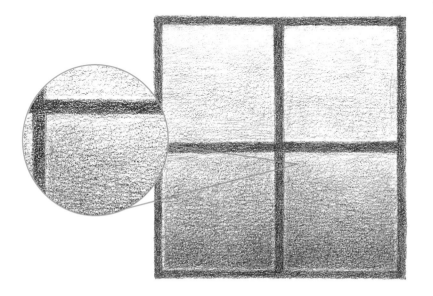

Develop the illusion of atmosphere beyond the window with a gradation. Shade a light, even tone in all the squares with short, overlapping strokes. Then build a darker tone from the bottom panes up that gradually becomes lighter before the horizontal bar. Avoid smearing the shading to fix uneven toning. Instead, shade very softly up to dark spots to camouflage them or lightly touch them with a pointed kneaded eraser.

watch

Steps: 5 **Difficulty:** ■ ☐ ☐ ☐ ☐

This drawing of a watch face will get you started drawing circles in
stages. The challenge is to draw a round shape that appears bal-
anced. Although using a compass or template would result in a clean
curve, circles drawn freehand are softer, blend with the rest of the
drawing, and are fun when you get the hang of it.

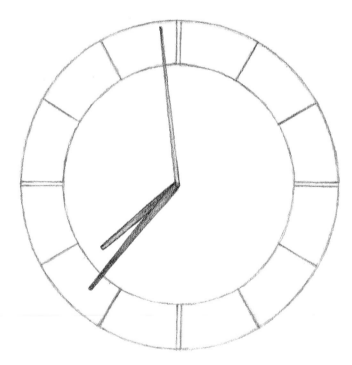

1 Draw a dot with a 4B pencil.
Then grip the pencil with your
forefinger and thumb about 2
inches (5cm) back from the tip.
Mark eight points this distance
around the dot.

TECHNIQUE
*Keep the pencil perpendicular to the
line you are drawing. Grip the pencil
a few inches (centimeters) back and
allow your wrist to bend as you draw.*

2 Connect the marks with curved
lines.

*Turn the page a quarter
turn and then upside
down to find areas that
need more refining.*

3 Refine the circle and create another one about a ½ inch (1.25cm) farther out using the same method as the preceding steps.

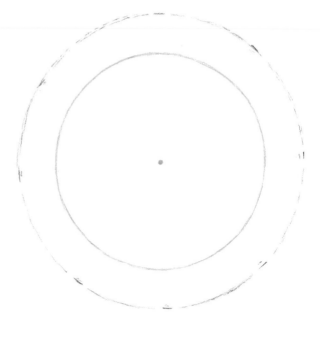

4 Estimate the positions of twelve, three, six, and nine o'clock in the outer ring and make light marks at these points. Light, dashed construction marks connecting opposite positions should run through the center dot. Estimate the positions of the remaining hour positions using this process.

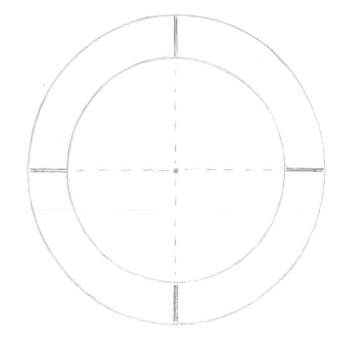

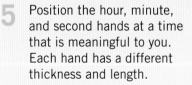

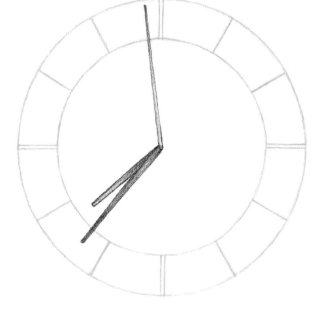

5 Position the hour, minute, and second hands at a time that is meaningful to you. Each hand has a different thickness and length.

ADVANCED VARIATION

Refine the outer ring with light shading that follows the direction of the ring. Then shade with marks that cross the first ones at a 90-degree angle. Continue shading to create an even tone.

celtic knot

Steps: 5 **Difficulty:** ■ ☐ ☐ ☐ ☐

The equilateral triangle construction for this knot design is a fun challenge and shows how to use construction to determine size and placement of the parts of a complex drawing.

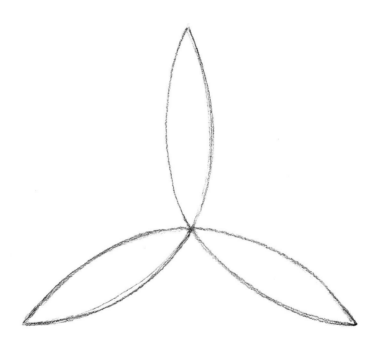

The new center.

1 Draw a horizontal line. Estimate where the center of the line is by letting the pencil tip hover over the spot, comparing the area to the left of it to the area to the right. When you've compared and adjusted, draw a dot on the line at the new center.

2 Draw a vertical axis. Draw diagonal lines from the base to the axis, each the same length as the base. Compare the measurements and revise to be the same. Mark the halfway point of the sides with the method from step 1.

Draw the two remaining axis lines.

3

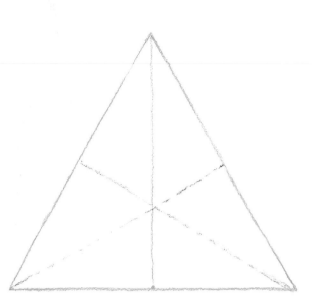

Lighten all the lines by pressing a kneaded eraser onto them.

Draw a curve that begins at one point of the triangle, intersects the center, and stops at another point.

4

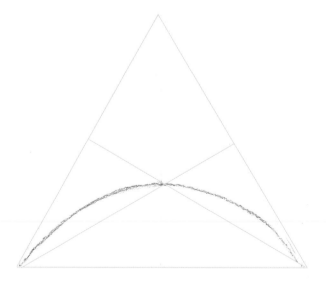

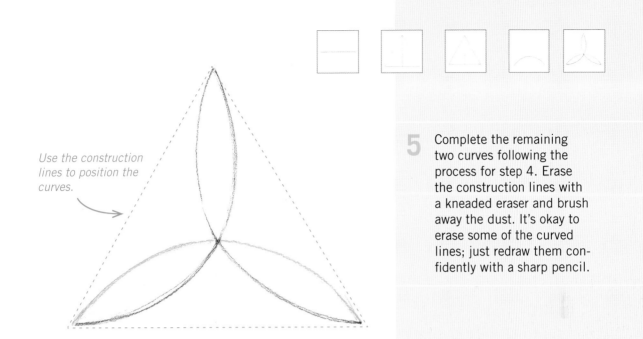

Use the construction lines to position the curves.

5 Complete the remaining two curves following the process for step 4. Erase the construction lines with a kneaded eraser and brush away the dust. It's okay to erase some of the curved lines; just redraw them confidently with a sharp pencil.

ADVANCED VARIATION

Draw the outside line of the knot. Erase the center and redraw the parts so they appear to weave over and under as in the finished example. Add some shading at these points to emphasize the effect.

basic face

Steps: 5 **Difficulty:** ■ ☐ ☐ ☐ ☐

There are few drawing subjects more challenging than the human face, perhaps because it's so familiar, but also for its symmetry and many details. This drawing presents the basic placement of the facial features. You can modify it to draw any human face seen from the front.

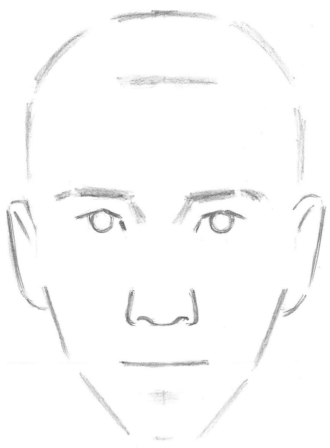

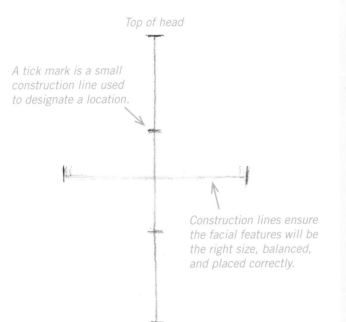

Top of head

A tick mark is a small construction line used to designate a location.

Construction lines ensure the facial features will be the right size, balanced, and placed correctly.

Chin

1 Draw a tick mark for the location of the top of the head and another marking the chin about 4 inches (10cm) apart. Draw a vertical line connecting the tick marks, and then divide it into thirds with two more tick marks.

Draw a horizontal line dividing the vertical one in half. Its width is two of the small vertical sections. A basic face is three sections tall and two wide.

2 Divide the horizontal line into four equal parts by drawing two new tick marks. Draw the irises just inside these new marks. Then draw the three angled lines of each of the upper lids.

The nostrils are two curves that meet as a straight line in the center below the lower tick mark on the vertical line. The sides of the nostrils are straight, then curve just under the openings.

Draw the four angled lines of **3** the jaw with a small space in between. The top two begin level with the top of the nostrils and the lower two angle in to the chin. The line of the mouth is level with the small spaces and the ends are in alignment with the inside of the irises.

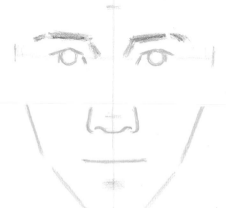

CONCEPT

When parts of a drawing subject are in **alignment,** *you can position them better. Items that line up vertically are plumb; those that line up horizontally are level.*

The spaces between the lines emphasize the different angles.

Draw a wide mark for the **4** hairline halfway between the top tick marks of the vertical line. Draw the three soft lines of the eyebrows and upper nose. Very softly shade the depression above the chin.

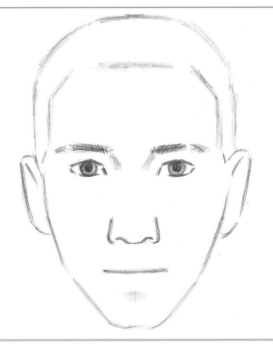

*Broken lines may be joined,
but are left separated here
to emphasize the parts.*

5 Draw the sides and top of the head, keeping the lines symmetrical. Draw in the ears at either side of the head even with the eyebrows and the bottom of the nose.

ADVANCED VARIATION

With light, curving shading, join the lines of the chin, jaw, and top of the head. Shade the irises and darken the pupils. Add the lines of the lower eyelids.

table

Steps: 5 Difficulty: ■ ☐ ☐ ☐ ☐

We're used to rectangular tables, but the angles of the edges are usually overlooked. Perspective is a method of using construction lines to determine the angles of parallel edges that seem to gradually become farther from the viewer. Objects with parallel edges and one edge facing the viewer are constructed with one vanishing point.

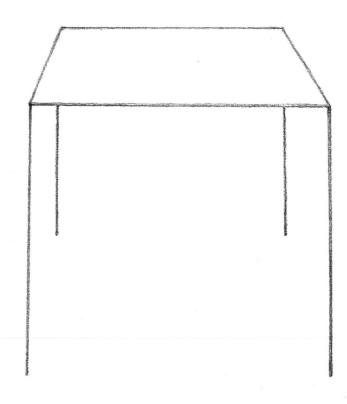

Draw the dot and lines lightly with a 4B pencil.

The vanishing point is always at the viewer's eye level.

1 Draw a dot a few inches from the top of your page and centered. This is the vanishing point for the one-point perspective you will construct. About 6½ inches (16.5cm) below the dot, place your ruler parallel to the bottom of the page and draw a 3½-inch (9cm) wide line. Then draw two lines that connect the ends of the line to the dot.

2 Draw another line about 1½ inches (3.75cm) above and parallel to the other horizontal line.

These lines will help you determine where the legs of the table touch the ground.

Draw the front legs and front edge of the table. The legs are vertical lines that are each 3 inches (8cm) tall. Check that they are parallel to the sides of the page. The front edge of the table connects the tops of the legs and is parallel to the bottom edge of the page.

3

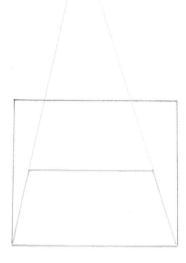

CONCEPT

Construction lines *are used to determine the placement of parts of a drawing and are eventually erased or incorporated into the shading.*

Similar to the angled lines drawn in step 1, draw angled lines from the tops of the front legs to the vanishing point. The rear legs are placed by drawing vertical lines that begin where the second horizontal line touches the lower lines of convergence and end at the upper lines of convergence. The rear edge of the table connects the tops of the rear legs.

4

The angled construction lines are called lines of convergence because they converge (meet) at the vanishing point.

Check that the front and rear edges of the table are parallel.

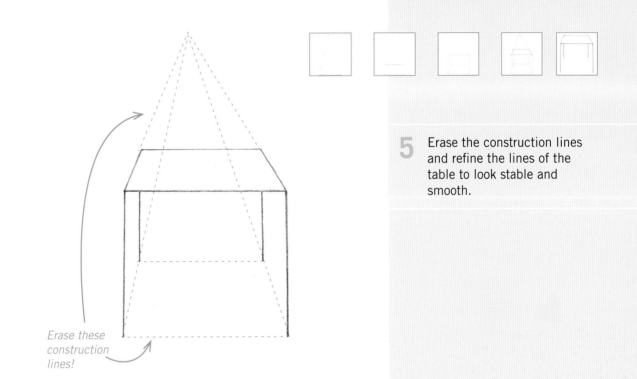

5 Erase the construction lines and refine the lines of the table to look stable and smooth.

Erase these construction lines!

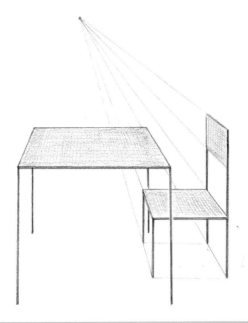

ADVANCED VARIATION

Draw a chair using the same method and vanishing point used to draw the table. Think of the chair as a small table with an upright section. The seat is not as wide as the table, so draw the seat's near and far edges closer together. Add stability to the objects by shading the chair and table surfaces with marks that follow the directions of the parallel edges.

hay bale

Steps: 5 **Difficulty:** ■ ☐ ☐ ☐ ☐

With its cylindrical form and grassy texture, a hay bale presents a unique drawing experience. At the two flat ends, the pattern of the hay slowly spirals inward while the side follows an elliptical curve. Shading marks that follow the surface of the form intensify the 3D illusion.

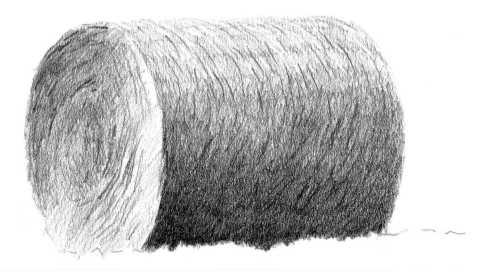

1 To begin constructing a cylinder, draw the axis. In the case of this hay bale, draw one that is angled slightly upward to the right and about 5½ inches (14cm) long. Draw a tick mark 2 inches (5cm) from the left, dividing what will be the ellipse end and the curved side.

Draw the construction lightly with a 4B pencil.

2 When a circle is turned at an angle, it becomes an ellipse. Draw the major axis of the ellipse 3¼ inches (8.25cm) long at a 90-degree angle to the axis of the cylinder.

The ellipse's major axis crosses the cylinder's axis at a 90-degree angle.

The construction lines show that the ellipse will lean to the left. With a broken line, draw the ellipse contour to touch the ends of the construction lines. Draw the sides of the cylinder parallel to its axis and draw the "hidden" ellipse on the right to have the same curve as the right half of the "facing" ellipse.

3

The texture of the broken-line contour will eventually become part of the hay texture.

CONCEPT
Directional shading *follows the surface of a form to intensify the illusion of 3D.*

Erase the crossing axis lines.

4

Shade the ellipse with a gradation of medium to pale tone at an angle.

To begin work on the longer side, draw a jagged, broken line that will show the texture of the ground. Then shade upward from that with loose marks in rows that gradually change direction to follow the curving surface.

Shading marks that repeat in one direction make a surface look flat.

Shading marks that gradually change direction make a surface look curved.

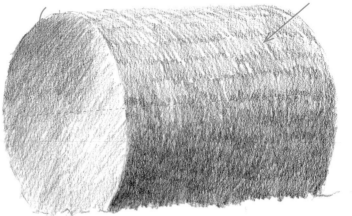

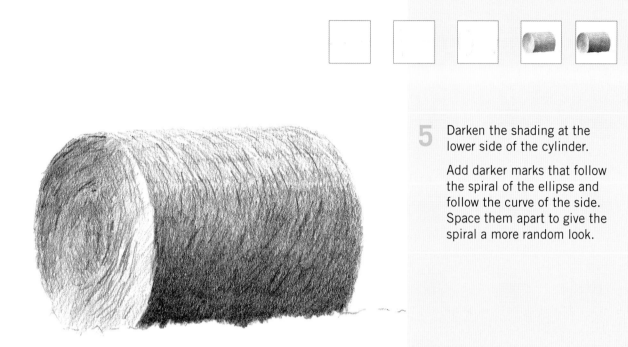

5 Darken the shading at the lower side of the cylinder.

Add darker marks that follow the spiral of the ellipse and follow the curve of the side. Space them apart to give the spiral a more random look.

ADVANCED VARIATION

Create the main shape of the shadow cast on the grass. Grip the pencil closer to the tip and change the direction of your shading frequently. Then, with more pressure and control, shade the darkest area of the shadow where the bale touches the ground and around some of the blades of grass.

castle tower

Steps: 5 **Difficulty:** ■ ☐ ☐ ☐ ☐

This tower is constructed with a cylinder for the walls and a cone for the roof. When the edges of these basic shapes curve upward, as they do at the eaves of the roof and in the rows of stones, it creates the illusion that the structure rises above the viewer.

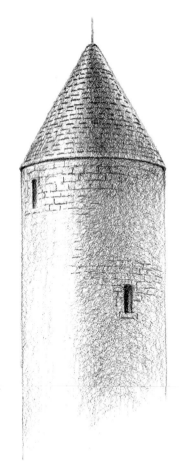

Use the sides of the paper as a visual reference to draw the vertical and horizontal lines.

1 With a 4B pencil, create a pale construction. Begin this by drawing a vertical axis and a shorter crossing axis.

For the roof, draw a triangular shape that is evenly divided by the axis.

Draw the left side of the tower a little longer than the right side. Keep the lines light as you refine them to be straight up and down (plumb).

2 Draw the horizontal curve of the eaves so that the right side of the curve is a reflection of the left. Notice there is a very small curve where the line of the eaves meets the side of the tower. Don't let it end in a point that would make it look flat.

With the pencil tip, draw rows of dark marks for the shadows beneath the roof tiles. These rows repeat the curve of the eaves.

3

Keep the rows curving and level.

CONCEPT
*A **cone** is a 3D basic shape with a circular base and curving side that tapers to a point.*

Shade the entire tower cylinder with short lines that follow the curve of the eaves. Leave the area just left of the center a little lighter, to show where the sunlight falls.

Adding darker shading on the right "shadow" side of the tower completes the illusion of it being lit from the left. The far-right edge is a little lighter to show that the form is turning away there.

4

Shading effects of the cone become more compressed toward the peak.

Changing value from dark to light describes change in the surface.

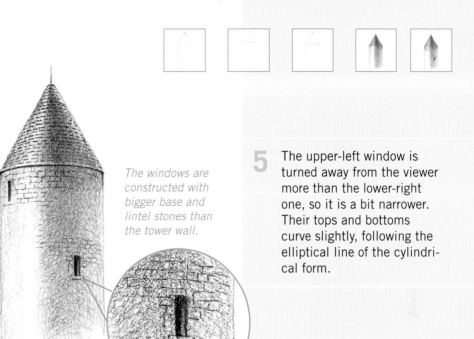

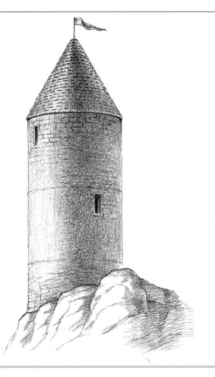

The windows are constructed with bigger base and lintel stones than the tower wall.

5 The upper-left window is turned away from the viewer more than the lower-right one, so it is a bit narrower. Their tops and bottoms curve slightly, following the elliptical line of the cylindrical form.

ADVANCED VARIATION

Add the flag by first drawing its contour with the tip of a sharp 4B pencil. Then shade it where the flag turns away.

The cliff base is angled like the top edge of a cube seen from below. Its peak starts at the right side of the tower with the top edges angling downward. Most of the shading lines follow these angles with heavier shading on the right, opposite the sun.

apple

Steps: 5 **Difficulty:** ■ □ □ □ □

Observe an apple and you'll probably think about how an apple tastes. Look at the outside edge, called the *contour*. Most apples are round, but each has its own combination of curves. What may look like one large curve might be a series of smaller curves. With this drawing, take time to observe the subtle changes of the contours.

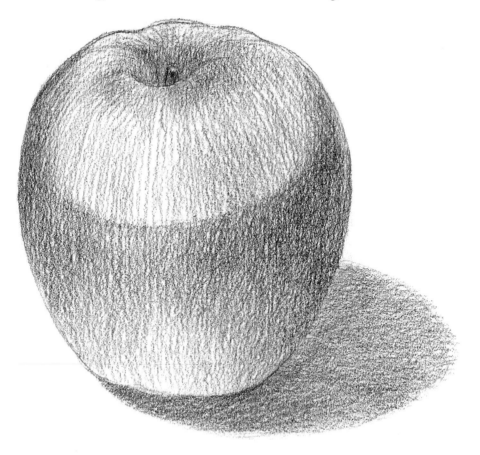

Draw a broken-line contour with small spaces between the lines.

1 Draw the contours of the apple and shadow with small spaces where the main changes happen. Use a 4B pencil and keep the lines light.

Turn the page to see the shape better.

2 Now refine the contour with multiple lines, but not so many that it becomes fuzzy. Include the horizontal curve of the top depression and the stem. If necessary, drag the kneaded eraser along the lines to smooth them.

Keep the pencil perpendicular to the line you are drawing.

Draw the cross contour curve where the transition between the light area and the shadow area of the apple surface occurs. Notice the curve is slightly higher on the right side because the light source is high and to the left.

3

Draw this cross contour line pale and broken.

CONCEPT

A **contour** *is an edge line.* **Cross contour** *lines appear inside a shape and describe curved surfaces with arcing lines and flat surfaces with straight lines.*

The contours are defined in most places with soft shading, not lines.

Shade the areas by drawing small, curved lines in the apple shape and straight, horizontal lines in the cast shadow shape.

4

The darkest areas appear darker when they are next to a light area.

5 Intensify values and gradations to develop the illusion of depth and light. The shaded area of the lower apple and the cast shadow should have a fairly even tone when you shut one eye and squint. But on closer view, they should have lighter and darker areas for interest.

ADVANCED VARIATION

Intensify the dark areas with a 6B pencil. Refine the apple contour to be soft in some places and more defined in others. Erase highlight areas by pointing a kneaded eraser and pressing it repeatedly into the paper. Knead the eraser when the tip is shiny with graphite. By erasing a little larger area than the final highlight will be, you can shade softly with a 4B pencil to define the erased area.

vase

Steps: 5 **Difficulty:** ■ ☐ ☐ ☐ ☐

Most objects are easier to draw when broken into smaller sections.
This vase is symmetrical, so it can be divided into similar left and
right sides. Dividing the halves into three more sections helps you see
details of the contour and size relationships.

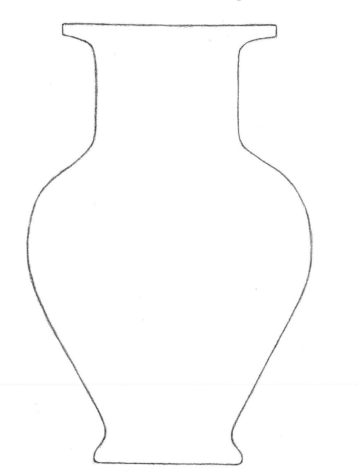

1 With a 4B pencil, create a six-square grid that is three squares tall and two squares wide. Mark a 1-inch (2.5cm) margin at the top and left sides. Then mark 2-inch (5cm) spaces to create the grid squares. Use the ruler's straightedge to connect the marks with horizontal and vertical lines.

2 Begin the contour by marking the main transition points with light line segments and leaving spaces between them.

When you're confident of **3** the placement of the transition points, connect them and refine them into a light, smooth contour.

Begin drawing the right-side contour and create it the same way as the left side.

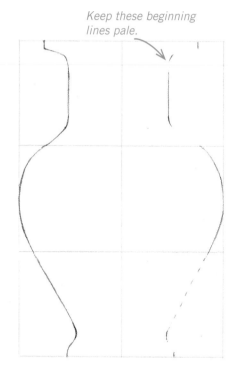

Keep these beginning lines pale.

CONCEPT

*A **grid** is a construction device with a pattern of horizontal and vertical lines that the artist can use to analyze and copy images block by block.*

Turn the page upside down for a fresh angle to compare the sides.

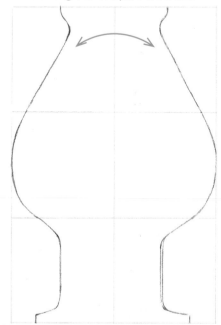

Critique your progress by **4** looking for parts that need adjustment. The neck of the vase was a little narrow on the right side and was revised.

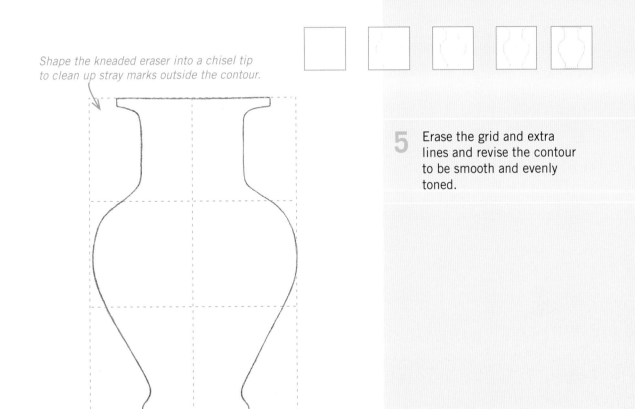

Shape the kneaded eraser into a chisel tip to clean up stray marks outside the contour.

5 Erase the grid and extra lines and revise the contour to be smooth and evenly toned.

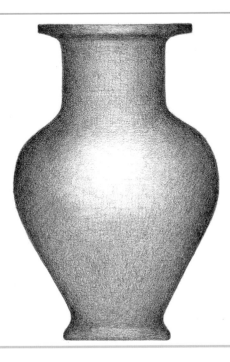

ADVANCED VARIATION

Shade the vase to intensify the 3D form with a kind of shading called *modeling*. This kind of shading makes the parts that are farther away darker and the parts that are nearer lighter.

Begin by shading the entire form with light horizontal lines. Then darken areas with short marks drawn at a different angle.

ribbon

Steps: 5 **Difficulty:** ▪ ☐ ☐ ☐ ☐

A drawn object is part contour and part surface. Ribbon is a great subject for exploring the way a surface twists and turns and discovering how to translate that surface with graphite. Curving this surface in pencil is a combination of gradations and overlapping shapes.

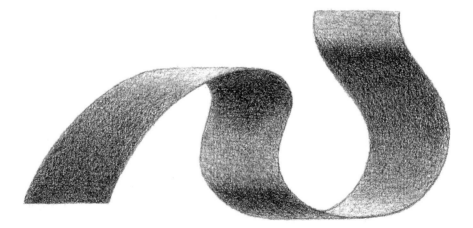

1 Draw a curving, broken line.

Draw this broken line to be pale and soft.

Align the ruler to be parallel to the page as you draw the ribbon-width construction.

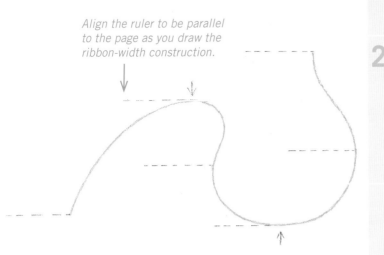

2 Refine the line to be smooth and evenly toned. Then, with a ruler, draw 1-inch (2.5cm) widths with broken lines. Draw these in several places where transitions occur. Note that the main transition is at the apex of the curve.

Draw the far edge of the ribbon to be 1 inch (2.5cm) to the left of the near-edge curve. Draw it as a pale, broken line. Some curves are easier to see and copy with a vertical plumb line as a visual reference. When you've drawn in the verticals lightly, compare the two curves by focusing on one and then glancing at the other.

3

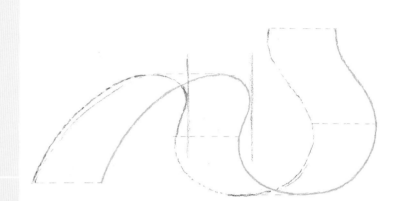

CONCEPT

Construction lines, *such as vertical "plumb" lines, horizontal "level" lines, grids, guidelines, or tick marks, help position parts of a drawing. Drawn lightly, they are usually erased later.*

Erase the construction lines and where the surface overlaps the rear edge. Then refine the contours of the ribbon.

4

Erase these lines too!

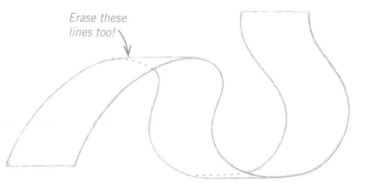

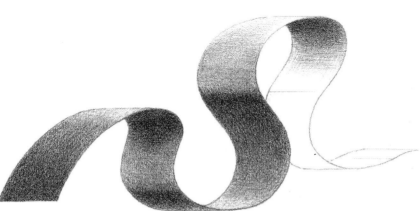

5

Shade the ribbon surface with horizontal lines. Darken the value of the underneath parts of the ribbon. Also create gradations that visually show the change of the surface direction.

Change the angle of darker shading layers.

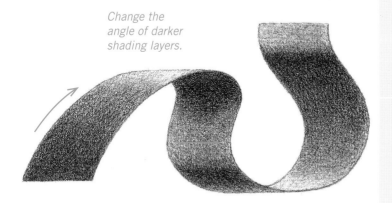

ADVANCED VARIATION

Extend the length of the ribbon using the preceding method. You might continue to the right while creating unusual overlapping sections. Or if you want a big challenge with a surprising result, use a rhythm similar to the first section and continue to the right and then upward, back to the left, and around to the beginning to create a closed loop.

linear pattern

Steps: 5 Difficulty: ■ ■ ☐ ☐ ☐

Patterns that repeat along a line can be ornamental or practical, or both simultaneously. They're present in a range of decorative and useful items from textiles to tire treads. Some complex and inventive linear patterns begin with very simple shapes. Repeating them while alternating the position develops a visual relationship between the colored shapes and the resulting background shapes.

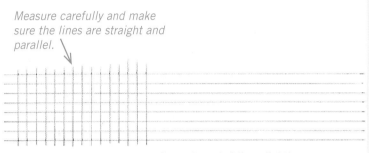

Measure carefully and make sure the lines are straight and parallel.

Draw the ruled lines lightly.

1 Draw a grid: Begin at the left side of the page and make a tick mark every $\frac{1}{2}$ inch (1.25cm) to create seven half-inch spaces. Do the same on the right side of the page. Then with a ruler as a guide, connect the marks that are level with each other to make eight parallel lines.

Using the same process, create 15 vertical lines, each $\frac{1}{2}$ inch (1.25cm) apart, that cross a section of the horizontal lines.

Lighten the grid area with a kneaded eraser.

2 Lighten the crossing lines by lightly rubbing the area with a kneaded eraser.

Erase excess ruled lines beyond the grid and brush away any eraser dust.

With a 4B pencil, shade a one-square wide, seven-squares tall section along the left side. On the first pass, shade the shape lightly to establish an even tone. On the second pass, shade it darker without pressing so hard that it becomes shiny. Refine the contour last.

3

When shading, save the edge for last and be careful to not over-darken it.

CONCEPT

Images involve a relationship between a prominent object (figure) and a setting (ground). Sometimes the two can reverse roles, as the dark and light parts of this linear pattern do.

Double-check that the squares marked on your grid correspond to the completed drawing.

It can be helpful to first mark the squares you will shade later with a light dot or scribble. Mark six more squares on the top row and shade them with the process from step 3.

4

Using soft vertical then horizontal marks, repeat the direction of the grid lines to incorporate them.

5 Complete the pattern with the same process of determining the number of squares based on rows or columns in the completed drawing. Mark the corresponding squares on your grid and shade them.

ADVANCED VARIATION

Using the same type of grid and shading process, invent a new linear pattern. Shade the squares of a grid to create a small segment that alternates and repeats. Remember that while you are creating the shaded figure, you are shaping the white space of the ground.

goldfish

Steps: 5 **Difficulty:** ■ ■ ☐ ☐ ☐

Gracefully bending, circular, billowing, bulging, and undulating describe the contours of oriental goldfish. Curves usually imply softness and relaxation, but when found in shells and bones, they also provide strength. To draw curves, allow the wrist (or elbow and shoulder for large curves) to be a pivot and turn the paper so the pencil remains perpendicular to the line.

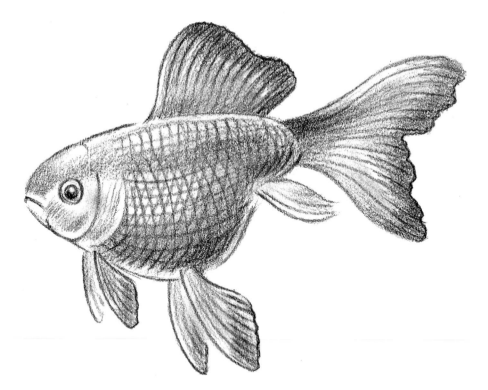

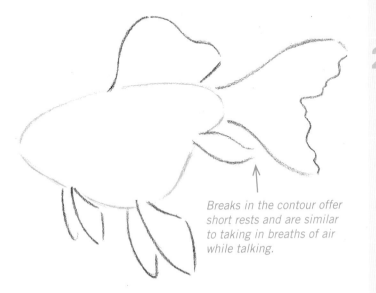

Leave spaces for a soft look and to emphasize where body parts will attach.

Curves can imply trajectory and speed; they can appear open and slow, or more closed and fast.

1 Draw a dashed construction line about 3 inches (7.5cm) long that describes the angle of the longest part of the body. The body of the goldfish is simultaneously round and triangular. Draw a light, broken-line contour of this shape. The top is a slower-looking curve, while the curves at the face and tail are more closed and appear faster.

2 Build out from the body: Draw the contours of the dorsal fin, pairs of pectoral and ventral fins, and tail with small spaces where transitions occur.

Breaks in the contour offer short rests and are similar to taking in breaths of air while talking.

Add the features of the head. **3** The curve of the mouth is level with the lower part of the eye, and both are made with soft lines. Lift the tip of the pencil off the paper at the end of the strokes to create a soft fade to the lines. The curve of the cheek points upward to the end of the mouth.

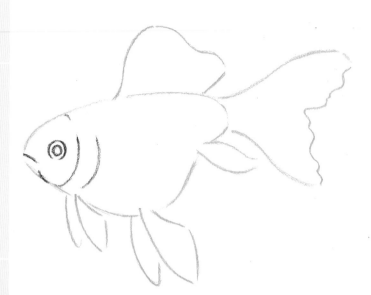

CONCEPT
Curvilinear *edges and contours arc and add soft, graceful, undulating, or rippling qualities to a drawing. Draw them with a flexible wrist and the pencil perpendicular to the line.*

Draw the long and curv- **4** ing medial line across the side of the fish. Shade the underside of the body with short, curving strokes, but stop before reaching the contour to create the illusion of rounding. Begin shading each fin at the tip, and then draw the thin, repeating bones within it.

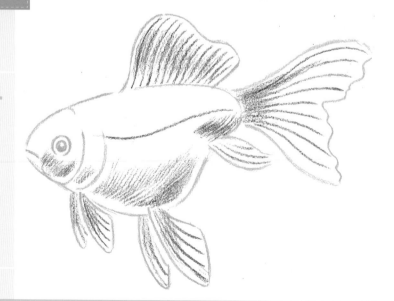

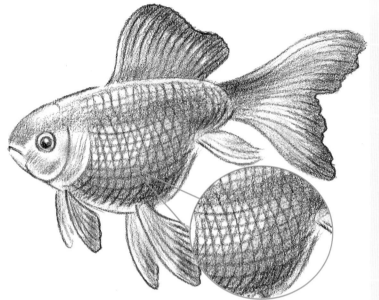

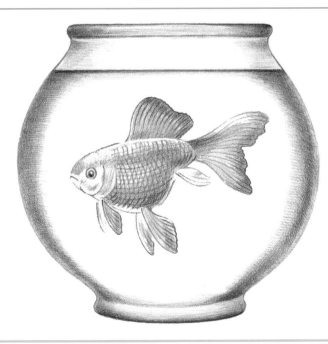

5 Shade the fish lightly, leaving light areas around the eye, mouth, ridge of the back, and belly. Darken the tips of the fins and the belly.

Finally, draw crisscrossing lines to create the texture of scales. Draw rows of them that curve with the body horizontally from gills to tail, then at an angle from belly to upper right, then from belly to upper left.

Evenly space the crossing lines of the scales to create small triangle shapes.

ADVANCED VARIATION

Complete the illusion of the goldfish in water by adding a fishbowl. First draw the symmetrical, curvilinear contour of the bowl and check that the top rim and foot are level. Draw a dark horizontal line at the water level and shade soft gradations at the sides with layers of short, curving strokes. Cross these at an angle to darken the area while leaving the part near the contour lighter, creating the illusion of rounding.

leaf

Steps: 5 **Difficulty:** ■ ■ ☐ ☐ ☐

The branching structure of leaves resembles the tree and appears in other natural forms. Rivers, the human circulatory system, the bones of the hand, and microscopic points of snowflakes are a few that make this design relevant. Knowledge of a subject's structure helps the artist determine shading patterns.

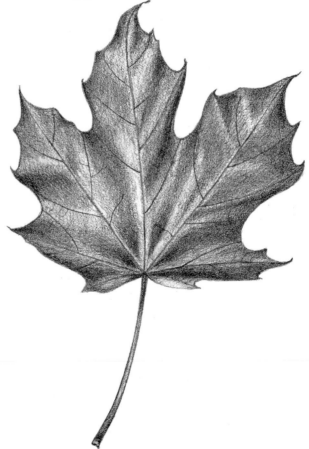

Veins on opposite sides of the central midrib end at slightly different heights.

1 Begin this maple leaf by drawing the central midrib, four veins, and stem with a 4B pencil. Begin with soft lines, and then go back and refine them to appear smooth.

2 Draw the leaf contour with smooth transitioning curves and points. Lighten the stem and then, using the original lines as a guide, redraw it as a contour shape, gradually widening and ending with a small curve where the two sides meet.

Begin with light lines and then refine the curves and points with slightly darker lines.

how to draw a **leaf** 69

3 Shade the leaf to make a light tone across the entire main shape.

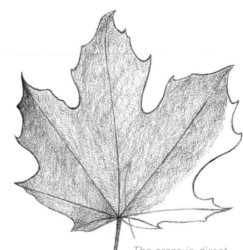

The areas in direct light will remain this pale tone in the final drawing.

4 Shade darker areas, such as some of the outside edges and depressions, in the leaf surface.

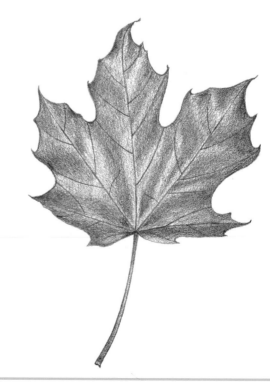

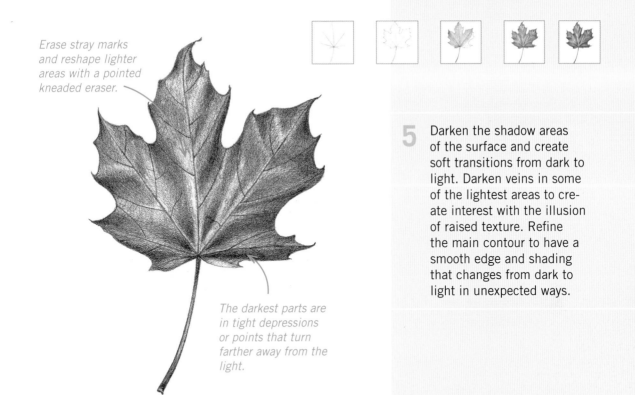

Erase stray marks and reshape lighter areas with a pointed kneaded eraser.

The darkest parts are in tight depressions or points that turn farther away from the light.

5 Darken the shadow areas of the surface and create soft transitions from dark to light. Darken veins in some of the lightest areas to create interest with the illusion of raised texture. Refine the main contour to have a smooth edge and shading that changes from dark to light in unexpected ways.

ADVANCED VARIATION

Create a series of drawings of leaves using the process in this lesson. They're free and easy to find. Look for interesting and unusual ones. Old, curling leaves can have surprising shapes and shadow patterns.

eye

Steps: 5 **Difficulty:** ■ ■ ☐ ☐ ☐

The eye and surrounding flesh is a landscape of form. The ridge of the brow plunges downward and disappears inside a fold, emerging as the eyelid. Shading light and dark with a pencil describes these exciting surface changes with values, from the white highlight to the black pupil.

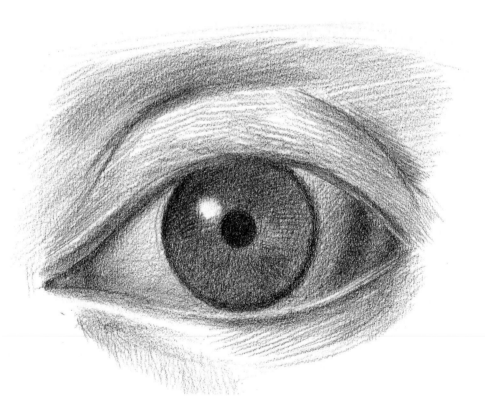

The line of the eye is a construction line passing through the lid's inside and outside corners.

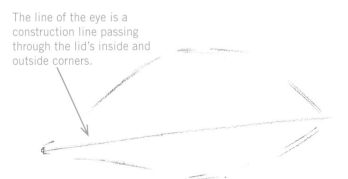

1 To draw an eye, first describe the unique angle of the eye being drawn. In this instance, draw a 4-inch (10cm) line that angles upward slightly to the right.

With a broken line, draw the main contour shape of the eyelids at the opening of the eye. The narrow area at the left is the start of the tear duct. These faint lines will be incorporated into the shading later.

Erase the line of the eye.

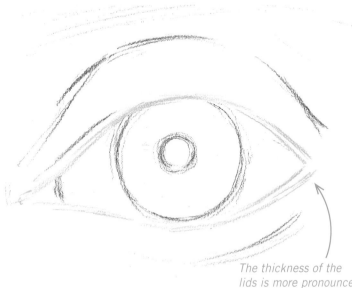

The thickness of the lids is more pronounced at the outside corner.

2 Rough in the remaining main shapes beginning with the circumference of the iris and the pupil. Notice that a small part of the iris disappears beneath the upper lid. Maintain the shapes of the white of the eye to the left and right.

Indicate the membrane of the tear area with a vertical mark.

Draw the light beginning of the crease of the upper lid and the bulge of the lower lid.

Shade the interior white of the eye, leaving only the highlight at the left of the pupil the white of the paper. Shade the far left and right darker to create the illusion of the sphere of the eyeball.

3

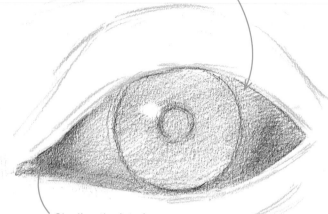

The white sclera of the eye is actually a light gray with only a few white highlights.

Shading the interior intensifies the edges of the lids.

CONCEPT

Value, *also called tone, is the lightness and darkness in an image. The artist designs images with values in patterns ranging from lightest light to midtones to darkest dark.*

Darkening the value of the iris intensifies the highlight. Shade the iris darkest there and slightly lighter to the right of the pupil.

4

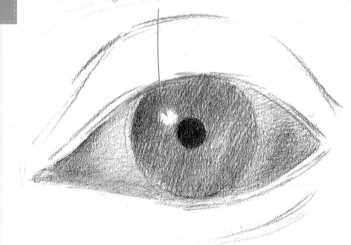

A light value appears even lighter next to a dark value.

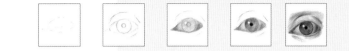

Directional shading lines change direction, with the form creating the illusion of rounding.

5 Add directional shading to develop the rounding of the lids as they stretch over the eyeball. Darken the value at the deepest part of the crease of the upper lid.

Refine the edges of the lids and the rim of the iris with soft, darker shading to intensify the illusion of the white sclera.

ADVANCED VARIATION

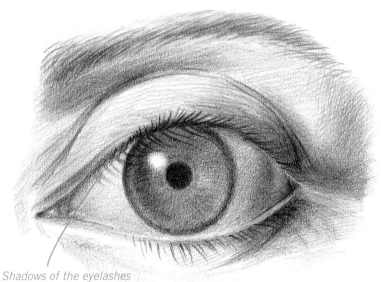

Add the eyebrow and eyelashes with quick lines that curve in different directions. While drawing the curves, lift away from the paper creating a light, sharp end.

Darken the shading at the eyebrow, the right of the lids, and the edge of the upper lid to develop the effect of lighting from the left.

Shadows of the eyelashes stretch across the curving surface of the eye.

nose

Steps: 5 **Difficulty:** ■ ■ ☐ ☐ ☐

Beginning with the nose, the whole front view of the face is a series of transitions. There are a few contour edges in this view, but most of the surface description is made with gradations changing softly from light to dark value. Gradations are key to drawing the nose.

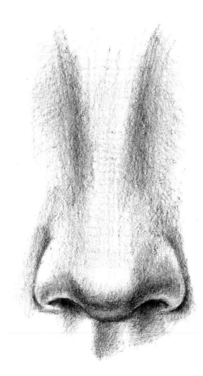

1 To draw the nose from the front, first make a vertical axis about 4 inches (10cm) tall and a horizontal level line about 2 inches (5cm) long, to determine the placement of the nostrils.

Draw the angled sides of the nostrils that connect to the horizontal construction line.

2 The nostrils are curves that dip lower as they meet in the center and are parallel to the horizontal guideline.

Grip the pencil at about a 30-degree angle with your fingertips 3 inches (7.5cm) from the tip.

Indicate the soft edge where the length of the nose transitions into the sides of the nose with several long, soft marks that angle inward and align with the tip of the nose.

3

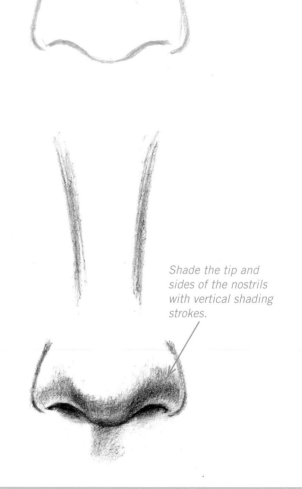

Grip the pencil farther back and allow the wrist to bend a little while you shade these marks.

Draw the contour of the nostril and shade small gradations that lighten below the openings. Shade the winged shapes just above the nostrils to create the illusion of the tip of the nose. Leave the area directly above the nostril light and shade the area to the sides of the tip darker. The combination of light and dark surfaces creates the illusion of depth.

4

Shade the tip and sides of the nostrils with vertical shading strokes.

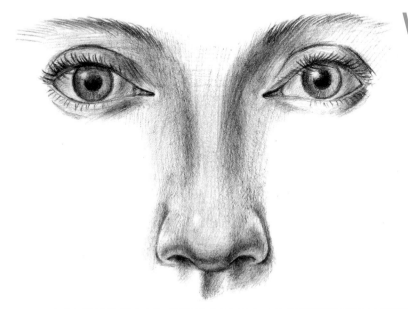

Describe the form with light directional shading angling downward at the sides of the nose.

5 Increase the shaded area of the bridge gradations with horizontal marks and then vertical marks. Add shading down the sides of the bridge and the sides of the nostrils (the ala).

The depression below the tip of the nose is called the philtrum. Soft shading that stops in an edge creates a ridge.

ADVANCED VARIATION

Add the eyes based on the eye in Lesson 14. Take the measurement of the width of the lower nose (2 inches/5cm) and turn it vertically. Balance it on the wing (ala) of the nostril; the top of this length in this position is the correct position for the inside corner of the eye. Note: The eyes are usually about one eye width apart.

dog (profile)

Steps: 5 **Difficulty:** ■ ■ ☐ ☐ ☐

Well-trained dogs are great models and will pose long enough to capture each stage of a portrait for the price of a kibble or two. In profile view, this Jack Russell terrier's eye appears larger in relation to the muzzle than a larger breed's would and the nostril and eye shapes are compressed. J.R.'s determination and poise deserve a tasty reward.

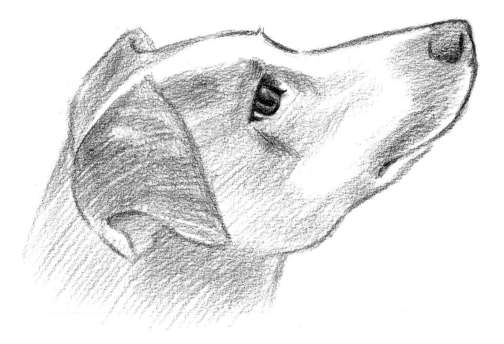

Draw this construction lightly with a 4B pencil.

1 Draw a construction line that is 5½ inches (14cm) long and angles upward at the right. Divide it in half with a perpendicular line. Draw a third line that is dashed and divides the segment to the left in half, also perpendicular to the first line.

Draw these lines with the side of the pencil's tip.

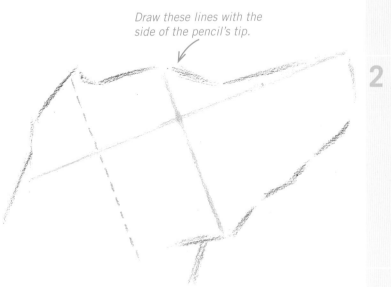

2 Rough in the main contours with broken lines, using the three construction lines as a guide. Notice that the nose is at the right and the back of the head is at the left. The brow is at the top of the second line and the cheek is at the bottom. The far ear is at the top of the dashed line. The eye will be just to the right of where the two solid lines cross.

Finish roughing in the ears. **3** To draw the nearer ear, notice how the construction lines divide it into four parts, the lower left being the most complex.

Begin the eye by drawing the two angled lines describing the upper lid. Draw the lower lid softly and wider as it angles upward. Leave small breaks at the two corners of the eye to avoid flattening.

Draw the lines of the nose and neck.

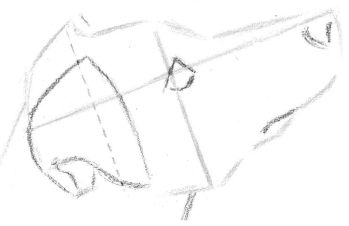

Continue drawing with the side of the tip to create soft lines.

CONCEPT

*The **profile view** describes the raw character of a head. The averted gaze is less intimate than the frontal view and invites the viewer to contemplate the subject's thoughts or the object of focus.*

Add depth to the eye, nose, **4** and ears with shading. Intensify the depth of the eye by darkening the nearer upper lid while softly shading the farther inside corner. Draw and shade the elliptical shape of the iris and pupil. Then touch the upper area with the point of the kneaded eraser.

Shade softly to create the illusion of the rounded side of the nostril and the tip of the nose.

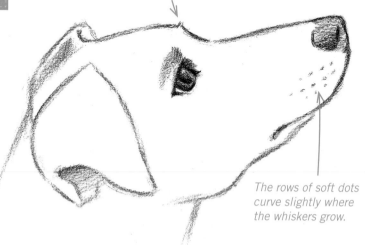

The small marks at the brow are hairs from the other side of the head.

The rows of soft dots curve slightly where the whiskers grow.

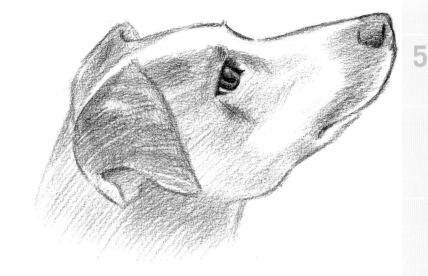

5 Shade the ears, head, neck, and jowl with longer directional shading lines. Then add a second layer of strokes at a different angle to create subtle changes in the surface, especially around the eye and on the surface of the ear.

ADVANCED VARIATION

Change the direction of the shading strokes to follow the various directions of the fur.

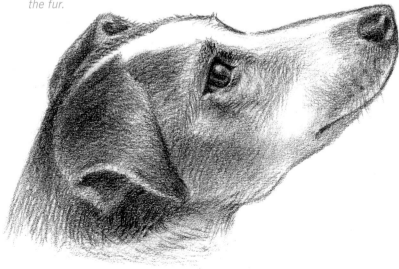

Darken the value of the ears, nose, and eye while leaving edges and highlights fainter. Create the growth pattern of the fur with smaller, darker strokes.

From this view, one nostril is visible. Describe it with a shadow that has an upside-down teardrop shape and with highlights below, above, and to the right.

Redefine highlights with a kneaded eraser.

Add small strokes at the contour to create the texture of the whiskers and fur.

water droplet

Steps: 5 **Difficulty:** ■ ■ ☐ ☐ ☐

The water droplet is the beauty mark of many art images and combines several basic drawing concepts. Its gradation, contrasting values, and distortion are found in most water and glass forms. Clear liquid refracts and changes the light and shapes seen through it. Here, the light source is at the upper left and travels at a 45-degree angle through the droplet.

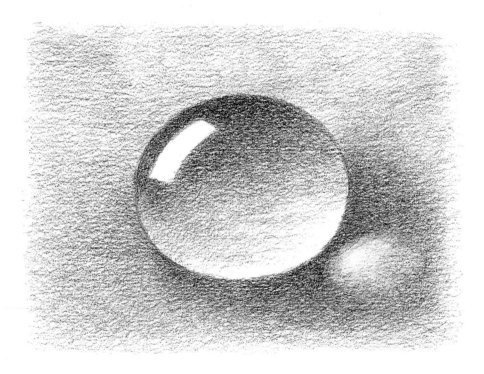

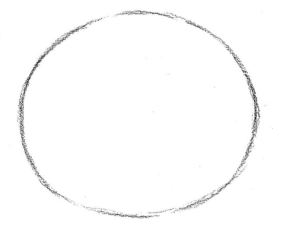

1 Draw the oval shape of the drop-let. Turn the page as you allow your wrist to bend and keep the pencil perpendicular to the line. Refine the shape to smoothen, then lighten it with the kneaded eraser.

Draw the highlight shape lightly and it will become part of the shading in the next step.

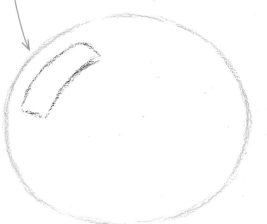

2 The main highlight of a reflec-tive sphere, like this water droplet, is shaped by the light source and also follows the form of the contour. If the light source is round, the highlight is round; if it's rectangular, the highlight is rectangular. The main highlight of the water droplet is a combination of the rectangular light source and the curvilinear contour.

Shade the gradation in the droplet from dark at the top to light at the bottom. Move the side of the pencil tip back and forth in short strokes, keeping the pencil in contact with the paper. Shade up to the highlight shape softly and avoid any outlines.

3

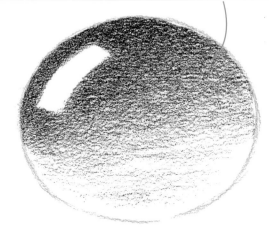

CONCEPT
*A **light source** can be natural (the sun) or artificial, and it determines the light and shadow shapes of a drawn object. Its rays travel in straight paths, but can reflect and refract.*

Shade a rectangular area outside the droplet with a faint value. It will be the surface beneath the droplet. Add a soft-edged shadow that spreads from the bottom of the droplet and to the right.

4

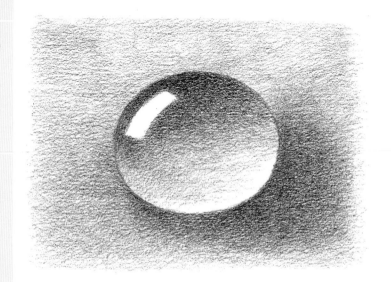

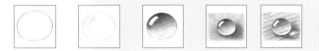

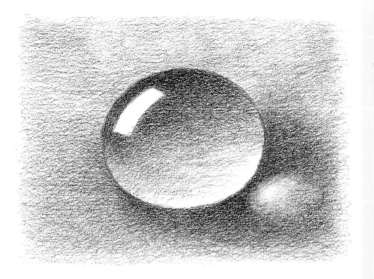

5 Create a light spot in the cast shadow that lines up with the light source and the main highlight. Use a kneaded eraser to lift the graphite of the shadow by pressing the rounded tip of the eraser into the paper a few times.

ADVANCED VARIATION

The final stage of the illusion increases the texture of the surface seen around and through the droplet. Shade soft lines with the side of the pencil tip evenly spaced outside the droplet. Then add the same texture as seen through water, magnified and slightly distorted from refraction.

Make sure that the lines on either side of the droplet line up.

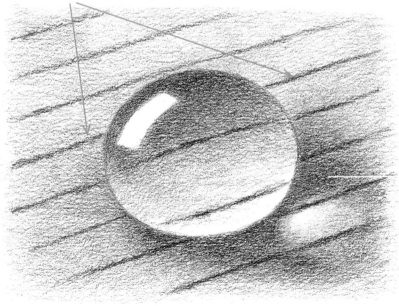

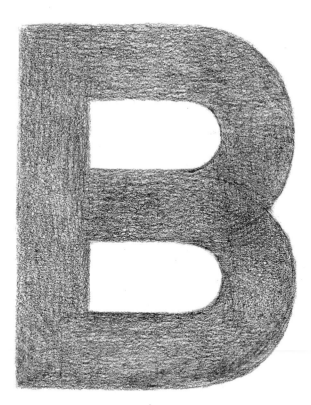

how to
draw a

letter B

Steps: 5 **Difficulty:** ■ ■ ☐ ☐ ☐

Letterforms are a great resource for practicing drawing skills. Learning one letter, like the B, prepares you to draw letters with similar interior forms and sizes like F, E, P, and so on. Master an alphabet and you'll learn pencil control and gain perceptiveness to sizes.

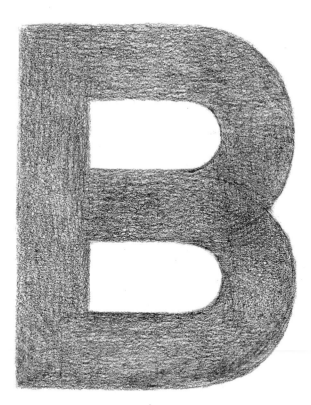

Draw this grid lightly with a 4B pencil.

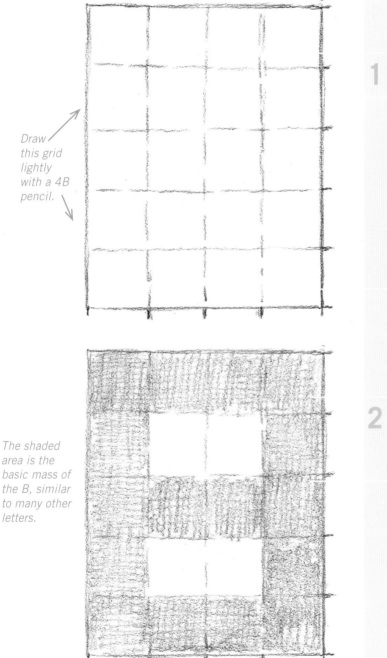

The shaded area is the basic mass of the B, similar to many other letters.

1 Create a grid that's four squares wide by five squares tall. Begin with a horizontal line 3 inches (7.5cm) long. Without a ruler, divide it into four equal parts with the visual method.

Make a vertical line connected to one of the ends of the first line that's five of the small segments tall. Complete the grid by drawing the other sides of the rectangle and dividing the area into 20 squares.

2 Shade in the outside ring of squares and those that cross horizontally in the middle with a light value.

The two curved parts of the B are half circles. Draw them to touch the grid where the arrows are pointing.

3

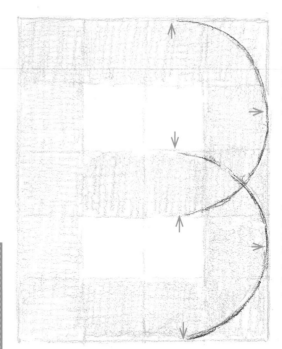

Turn the paper to keep the pencil perpendicular to the curved segment you are drawing.

Gripping the pencil farther from the tip will keep your hand from smudging the drawing.

CONCEPT

Proportion *is a relationship of sizes, such as height compared to width. The letter B here has a proportional relationship of 4 to 5, also written 4:5.*

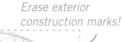

Erase exterior construction marks!

Erase the top and bottom corners on the right side, stopping at the curves.

Erase the curved triangular shape at the outside edge between the two large half circles.

Draw the smaller half circles of the interior shapes (counters) to touch where the arrows are pointing.

4

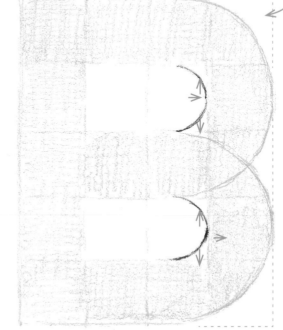

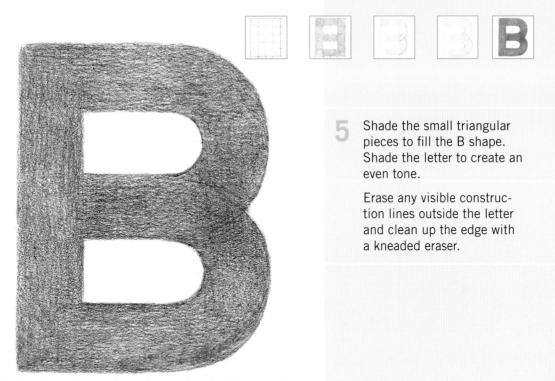

5 Shade the small triangular pieces to fill the B shape. Shade the letter to create an even tone.

Erase any visible construction lines outside the letter and clean up the edge with a kneaded eraser.

Shade with similar marks as the construction lines—curving, vertical, and straight—and they will blend together.

ADVANCED VARIATION

Shade the letter to give a raised and rounded look. Begin by darkening the edges, then lift off value in the middle of the entire letterform with a pointed kneaded eraser.

If you want to practice what you've learned with another letterform, try an R using the same grid process.

deck of cards

Steps: 9 **Difficulty:** ■ ■ □ □ □

To draw rectangular objects, answer two questions first: "How many sides do I see?" and "Is a corner pointing toward me?" If the answer to the first question is "Two" or "Three," and the answer to the second question is "Yes," then the drawing involves two-point perspective, a method for calculating angles of a rectangle's edges.

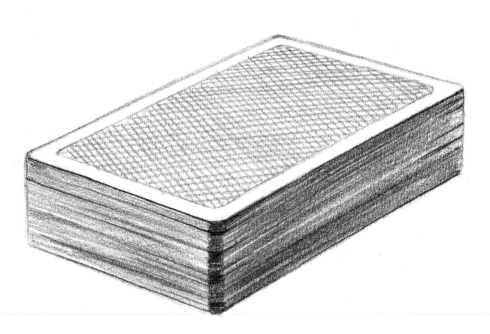

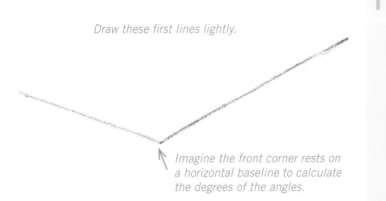

Draw these first lines lightly.

Imagine the front corner rests on a horizontal baseline to calculate the degrees of the angles.

1 Though you won't need to plan a complete two-point perspective construction to draw the edges of this deck of cards, you will draw them to become closer together, or converge, as they recede into the distance.

Draw the two nearest edges that meet at the front corner. The left edge is 20 degrees and about 3 inches (7.5cm) long and the right edge is 30 degrees and 4 inches (10cm) long.

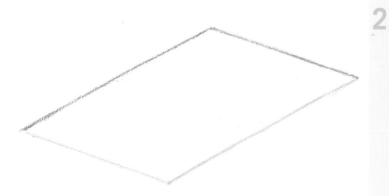

2 Draw the two far edges and make sure they're parallel to the opposite near edge. You can check this by placing a ruler 90 degrees to one of the lines while measuring the distance between the two in a couple of places.

Draw three vertical lines, each ¾ inch (2cm) long, that extend downward from the ends of the angled lines where they meet. Then connect the vertical lines with two more angled lines to form the bottom of the deck.

3

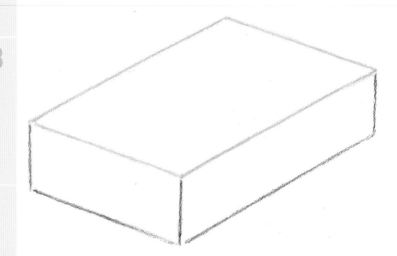

Lighten the two far edges with a kneaded eraser. Draw them again to appear less steep. The first set of far edges was drawn to be parallel to emphasize that the revised lines are *not* parallel and angle downward from parallel at the far corner. This will ensure they converge, which is a requirement of perspective.

4

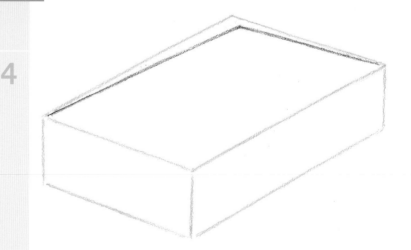

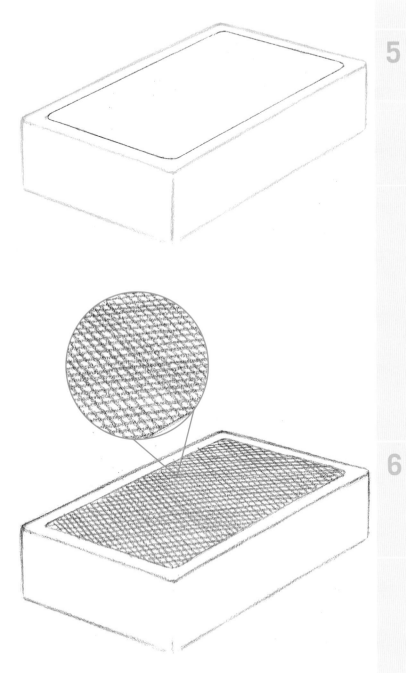

5 Draw four lines inside the top of the deck of cards that are parallel to the original outside edge. This will be the shape of the design on the back side of the top card.

Round off the outer corners.

6 Draw repeating parallel lines to shade the inside rectangle, then cross them at another angle with similar lines to create the design on the back of the card.

With the overhand grip and the side of the pencil tip, draw long shading lines that run parallel to the angled edges. Begin at the outside corners and shade inward to the near corner.

7

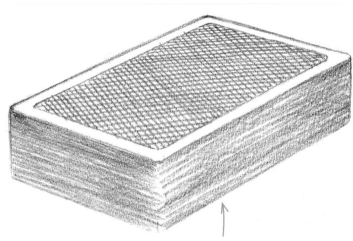

To create the texture of layers of stacked cards, don't overlap these too much.

Shade the right side with a second layer to create a shadow on this side. Then, with short horizontal strokes and pressure on the side of the pencil tip, darken the near corners of the cards.

8

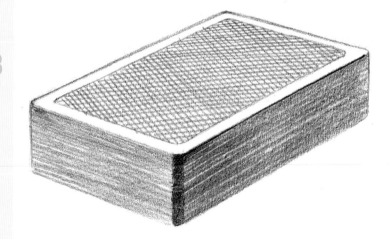

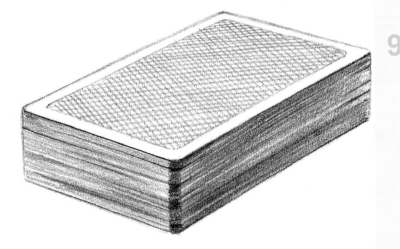

9 Add a few more shading strokes on the angled sides to create the illusion of stacked cards that are not perfectly aligned.

ADVANCED VARIATION

Draw the shadow shape lightly. Shade it with the side of the pencil tip with lines that run parallel to the angle of the stack to the left of the front corner.

Clean up any unevenness when shading by erasing with a mask of thick paper. Lay it over the shadow against the shadow contour and, while holding it down firmly, erase along the edge with a kneaded eraser.

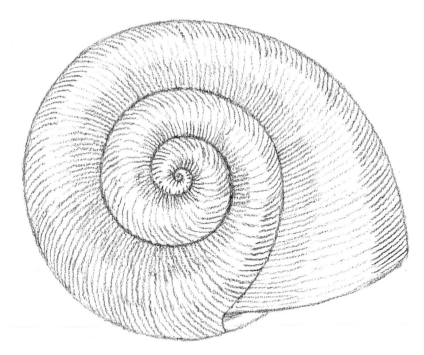

how to
draw a

shell

Steps: 5 Difficulty: ■ ■ □ □ □

Though snails don't make playful pets, they do attract the attention of
designers. The spiral growth pattern of their shells has been carved into
rock and designed into jewelry for millennia. This elegant curl can also
be found in the way galaxies expand, in the motion of whirlpools, and
in the growth sequence of plant leaves.

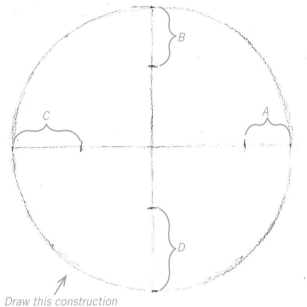

Draw this construction lightly.

Turn the paper to keep the pencil perpendicular to the line as you draw the curves.

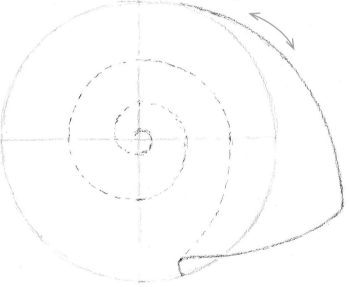

1 Draw a 3-inch (7.5cm) tall cross. Draw a circle whose halves meet at the ends of the lines.

Mark four places where the spiral intersects the cross: A is ½ inch (1.25cm) long. B is ⅝ inch (1.5cm) long. C is ¾ inch (2cm) long. D is ⅞ inch (2.5cm) long.

2 Draw the right side contour of the shell that curves downward to the right, and then turns left and stops just inside the lower part of the circle.

Begin the spiral at the bottom right and draw a broken line curving upward to mark A. Continue the curving line to mark B, then C, and then D, all the way to the center point of the cross.

Erase the vertical and horizontal construction and the right side of the circle.

Refine the spiral into a smooth, continuous curl.

3

Add cross contour lines to develop the 3D illusion of lateral rounding. These lines curve with a little extra bend where they meet the spiral. They will be lightened and then incorporated into the shading marks of step 4 and will be reminders of the changing angle of the shell's texture.

Grip the pencil farther back for lighter lines and to keep from smudging the drawing.

CONCEPT

Crosshatching *is a way of shading with rows or patches of parallel hatch marks that intersect at a different angle with another layer of hatch marks to create visual texture.*

Lift the pencil tip up at the end of the strokes to create a softer end.

Draw a continuous band of short marks that curve inward from the outside contour. These lines follow the curve of the cross contour lines from step 3 and are about a third of the width of the shell chamber. Draw another band of lines, opposite the first band, that follow the full length of the spiral.

4

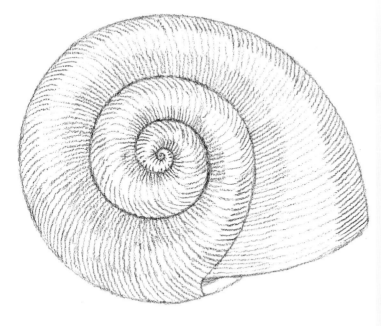

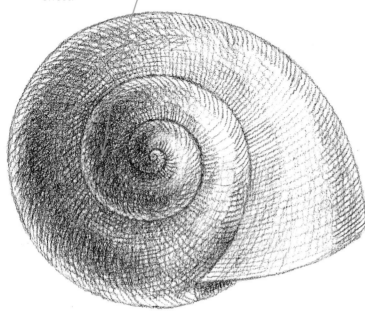

5 Draw a continuous band of light lines that cross over the highlight area.

Leave an area of reflected light in the shadow side to intensify the rounding effect.

ADVANCED VARIATION

Develop the light and shadow illusion by adding more layers of crosshatching. Begin drawing some of the marks to follow the direction of the spiral at 90 degrees to the first marks. Then add more layers at the left at a 45-degree angle to the original marks. Finally, add marks to fill in any holes in the tonal gradations and touch up the right side highlight with a kneaded eraser.

marble

Steps: 9 **Difficulty:** ◼ ◼ ◼ ☐ ☐

Cat's eye marbles are striking for the unique design of their colored glass interiors. This drawing is a celebration of these curvilinear forms, from their swirling interiors to the surrounding circle of the marble casting its elliptical shadow. Any straight line here would be out of place, except for the path of the rays of light.

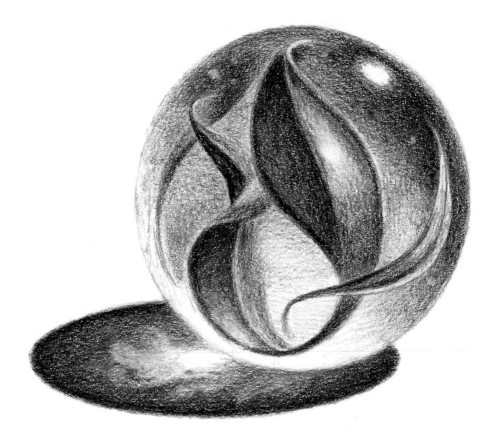

Turn the page as you draw the circle and ellipse to perfect the shapes.

Draw these first lines lightly.

The light travels here in the direction of the arrow.

1 Draw a circle that is about 3 inches (7.5cm) tall. Draw two dashed lines at a 45-degree angle to determine the width of the ellipse of the cast shadow. Draw the horizontal major axis of the ellipse to span the two dashed lines. Draw the curves of the ellipse to be symmetrical.

After the shape of the shadow is complete, erase the dashed lines, the major axis, and the curve of the ellipse inside the circle.

2 Draw a small oval where the light source creates a highlight at the top right of the circle. Draw another where the light hits the table.

Draw the swirling colored glass inside the marble. Begin with the center of the S curve, and then draw its two undulating wings.

3

The swirl's axis is where two colors of the once molten glass came together.

Continue drawing the swirling colored glass shape as it curves upward and to the left. Draw it to disappear behind the larger part. Overlapping parts is a key to the illusion of the interior world of the cat's eye marble.

4

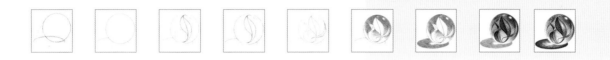

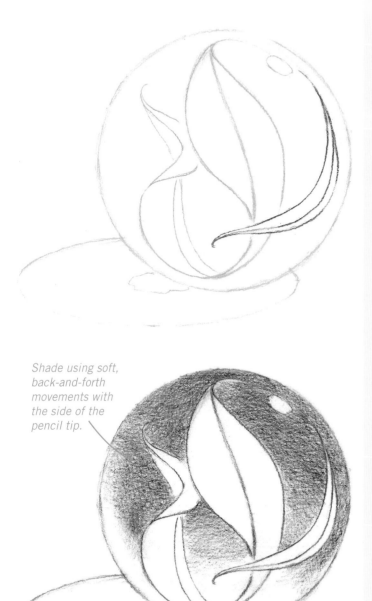

5 Complete the interior swirls by adding the thin one at the right that passes in front of the others.

Shade using soft, back-and-forth movements with the side of the pencil tip.

6 Shade inside the circle around the highlight and the swirling forms.

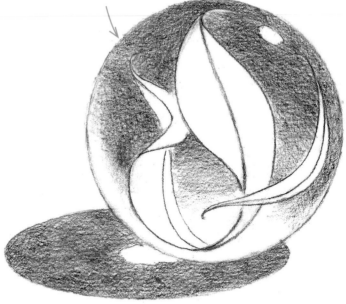

Avoid outlining the shape. Keep the edge smooth and soft.

7 Shade the ellipse and around the oval spot of light with soft, horizontal back-and-forth shading.

Shading darker around a highlight makes it appear brighter.

8 Shade the swirling forms with gradations of dark and light. Emphasize the contours with darker shading. Also, shade the upper area around the highlight darker.

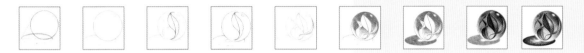

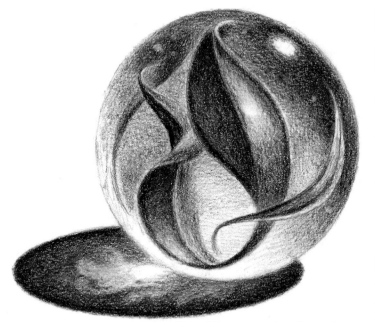

9 Darken the ellipse at the outside contour, becoming lighter where the rays of light fall.

Shape a kneaded eraser by pinching an end of it flat. Press the eraser end into the shadow area to build out the light spot and produce the effect of light passing through the marble being distorted by the colored glass.

Point the kneaded eraser to lift off small spots to create the illusion of bubbles trapped in the glass.

Knead the eraser when the end has become shiny with graphite.

ADVANCED VARIATION

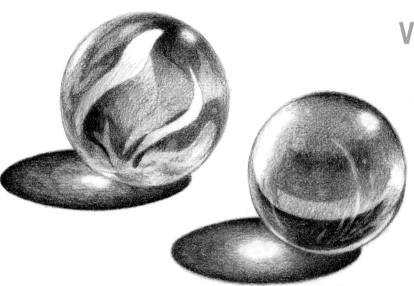

Create other marble designs using the preceding process with swirls that overlap in different ways. Look up cat's eye marbles online or find them at an antique store to help invent your own in a drawing!

night sky

Steps: 9 **Difficulty:** ▣ ▣ ▣ ☐ ☐

This starry night lake scene involves very dark values made with multiple layers of shading. Soft edges and gradation are fitting for this calm and vast view, with the darkness appearing even darker from contrasting touches of white. If you find yourself wanting to alter the tree shapes, please do—you just might be familiar with night skies, too.

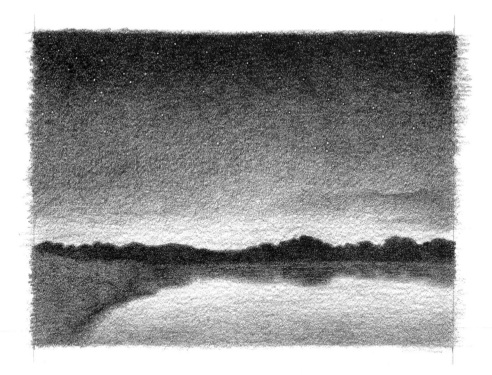

1 Draw a 5 × 7-inch (12.75cm × 17.75cm) rectangle. About 1½ inches (4cm) up from the bottom, indicate a skyline of tree forms with an irregular, bumpy contour.

Press the pen straight down firmly to create a clean, round indentation.

Make indentations in a random pattern.

2 Begin creating the stars by making indentations in the sky area. To do this, first place a mat board or several pieces of copy paper beneath the drawing page. Then cover the drawing page with a piece of copy paper; you should be able to see the preceding step's lines through it. Press the tip of a ballpoint pen into the cover sheet in the pattern of stars in the sky area only.

Try to make the value even; however, a little unevenness will be smoothed with the second layer.

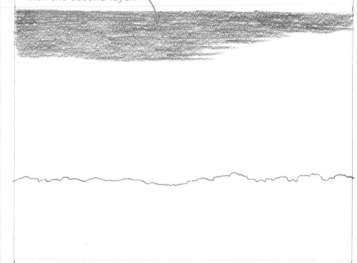

With the side of the pencil tip, make short horizontal marks in a middle value and proceed halfway down the drawing area.

3

CONCEPT
*Dark tones are best created in several **layers**. Each layer is made with smaller strokes at a slightly different angle and with more pressure.*

Grip the pencil about 3 inches (7.5cm) back from the tip.

To avoid smudging the shaded area, place a piece of copy paper beneath your shading hand.

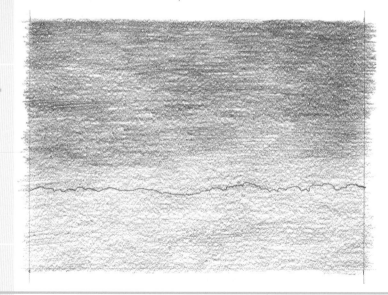

Continue shading and gradually apply less pressure so the value becomes lighter just above the horizon and all the way to the bottom. If the transition from middle to light tone is rough or abrupt, you can go back and add more shading to light patches to even the tone.

4

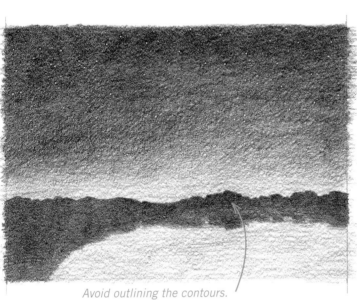

Avoid outlining the contours.
Instead, gradually shade out
to the finished edge.

5 Begin a second layer of shading to further darken the sky. You'll start to see the stars appear. Transition this second pass to be lighter just above the horizon.

6 Shade the distant tree line and lakeshore to be the darkness of the upper sky. The lower part of this thin dark area is the reflection of the trees in the lake. Being a reflection, this lower contour is a mirror image of the contour above, only softer. Where points rise up in the upper contour, they dip down in the lower contour.

Shade a third layer over the tree line at the left. With small back-and-forth movements, refine the top edge of the tree line and then the contour of the lower rolling hills. Also add some softer dark tone at the water's edge.

7

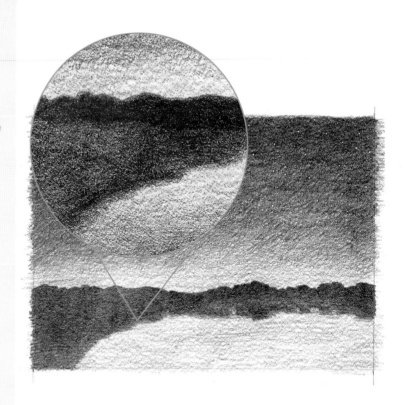

Shade the tree line with the same dark tone from the preceding step. Begin halfway between the top and bottom contours of this thin area and work your way to the upper contour. Refine it to be dark with a soft edge.

8

Drag the sharp, flattened edge of a kneaded eraser horizontally across the reflection area. This will create a subtle effect of the twilight sky reflecting on the water.

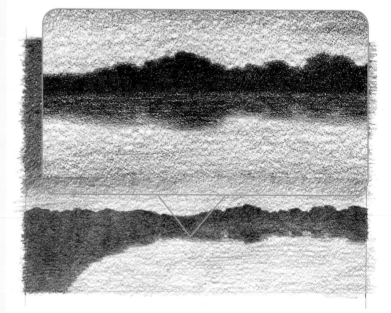

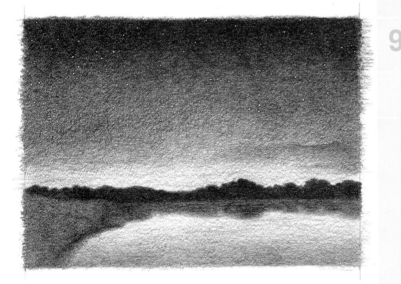

9 Darken the upper sky to the darkest value of the tree line. Carefully transition this value into the medium value below it.

Shade the wispy texture of clouds with the side of the pencil tip.

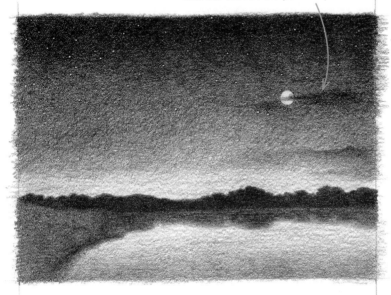

ADVANCED VARIATION

To create a full moon, use a hole punch to cut out a circle mask in a heavy piece of paper. Lay the paper down on the drawing so the hole is on the right side and halfway between the horizon and the top edge. Hold the paper down with your nondraw-ing hand and rub a kneaded eraser over the hole firmly and in different directions. After removing the paper, shade the clouds that are drifting across the moon.

fork

Steps: 5 **Difficulty:** ■ ■ ■ □ □

This simple utensil, the fork, is designed to fit the hand at one end and the mouth at the other. The curvilinear form of this fork has an angle that can be described with a straight line, but the beauty is in the repetition of its tines, the taper of its handle, and its shiny surface. It seems to say, "Pick me up!"

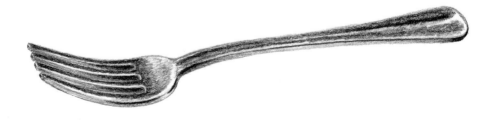

The top end of this line angles slightly more to the left.

1 Draw the angled construction line 7 inches (17.75cm) long. The angle at the left is the end of the tines; the middle mark is where the handle transitions to the curved base of the tines; and the mark at the far right describes the angle of the head of the handle.

Far contour

Near contour

2 Draw the curving midline that begins at the middle point of the tines and ends at the center of the head of the handle. Draw the nearer contour to be farther from the centerline, while the farther contour is closer to it.

Draw the faint angled line at the base of the tines and draw the space between the tines. Turn the page with the tines pointing downward to draw the small curves at their base.

3

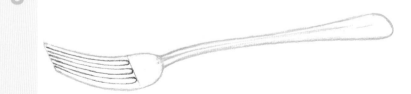

Carefully draw the contour of the thickness of the fork. It follows parallel to the near edge, and then disappears as it curves behind at the head and at the middle transition. The ends of the tines are small parallelograms. Shade the thickness at the side of the tines, at the base, and at the head of the handle. Add extra shading to the base of the tines.

4

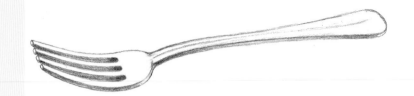

The dark and light areas create a visual rhythm.

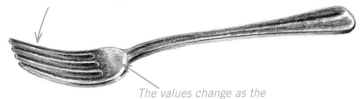

The values change as the surface changes.

5 Shade the top surface of the tines dark, leaving the lower edges white. Do the same on the handle. Intensify the dark shading of the reflections on the side.

ADVANCED VARIATION

Add a soft shadow under the fork. It's darker where the fork touches the surface underneath and grows fainter where the handle and tines curve away from the surface.

standing figure

Steps: 9 **Difficulty:** ■ ■ ■ ☐ ☐

The human form is a good subject for studying proportion. The head is often used as a measuring increment to correctly size the other parts of the body. This little girl is just over five heads tall and has childlike proportions—her head is much larger in relation to the body than an adult's would be.

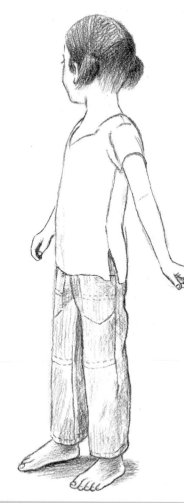

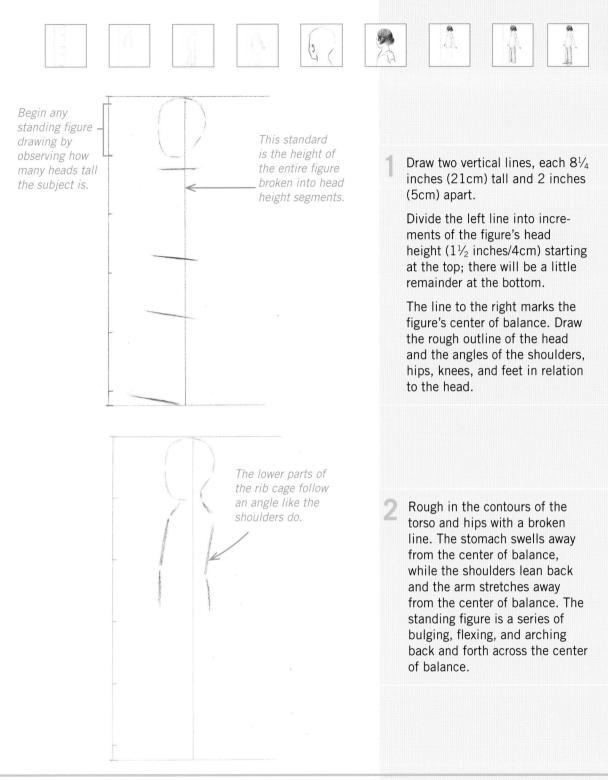

Begin any standing figure drawing by observing how many heads tall the subject is.

This standard is the height of the entire figure broken into head height segments.

The lower parts of the rib cage follow an angle like the shoulders do.

1 Draw two vertical lines, each 8¼ inches (21cm) tall and 2 inches (5cm) apart.

Divide the left line into increments of the figure's head height (1½ inches/4cm) starting at the top; there will be a little remainder at the bottom.

The line to the right marks the figure's center of balance. Draw the rough outline of the head and the angles of the shoulders, hips, knees, and feet in relation to the head.

2 Rough in the contours of the torso and hips with a broken line. The stomach swells away from the center of balance, while the shoulders lean back and the arm stretches away from the center of balance. The standing figure is a series of bulging, flexing, and arching back and forth across the center of balance.

3 Rough in the contours of the legs and feet. Indicate the change in direction and the main shape without adding details. As you rough in forms, think, *What is the least amount of lines that can describe the main form?*

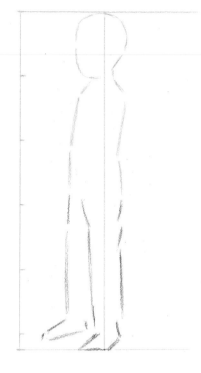

CONCEPT

Comparing measurements *is essential to avoid distorting natural proportions. Use the measurement of a small part of an object or figure to determine the length of its other parts.*

4 The arrow indicates the position of the hand at the right, found by measuring three heads down from the top of the head and one head height out from the center of balance.

The hand at the left begins just below the center of the third head height down on the standard and is one head height out from the center of balance.

Make sure the shape between the arm and body of your drawing resembles the illustration.

The eye is mid-way between the top of the head and the chin.

The top of [the e]ar is [level] with the [eyelas]hes.

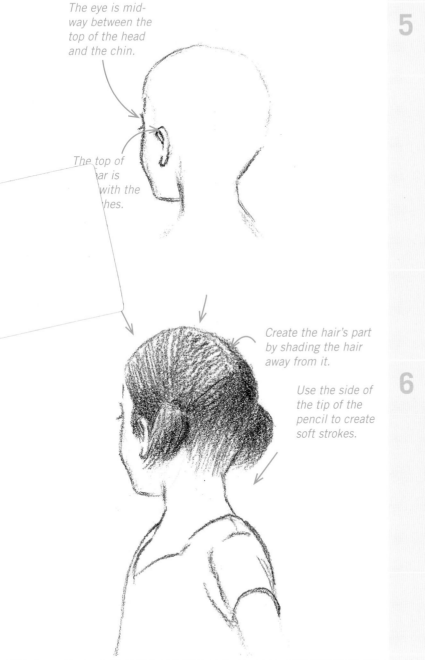

Create the hair's part by shading the hair away from it.

Use the side of the tip of the pencil to create soft strokes.

5 Rub a kneaded eraser over the lines of the figure to lighten them. Wipe any remaining eraser dust off with a paper towel.

Refine the contours of the face with soft lines made with the side of the pencil tip. Use more of the tip to draw the small curved line of the eyelashes. Also draw the lines of the neck, but leave the back of the head light where the hair will be added.

6 Shade the hair with strokes that follow the arrows. Draw the pigtails with light strokes, then add darker shading. Shade just above the ear and the back of the head to further soften some of the repeating lines and to create the illusion of a light source at the upper left. Draw the contours of the neck and upper blouse.

7 Draw the contours of the chest, blouse, arms, and hands. Notice where the lines appear dark, fine, or faint, or are broken. Dark lines describe extreme changes, turning, and crevices. Fine lines describe elegant curves and details. Faint lines describe soft or shaded parts. Breaks in lines create a lighter feel or help simplify complex areas like the face and hands.

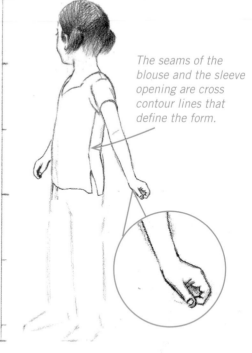

The seams of the blouse and the sleeve opening are cross contour lines that define the form.

8 Draw the curving contour of the pants. Add the seams and stitching with broken lines that follow the cylindrical forms of the legs. Shade the right side with soft vertical strokes.

The subtle detailing of the pants provides another level of interest.

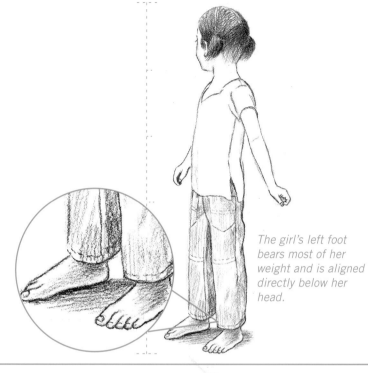

The girl's left foot bears most of her weight and is aligned directly below her head.

9 Draw the contours of the feet and toes light at first, and then define them more with the pencil tip. Look at your progress at arm's length and, if necessary, erase and revise the toes.

Erase the standard.

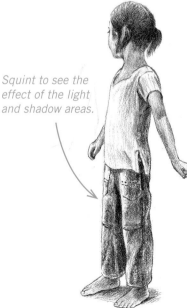

Squint to see the effect of the light and shadow areas.

ADVANCED VARIATION

Develop the overall soft tone of the flesh and increase the richness of the shadows. The darkest parts are grouped on the near side and at the back of the head. Develop the different textures and values of the blouse and pants. Cross-hatching creates a unifying shadow at the feet.

car

Steps: 9 **Difficulty:** ■ ■ ■ □ □

After the human figure, a car is probably one of the most exhilarating yet difficult objects to draw because of the wheels, proportions, and carefully crafted details. The look of a well-designed machine is inseparable from the task for which it was built. This car was designed to intimidate and appear very fast even at a stoplight.

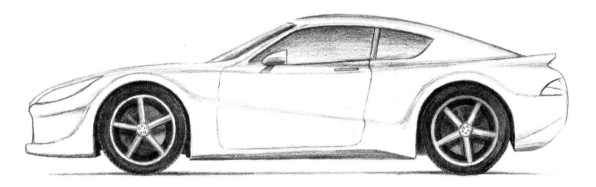

Draw these lines lightly with a ruler or T square; they will be erased later.

1 Draw the baseline of the car's length (A) to be 9 inches (23cm) long. Mark the location of the wheels in distance from the front of the car (B):

C = 1¼ inch (3.25cm)

D = 2¾ inches (7cm)

E = 2½ inches (6.25cm) tall, at center of baseline

F = 6¾ inches (17.25cm)

G = 8¼ inches (21cm)

H = 9¼ inches (23.5cm)

Turn the sheet and book to keep the pencil perpendicular to the line as you trace.

Tape the trace sheet to the page.

2 Trace this wheel illustration carefully. Tape a piece of translucent layout paper or tracing paper over the wheel image and trace with a sharp 4B pencil.

3 Transfer the wheel to rest on the baseline between points B and C and also points F and G. Trace the wheel and lay this traced part face down between points B and C so the wheel rests on baseline A. Rub the traced area with your thumbnail, and then do the same between points F and G.

CONCEPT

Transfer *a traced design to save time redrawing complicated parts and for consistency. Retouch transferred lines with freehand touches to enhance their flat look.*

4 Begin drawing the body contour at the front fender, leaving a small gap around the wheel. The front is vertical and transitions to the hood below the height of the tire. Stop just beyond the right side of the front wheel.

Next, draw the fender curve around the rear tire. The rear section begins a little above the level of the rocker panel between the wheels.

Draw the contour with a distant grip to create a soft, smooth line.

5 To draw the windshield, lay your pencil along the windshield of the illustration to help make a mental picture and memorize its angle. Draw it down from the top center. Don't change the angle to meet the hood; extend the hood to meet the windshield.

Continue from the top center, drawing the curve of the roofline down to the rear spoiler, and finish with the vertical line of the back end.

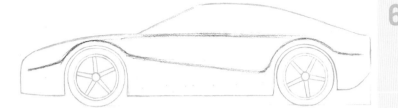

6 Draw the lower edge of the window with a soft line. Then draw the bodyline that angles up and over the front wheel and across the car.

Draw the details of the windows with the pencil tip. Erase any visible construction lines.

7

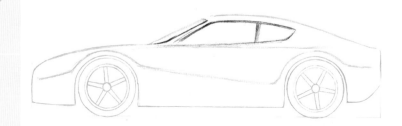

The illustration shows, in a clockwise order, the layers of shading of the wheels: 1. Shade the edges. 2. Create even shading. 3. Darken the shading. 4. Lift highlights with a kneaded eraser. 5. Add details.

Shade the gap of the wheel well very dark.

8

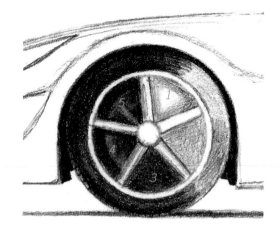

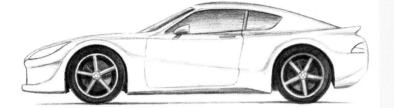

9 Shade the gradation of the windows and body. Refine the headlight shape and the front end's contours.

Add body detailing of the side panel, door, handle, rearview mirror, and taillight. Draw five bolt heads at the center of each wheel. Lay in a shadow beneath the car.

ADVANCED VARIATION

Develop the gradation shading of the polished surfaces of the body. Refine the wheels with brake details. Refine the highlights with a pointed kneaded eraser to describe changes in the shape of the surface. Darkening other areas enhances the illusion of recessed surfaces.

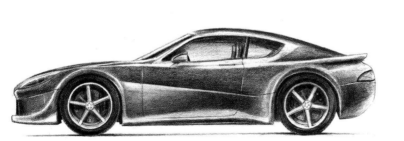

letter K

Steps: 5 Difficulty: ■ ■ ■ ☐ ☐

This drawing of the letter K has fun with the features of the fascinating and fuzzy koala bear. This mammal loves munching on eucalyptus leaves and sleeping in the shade.

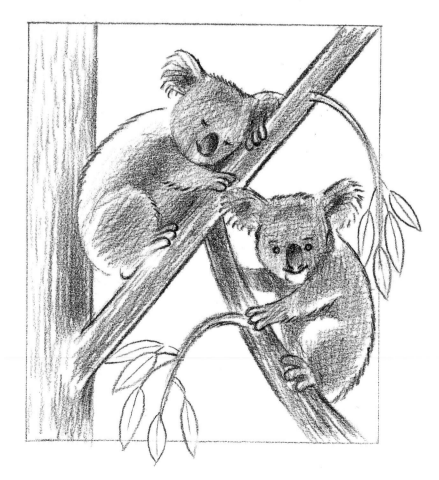

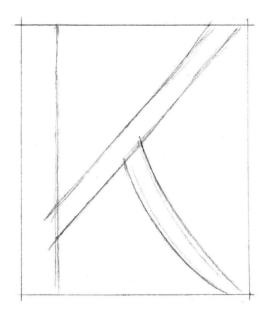

1 Draw a 3-inch (7.5cm) wide by 4-inch (10cm) tall rectangle. Sketch in the lines of the letter K that will also be the tree and its branches.

Draw the rough shapes with broken lines.

2 Draw the basic shapes of the heads and bodies of the koalas. Both heads have a pentagonal shape.

3 Add the features of the face, feet, and fur, keeping the lines as thin and soft as possible. The softness is created by lightly stroking the line multiple times. Create the texture of furry ears with short hatch marks. Shade the oval shapes of the noses with a slight gradation to create dimension.

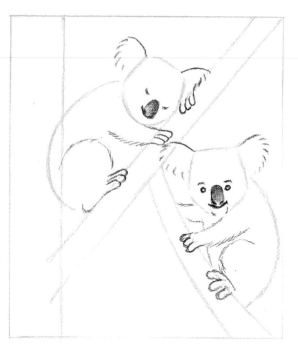

Draw the leaves with integrity of shape and texture.

4 Add the eucalyptus tree limbs and leaves.

Shade the bears to attain integrity of value with a similar light-to-dark range on their fur.

Shade the limbs to create integrity of texture.

5 Shade the bears and tree to create the look of solid form and texture and for tonal interest. Crosshatch the fur with soft lines and shade the bark with strokes that follow the length of the forms. Give textural dimension to the bear contours with short strokes, creating the illusion of fur.

ADVANCED VARIATION

Further develop the illusion of light and texture with soft shading. Begin with cross-hatching the fur of the bears, stopping short of the edges in some places to create effects of filtered sunlight. Place a gradation of tone in the lower area to define the leaf shapes and the letter. Touch the eyes and mouths with a kneaded eraser to emphasize these features, and then redraw their details.

butterflies and flower

Steps: 9 **Difficulty:** ■ ■ ■ □ □

Butterflies are a symbol of dynamic change through metamorphosis. They are also dynamic in the way they move and the way their wings change shape depending on the viewing angle. This drawing investigates the basic anatomy of these flying transformers and how delicate natural objects like wings and petals present a variety of shapes within one image.

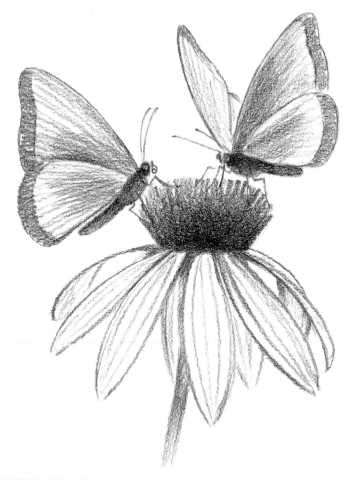

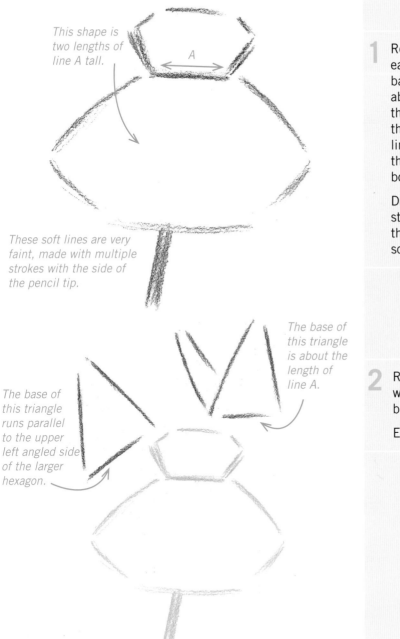

This shape is two lengths of line A tall.

A

These soft lines are very faint, made with multiple strokes with the side of the pencil tip.

The base of this triangle runs parallel to the upper left angled side of the larger hexagon.

The base of this triangle is about the length of line A.

1 Rough in the cone and petal areas of the coneflower. Draw the base of the cone with a soft line about 1½ inches (3.75cm) long that slants downward slightly at the right. Draw a small broken-line hexagon above that, and then a much larger one beneath, both angled like line A.

Draw two parallel lines for the stem that extend down and to the left from line A and shade softly between them.

2 Rough in the triangular-shaped wings of the butterflies with broken lines.

Erase the slanting axis.

Lighten the roughed-in forms by pressing a kneaded eraser into them. Knead the eraser after every 2 or 3 presses.

3

Draw the oval thorax of the butterfly to the right, and then the thinner abdomen. Draw the circular form of the eye and the short diagonal line of the palpi sensory organs. Complete the same on the butterfly at the left.

The far eye is visible here.

The butterfly body on the right is a little shorter because it is partially turned forward.

A butterfly has six legs, each with three parts and two main joints. Begin with a short downward stroke where the leg attaches, then the leg angles outward, and ends downward with a slight outward curve.

4

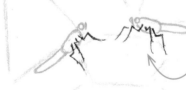

Draw the three legs on the nearest side and one more if the insect is turned.

The hind wing attaches on the outside and the fore-wing attaches on the inside.

5 Draw the hind wing first. Begin in the middle of the thorax with the upward curve and then down and back to the thorax. The forewing begins farther up on the thorax and has a concave curve on the outside of the wing.

The antennae of the turned butterfly appear shorter.

6 The proboscis is the butterfly's straw for drinking nectar. When retracted it's a tight curl, and when extended it's fairly straight. Use a light touch and draw it with the pencil tip.

Draw the thin, curving antennae with a small bulb on the end.

Shade the flower's cone up
from the base and then down
from the splayed tips with
the side of the pencil tip.
Also shade the bodies darker
at the sides and with lighter
areas to create dimension.

7

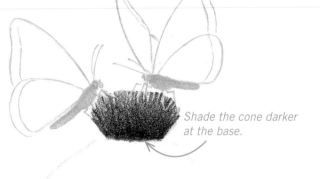

*Shade the cone darker
at the base.*

Draw the curving contours of
the petals. Refine the stem
with shading and extend
it to disappear behind the
center petal. Add three long
interior lines. Draw the parts
of petals that can be seen
between the nearer petals.

8

*Add darker
shading
between the
petals near
the base of
the cone.*

*Erase any visible
construction lines.*

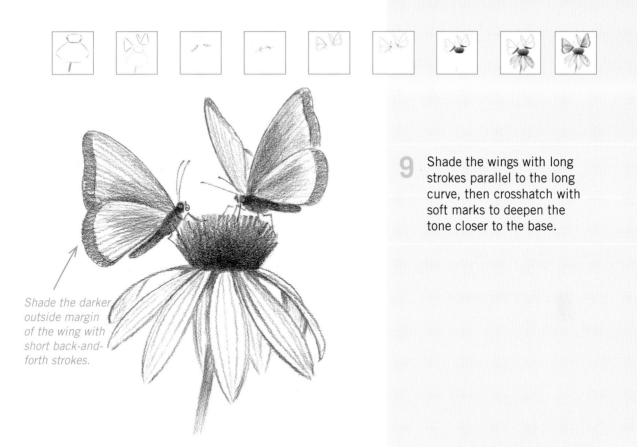

9 Shade the wings with long strokes parallel to the long curve, then crosshatch with soft marks to deepen the tone closer to the base.

Shade the darker outside margin of the wing with short back-and-forth strokes.

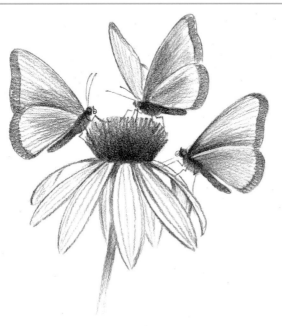

ADVANCED VARIATION

Add another butterfly on the right side of the flower. Draw it in the side view as a reflection of the butterfly on the left, but position it lower, resting on a petal.

naturalistic face

Steps: 9 **Difficulty:** ▣ ▣ ▣ ☐ ☐

A portrait hopes to capture an individual's expression at a specific moment. This young subject is daydreaming and smiles faintly. Her head is turned to the side, but not completely; part of the far eye is visible and the center of the mouth is turned inward slightly. These subtle details create tension, while her smile and eyes express, perhaps, realization.

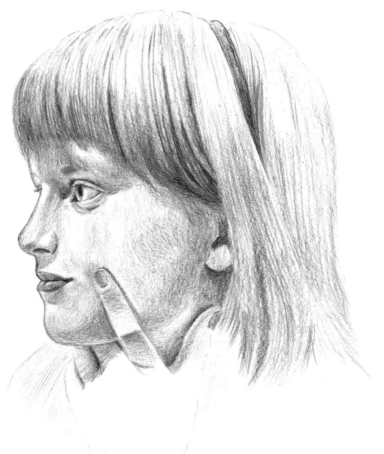

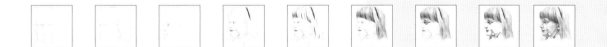

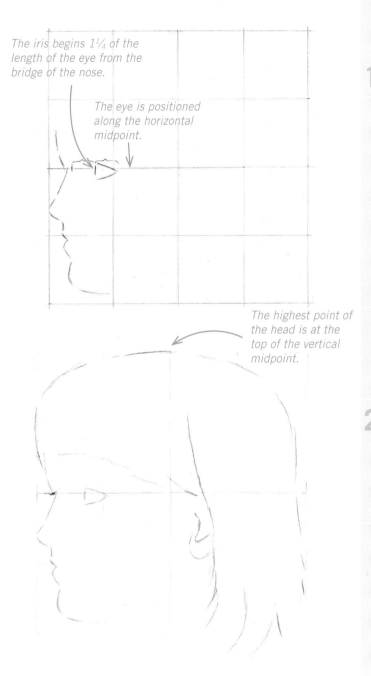

The iris begins 1¼ of the length of the eye from the bridge of the nose.

The eye is positioned along the horizontal midpoint.

The highest point of the head is at the top of the vertical midpoint.

1 To create the grid for this portrait, draw an 8-inch (20.25cm) square and allow for 2 inches (5cm) free space below the square. Divide the square in half with vertical and horizontal midpoints, then divide the quadrants in half vertically and horizontally to create 16 smaller squares in the large square.

Use the grid to position the parts of the profile and then the rough shape of the eye. Draw these with soft, faint lines.

2 With soft lines, draw the contour of the head, the broken line of the bangs and tresses, and the ear.

Indicate the lashes of the far eye with a small, curved line.

Draw the curve of the cornea at the left side of the roughed-in eye, then draw the pupil and the slightly curved right edge of the iris. Indicate the folds of the upper and lower eyelids, the position of the eyebrows, and the lashes of the far eye. Indicate the thickness of the lower lid with another curved line.

Draw the nostril and its curved alar crease, then the softly curved line where the lips meet.

3

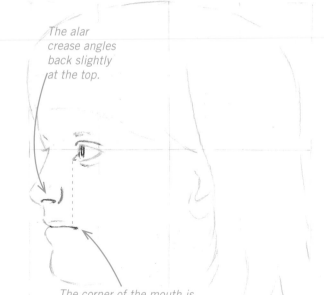

The alar crease angles back slightly at the top.

The corner of the mouth is aligned with the inside of the irises.

CONCEPT
The **midpoints** *mark the vertical and horizontal center, dividing a subject into quadrants for analyzing positional and proportional relationships.*

Draw the hand. Begin lightly marking the position of the fingertip and the "V" between the index finger and thumb. The left part of the hand angles upward to the chin, while the thumb angles toward the ear.

Draw the curving hairband and shade it darker where it disappears behind the hair.

4

This line marks the shadow at the middle joint of the index finger.

5 Shade the dark shapes of the hair.

These curved cross contours of the lips indicate the midline of the face.

Create soft strand divisions and shadow shapes, not individual hard lines.

6 Continue to develop the hair by shading in the middle values with long, soft strokes with the side of the pencil tip. Change the angles of the curves to follow the head and to curve toward the crown of the head.

Shade the midtone and darker shadows of the eye area. Create the illusion of the brow by adding the darker eyebrow and the darker shadow shapes to the right and left of the eye. Shade the forehead with a middle gray; continue shading the lower lid and then add the darker crease.

7

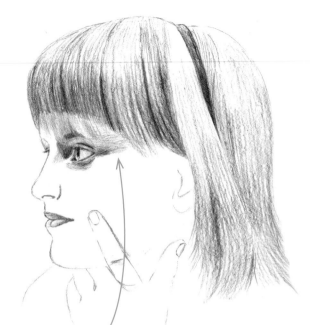

Shade with short strokes and the side of the pencil tip.

Shade the midtone shapes of the lower nose, the curving cast shadow beneath it, below the lips, and under the chin and jaw.

Draw the fingernails with faint lines and then shade the hand midtones, followed by the darker shadows between the fingers, at the finger joint, and above the thumb at the neck.

8

Leave a reflected light under the chin.

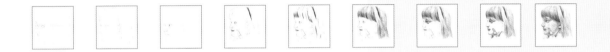

Shade the face with very light back-and-forth strokes.

Shade the hair with long, light strokes to create soft tonal areas and strands.

View your progress at arm's length distance. Squint to see if the tones group together in pleasing larger areas.

9 Shade the lighter tones of the face with soft, directional shading to develop the rounded, soft cheek, nose, and chin. The sclera of the eye has a faint tone with darker shading at the lower lid.

Add light shading to the hair to unify tonal areas and create soft tone in the upper highlight areas.

Avoid drawing too many individual strands; allow tone to describe the shape of the hair in some places.

ADVANCED VARIATION

Refine the eye, nose, mouth, cheek, and chin to show greater dimension. Refine the shadow shapes with very soft shading and with defining touches from the kneaded eraser. Pinch the end of the eraser into a thin edge and press this into the hair midtone to create individual hair highlights. Refine the shading of the finger touching the cheek with dark tone at the tip and soft tone at the side.

candle and flame

Steps: 9 **Difficulty:** ■ ■ ■ ☐ ☐

This image depicts shapes and edges associated with light: the wavering teardrop shape of the flame and its smooth, glowing edges; the charred wick; the molten rivulets of wax; and the melting shape of the candle. Ultimately, what describes the effect of light is tonal contrast. To make something look bright, put dark tone around it.

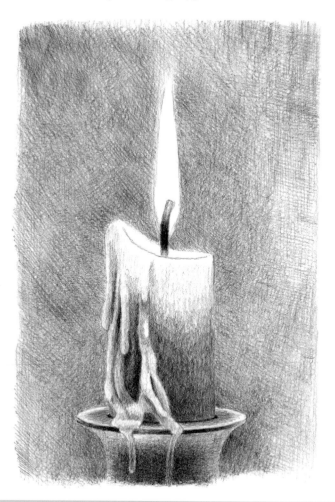

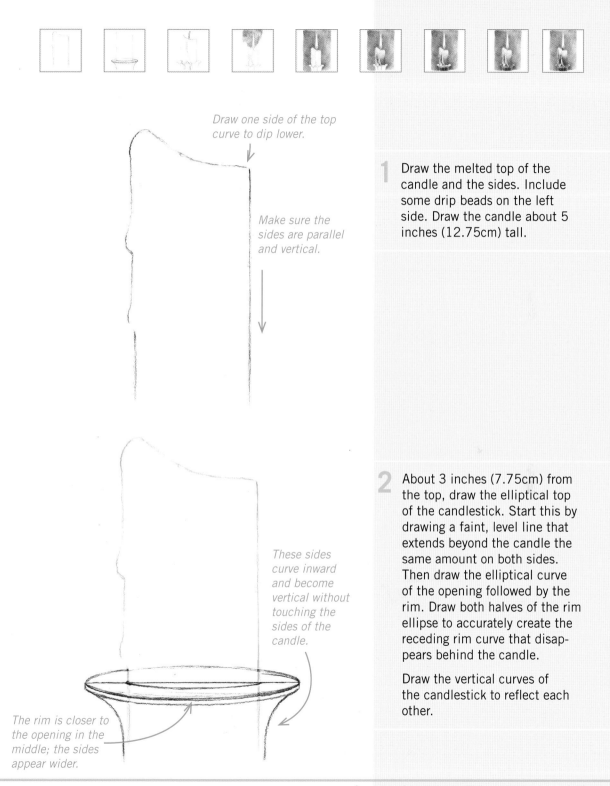

Draw one side of the top curve to dip lower.

Make sure the sides are parallel and vertical.

These sides curve inward and become vertical without touching the sides of the candle.

The rim is closer to the opening in the middle; the sides appear wider.

1 Draw the melted top of the candle and the sides. Include some drip beads on the left side. Draw the candle about 5 inches (12.75cm) tall.

2 About 3 inches (7.75cm) from the top, draw the elliptical top of the candlestick. Start this by drawing a faint, level line that extends beyond the candle the same amount on both sides. Then draw the elliptical curve of the opening followed by the rim. Draw both halves of the rim ellipse to accurately create the receding rim curve that disappears behind the candle.

Draw the vertical curves of the candlestick to reflect each other.

3 Draw the bent wick with even thickness. Draw the curve of the nearer edge of the top of the candle. Add the contours of the curving molten wax running down the side of the candle. It angles out slightly at the rim and curves back in as it flows down the candle-stick.

Darken the line of the candlestick opening at the sides.

CONCEPT
*Sharpen the pencil and rotate it clockwise periodically while you shade to maintain the **pencil's edge.** When it becomes rounded, stroke definition is lost and a bland line quality results.*

4 Shade the entire background with soft vertical marks. Create even shading with the side of the pencil tip. Rotate the pencil a quarter turn clockwise every 5 to 10 strokes, then sharpen it.

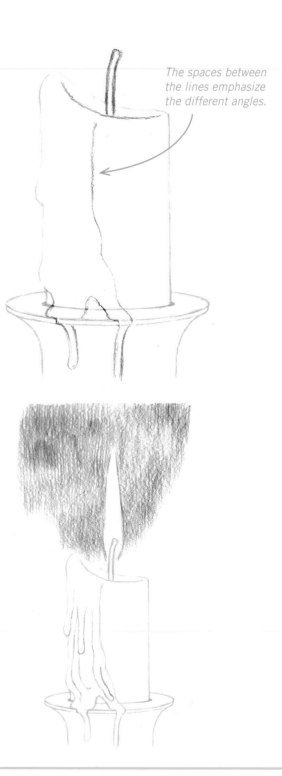

The spaces between the lines emphasize the different angles.

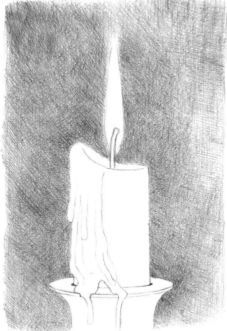

Lay a protective piece of paper on the drawing where you rest your hand as you shade.

5 Shade the entire background again with strokes that angle 45 degrees to the right, then one more layer at 45 degrees to the left. Develop a rhythm and practice maintaining consistent pressure as you create even layers.

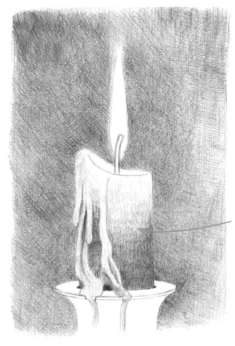

Shade the gradation with short, vertical strokes.

6 Shade the candle with a gradation that is light at the top and darker at the bottom. Shade the melted wax separately to be lighter, with darker shading at the side to create the illusion of rounding. Darken the shading in the tighter crevices.

Shade underneath the candlestick rim around the wax drips in a complex gradation that is light under the rim and darker as it proceeds downward while it becomes lighter laterally, too.

Shade the wax drips darker in the center and lighter at the sides.

7

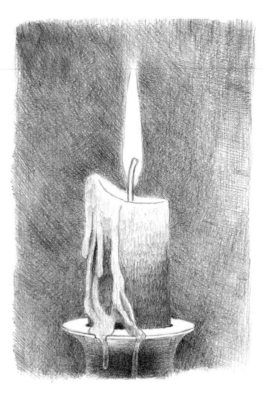

Shade the top of the candlestick with level strokes and create the illusion of a cast shadow by shading darker toward the candle. Shade the rim's thin vertical edge dark in the center and lighter at the sides.

8

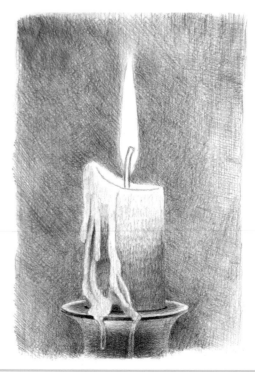

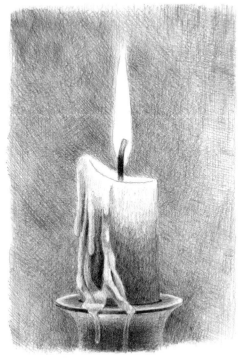

9 Shade the wick darker at the base of the flame and lighter in the interior.

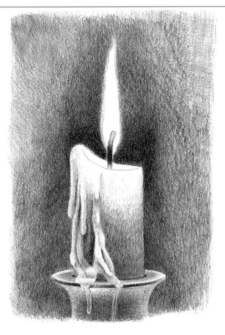

ADVANCED VARIATION

Darken the value of the background to intensify the effect of the flame's light. Shade it to show variation from dark to very dark near the flame to create greater interest there.

abstraction

Steps: 5 **Difficulty:** ■ ■ ■ ☐ ☐

Take away some or all of the surface details of a naturalistic image and
the result is an abstraction. Every image can be reduced to a combina-
tion of circles, squares, and triangles with some imagination. While
you create this drawing, be aware of the way shapes are arranged to
tell a story and how you can play with edges that align.

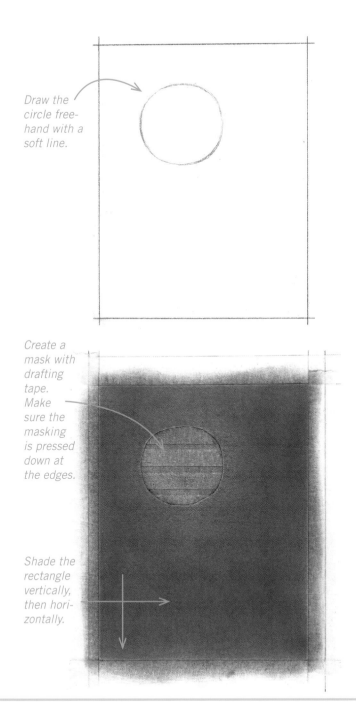

Draw the circle free-hand with a soft line.

Create a mask with drafting tape. Make sure the masking is pressed down at the edges.

Shade the rectangle vertically, then horizontally.

1 Draw a rectangle 5½ inches (14cm) wide and 7 inches (17.75cm) tall. Within the rectangle, draw a circle with a 2¼-inch (5.75cm) diameter above the rectangle's horizontal midpoint and to the left.

Cover the circle with drafting tape, each piece overlapping the preceding one a little. Trace the circle onto the tape and then peel it off the paper.

Place the tape down on a piece of mat board and cut out the circle with a craft knife.

2 Position the mask on the original circle. Run your finger along the edge of the mask to adhere it well to the paper.

With drafting tape, mask outside the edge of the rectangle. Then, with a 6B pencil, shade in the rectangle up to the edges of the tape masking.

Fold a piece of paper towel into a pad and wipe the shaded area to blend it into a smooth tone.

Drag the edge of a flattened kneaded eraser in horizontal strokes above and over the circle mask.

3

While dragging the eraser, roll it slightly to create subtle curves.

The triangle is a visual counterbalance of the circle.

Create a shaded triangle by drawing a "V" that is a little taller on its left side with short back-and-forth shading strokes. Then shade the interior, beginning at the right and ending a little lighter at the left to give it some dimension.

Gently peel away the circle mask from the paper. With the tip of a kneaded eraser, trace the edge of the circle to soften it.

4

Lift off tone with a kneaded eraser to create the pale triangles.

5 Shape the kneaded eraser into a rounded tip and touch it to the paper to lift off three small triangles. Lay a piece of copy paper over the dark triangle and erase up to it to create a sharper edge. As you progress from one triangle to the next, reposition the mask and create the outside edges to have continuation.

ADVANCED VARIATION

Shade the lower sides of the background, stopping in alignment with the downward edges of the pale triangle to create a larger sixth triangle.

old door

Steps: 9 **Difficulty:** ■ ■ ■ ■ □

Usually doors are carefully plumbed and measured when set, as this door was long ago. This subject presents a great opportunity to create lines with character using the freehand technique. Draw this door to have such an extreme weathered texture that you can't help but imagine the wood creaking and the hinges complaining as it slowly swings open.

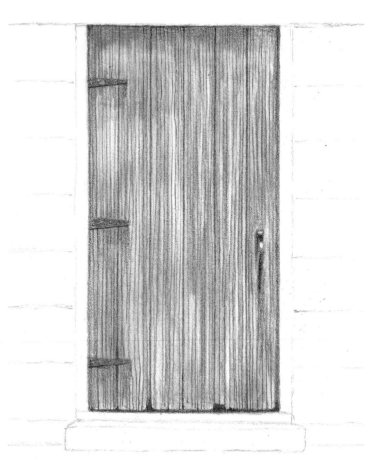

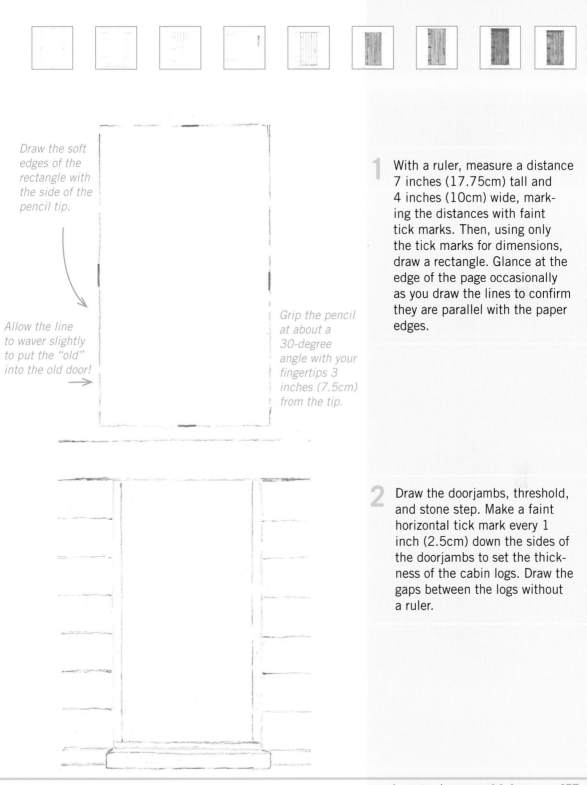

Draw the soft edges of the rectangle with the side of the pencil tip.

Allow the line to waver slightly to put the "old" into the old door!

Grip the pencil at about a 30-degree angle with your fingertips 3 inches (7.5cm) from the tip.

1 With a ruler, measure a distance 7 inches (17.75cm) tall and 4 inches (10cm) wide, marking the distances with faint tick marks. Then, using only the tick marks for dimensions, draw a rectangle. Glance at the edge of the page occasionally as you draw the lines to confirm they are parallel with the paper edges.

2 Draw the doorjambs, threshold, and stone step. Make a faint horizontal tick mark every 1 inch (2.5cm) down the sides of the doorjambs to set the thickness of the cabin logs. Draw the gaps between the logs without a ruler.

Draw the hinges and then the spaces between the door planks.

3

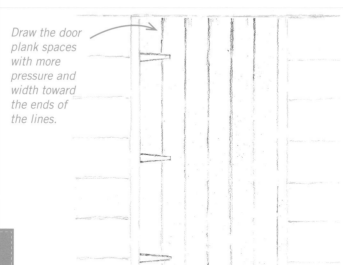

Draw the door plank spaces with more pressure and width toward the ends of the lines.

Draw the door handle slightly turned so the curve is visible. It's about as tall as the length of the hinges and just below the level of the center hinge.

4

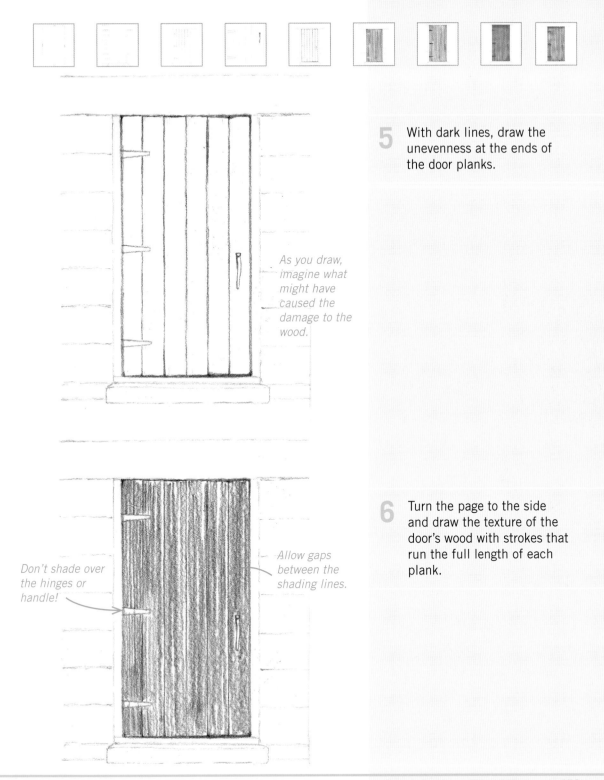

5 With dark lines, draw the unevenness at the ends of the door planks.

As you draw, imagine what might have caused the damage to the wood.

6 Turn the page to the side and draw the texture of the door's wood with strokes that run the full length of each plank.

Allow gaps between the shading lines.

Don't shade over the hinges or handle!

7 Shade the hinges dark. Shade the handle to be lighter at the height of its curve and at the tip of the latch.

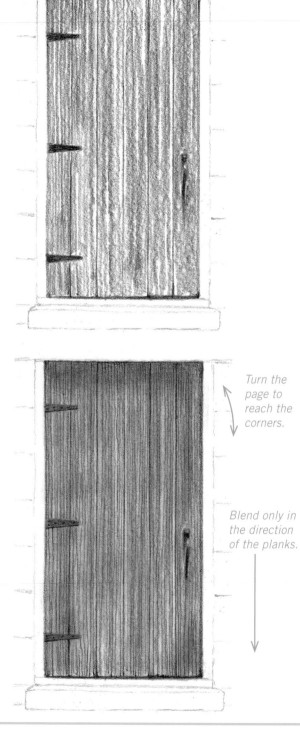

Turn the page to reach the corners.

Blend only in the direction of the planks.

8 Drag a folded paper towel (smaller than the width of the door) down the planks and over the hinges and handle to lightly blend the shading lines.

Create the shadows of the nail heads on each hinge with very small half circles. Draw two aligned vertically nearest the jamb and three aligned horizontally to the right.

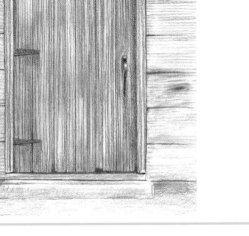

Shade beneath the overhanging lintel.

Add your own touches of texture!

9 Shape the kneaded eraser by pressing the end to be about a ½ inch (1.25cm) wide. Drag it with slight pressure down the length of the planks to create the sun-bleached tone of the wood.

Darken the handle, the plank cracks, and the missing parts at the ends. Draw a dark shadow line under each hinge and its nail heads. With a pointed kneaded eraser, lighten the nail heads and create the highlights on the handle and latch.

ADVANCED VARIATION

With a similar process as you followed with the door, create the wood texture of the cabin logs. Shade the stone step to be worn down in the middle. Shade the ground with short, horizontal back-and-forth strokes.

skin and hair

Steps: 9 **Difficulty:** ■ ■ ■ ■ □

Human skin and hair present textures befitting the soft gray tones of graphite pencils. Remember, whether the subject is simple or complex, drawings are made of values and shapes. Follow the principle of starting with the biggest issues first and determine the placement of main contours; then divide the image into light and dark areas.

Much of the face is cropped out of the image to focus attention on the textures.

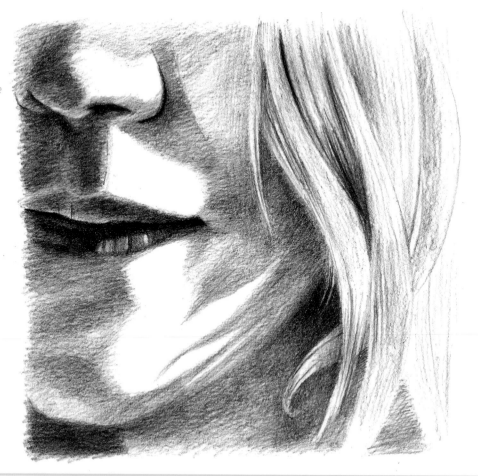

A B

*The breaks emphasize the
changes in direction.*

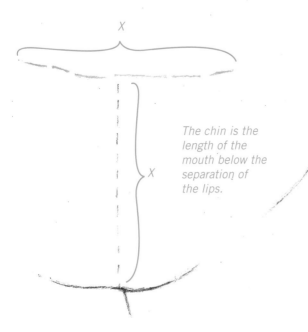

X

*The chin is the
length of the
mouth below the
separation of
the lips.*

X

1 Lightly draw a 3-inch (7.5cm)
long construction line (indicated
by the dashed line) that angles
downward at the right. Draw the
line of the separation of the lips
that curves below the construc-
tion line. Notice the lowest part,
the bulging center of the upper
lip, is to the left of the center of
the construction line.

2 Draw the chin and the line of
the neck and jaw with shading
lines.

Sketch the contour of the lips very lightly. They will be incorporated into the shading later.

3

Draw the construction lines of the angle of the nose that is parallel to the angle of the mouth, and another up from the chin at the neck. Draw the line of the philtrum leading up from the right peak of the upper lip (A) to the nostril, and then the lines of the lower nose.

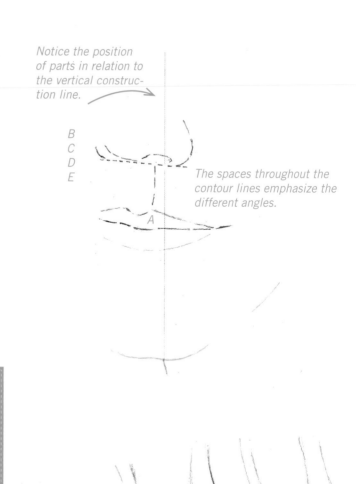

Notice the position of parts in relation to the vertical construction line.

B
C
D
E

The spaces throughout the contour lines emphasize the different angles.

CONCEPT

Draw large to small *by positioning the main contours first without details and then divide the image into dark and light areas with a narrow range of values.*

Erase the construction lines.

4

The lips are positioned at the horizontal midpoint and the vertical midpoint is just to the right of the corner of the mouth. Use them as guides to position main curving lines of the strands of hair.

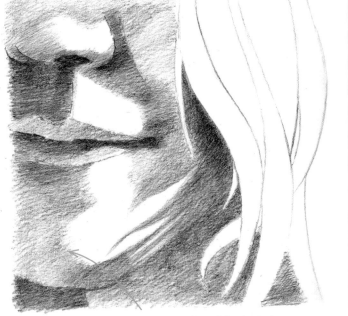

Shade with short, overlapping, back-and-forth strokes.

5 Shade the dark parts of the skin area as one intricate yet connected shape. Maintain a narrow range of 40 to 60 percent value. The curving shapes of the hair's cast shadows follow the changing surface of the cheek.

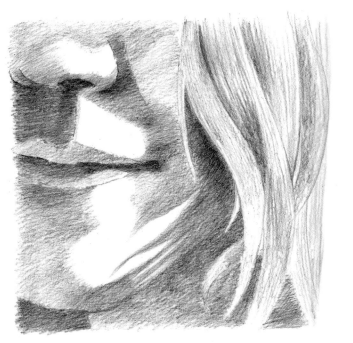

6 Shade the hair with vertical strokes that follow the curves of the strands. Create the illusion of depth with darker shading where the hair is overlapped or shaded by other strands.

Put more definition in the dark areas: at the alar crease, the nostril, the line of the lips, and a few deep, thin shadows in the hair. Darken the shadow at the upper jaw.

7

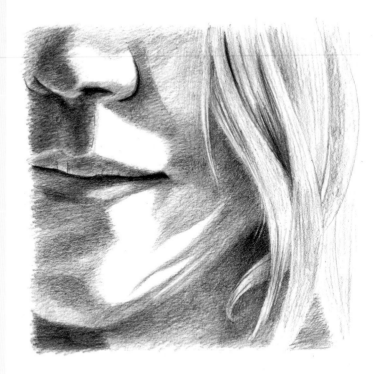

Define the light and shadow on the lower lip by darkening the upper edge of the light shape and drawing a few slightly curving vertical creases across the light area. Highlight to the left of the creases by flattening the tip of a kneaded eraser and gently touching it to the surface to lift off the shading there.

Shade the upper lip without losing the lower, lighter part.

8

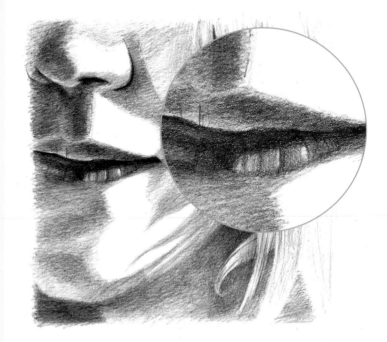

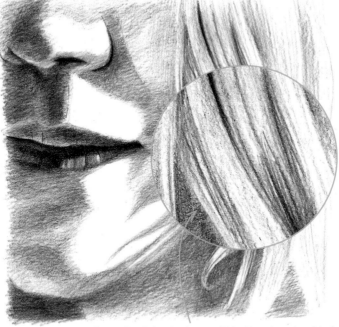

Draw the thin shadows within the strands of hair with the tip of a sharp 6B pencil.

9 Add thin, dark shadows that follow the curve of the strand of hair to increase the hair texture. Do this more to the strands closest to the face and less as you move away from the face.

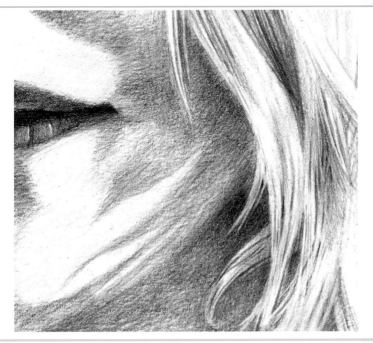

ADVANCED VARIATION

Add 20 percent value shading to the lightest areas with an HB grade pencil.

With a flattened kneaded eraser, lift off thin ends to the strands of hair. Then with a 6B pencil, add some very small shadowy spaces throughout the lower portion of the hair.

eggs on a cloth

Steps: 9 **Difficulty:** ■ ■ ■ ■ □

What's the key to drawing white objects with a pencil? The answer is values. Although they appear to need no shading, they do have some darkness when compared to the whitest highlight. A white object in an image is understood by contrast to the darkness of other objects. And when the other objects are white, squint to discern which is darker.

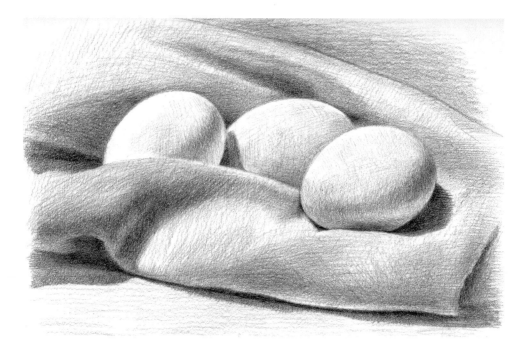

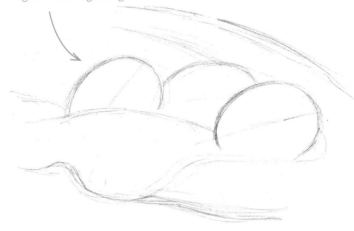

Keep the drawing soft and light in the beginning.

1 Begin by finding the placement of the main egg at the right with a faint axis line and then the contour with overlapping lines. Continue by drawing the other axes and contours as you proceed to the left. Also indicate the main lines of the cloth with soft lines.

The shaded cloth describes itself and the eggs simultaneously.

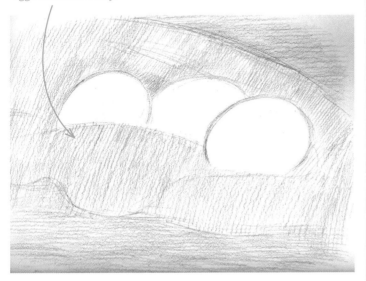

2 Even though it is white, the cloth is a little darker than the eggs. So with long, soft lines, shade the entire cloth and background. The eggs have no value and, for now, are left the white of the paper.

Erase the axis lines of the eggs.

Shade the areas that will be the darkest in the final image with medium dark tone first to establish their shapes.

3

Begin the dark shapes by shading them with even tone.

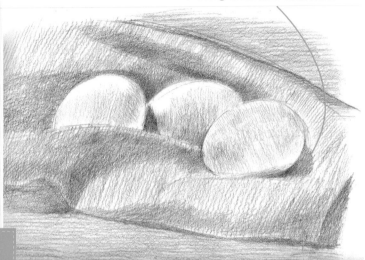

CONCEPT

There are two components to determine how dark something is: Its natural darkness in relation to other objects, or **local value**, *and its ability to reflect and absorb light.*

Increase the value of the egg on the right to transition gradually from very light at the top to a curved dark area, then lighter again at the bottom. Darken the cast shadow with horizontal shading.

4

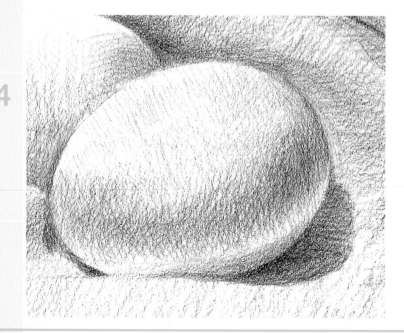

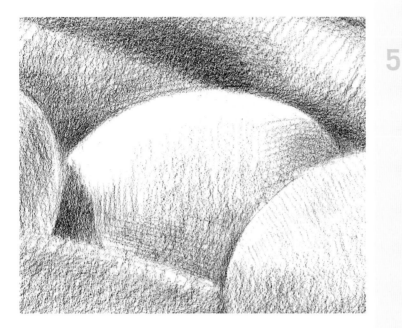

5 Shade the light area of the middle egg with very light strokes. Shade the shadow cast by the egg on the left with much darker value.

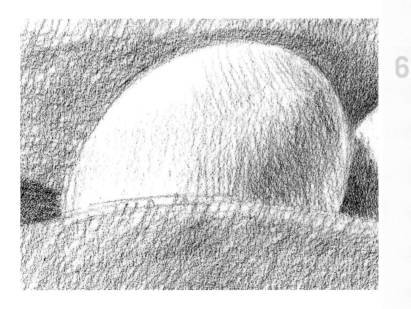

6 The egg at the left has subtle value changes, but is defined by the surrounding, slightly darker value of the cloth.

Define the edges of the shadows without outlines.

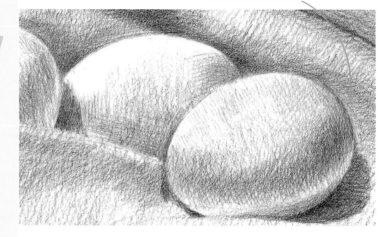

Shade the cloth to create light, medium, and dark areas. Shade cast shadows with dark tone to be well defined, but not hard edged. **7**

Create subtle transitions in the well-lit areas of the cloth and eggs. **8**

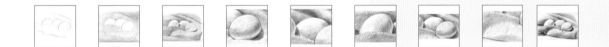

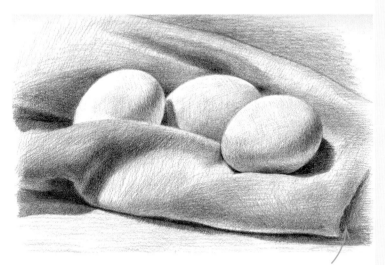

9 Refine the contours of the cloth's shadows to have more sensitive and subtle curving as well as softer or harder qualities. An example of this is the shadows below the left egg.

Refine the shadows' edges with very short back-and-forth strokes and little pressure.

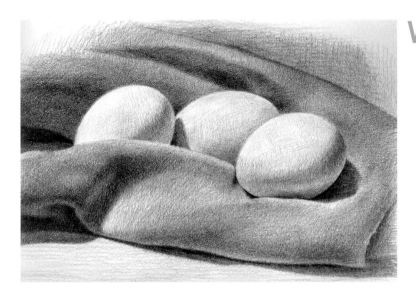

ADVANCED VARIATION

"Push" the values of the cloth to produce greater contrast to the eggs. Shade with soft marks without losing details. Check the value contrast by squinting or taking a few steps back and observing from a distance. The eggs should look very white, but the cloth shouldn't appear too dark.

sailboat

Steps: 9 **Difficulty:** ■ ■ ■ ■ ☐

The two ends of this transom-style sailboat are flat and parallel to each other, while the two similar, symmetrical curves of the hull appear asymmetrical here. This extreme view from behind also makes it more difficult to know the exact length of the boat, but when constructed correctly, it should be the right size for one or two passengers.

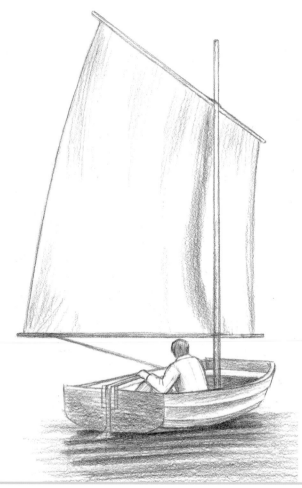

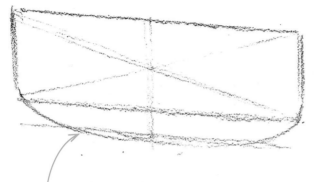

The nearer end of the boat is 2 ¼ inches (5.75cm) wide.

1 Draw two parallel lines that angle downward slightly at the right. Connect them with two short parallel, vertical lines to create a parallelogram. Find the center of the rectangle by connecting diagonally opposite corners. Draw a vertical line that intersects the center of the crossing diagonals.

Draw another line, parallel to the first two lines, that indicates the bottom of the boat. Draw two curves that meet just below this line at the center.

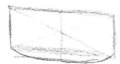

2 Repeat the process of step 1 to create a similar, narrower, shape to the right of the first, its bottom level with the top of the first.

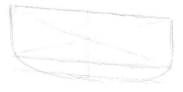

Draw the top edges of the sides. The left one is slightly curved and the right one is more curved at the right and includes a second line indicating the thickness of the board.

3

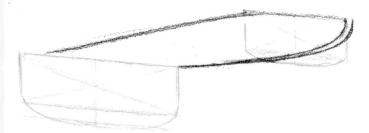

CONCEPT

Foreshortening *is a view down the length of an object resulting in an unusual illusion of depth with a compressed appearance.*

The hull boards appear narrower as they recede.

Draw the curved lines of the nearer side of the hull of the boat, then draw the far side.

4

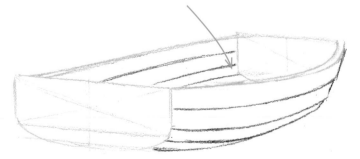

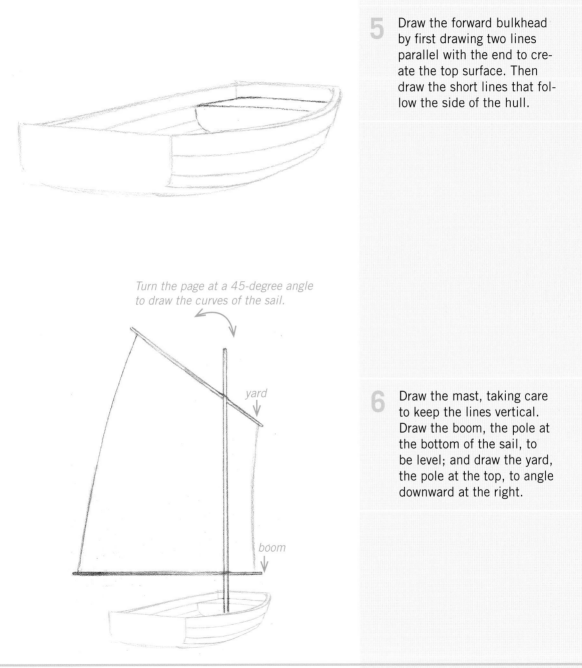

5 Draw the forward bulkhead by first drawing two lines parallel with the end to create the top surface. Then draw the short lines that follow the side of the hull.

Turn the page at a 45-degree angle to draw the curves of the sail.

yard
↓

boom
↓

6 Draw the mast, taking care to keep the lines vertical. Draw the boom, the pole at the bottom of the sail, to be level; and draw the yard, the pole at the top, to angle downward at the right.

7

Draw the rudder and the vertical blocks that hold it in place.

Draw the figure in the boat. Begin with basic rectangles for the torso and arm and an oval for the head, and then draw the folds in the clothing, the cuff, and the collar. Shade the hair to be lighter at the top. The bent leg is beneath the hand gripping the rudder handle.

The lower part of the rudder disappears beneath the water.

8

Shade the back of the boat with horizontal lines and the hull with directional lines that follow the boards.

The water ripples are developed by first shading the lower water area with horizontal strokes to create a light tone. Determine the shadow reflected in the water by drawing two faint vertical lines down from the farthest tips of the boat. Shade the horizontal light-dark-light pattern of the ripples at an angle between these lines.

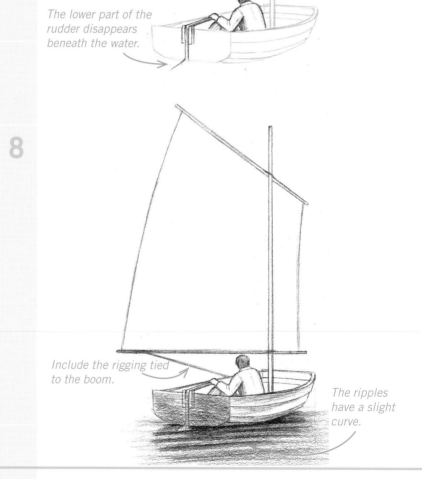

Include the rigging tied to the boom.

The ripples have a slight curve.

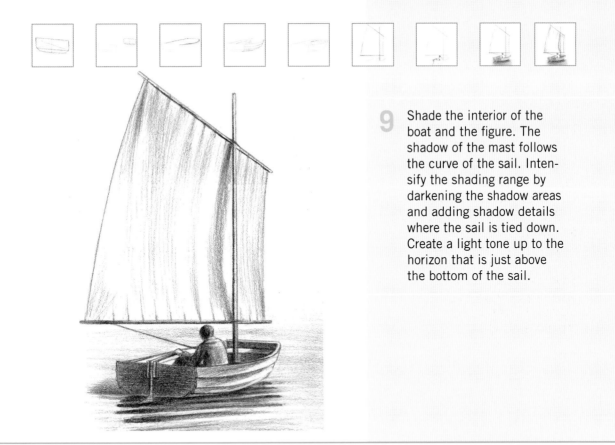

9 Shade the interior of the boat and the figure. The shadow of the mast follows the curve of the sail. Intensify the shading range by darkening the shadow areas and adding shadow details where the sail is tied down. Create a light tone up to the horizon that is just above the bottom of the sail.

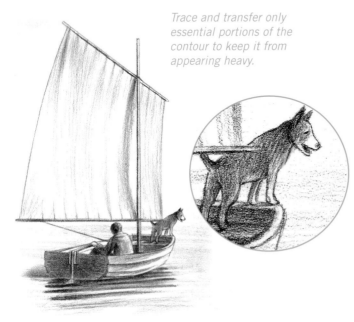

Trace and transfer only essential portions of the contour to keep it from appearing heavy.

ADVANCED VARIATION

Add the dog by tracing it from the image provided, then turn the paper over and shade over the lines of the dog. Position the shaded side down on the boat's bow, so the dog's front feet stand on the ledge and so he appears level. Trace the dog with a sharp 2B pencil. Remove the tracing paper. Erase the interior of the dog, then refine his contour and shade his fur.

sunlit object

Steps: 9 **Difficulty:** ■ ■ ■ ■ □

Direct sunlight on this simple cup emphasizes details usually over-
looked. The rim and foot both are locations of interesting transitions
and highlights. Some edges are made prominent, almost flat, like the
right side and left rim, while the right rim and left side visually dissolve
into the background. Drawing sunlit forms is a game won with shape
and value control.

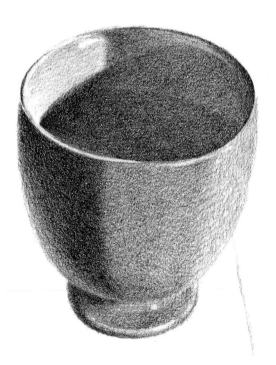

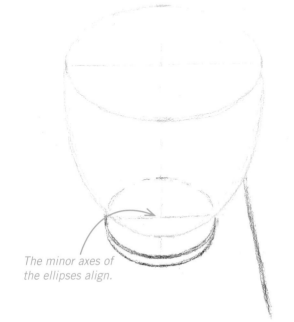

Turn the page to keep the pencil perpendicular to the line as you draw the curves.

The minor axes of the ellipses align.

1 Draw an ellipse with a 3-inch (7.5cm) long major axis and a 1⅝-inch (4cm) long minor axis. The height of the front side of this cup is the length of the ellipse's minor axis. Mark this length below the center of the rim and draw two reflecting curves from the ends of the el- lipse that meet there.

2 Draw a smaller ellipse for the foot of the cup with its minor axis lined up with the minor axis of the larger ellipse. Place its major axis ¼ inch (.75cm) above the lower part of the cup. Its major axis is 1¾ inches (4.5cm) long and its minor axis is 1¼ inches (3cm) long. Complete this step by adding another elliptical curve below the lower curve of the small el- lipse to create the thickness of the foot.

3 Construct the shadow divisions of the interior by drawing a curve parallel with the rim (A) that turns back and curves upward (B) and stops before the upper rim. Then shade with short horizontal strokes (C) the vertical shadow transition area. At the bottom of this, shade a curve that is parallel to the rim.

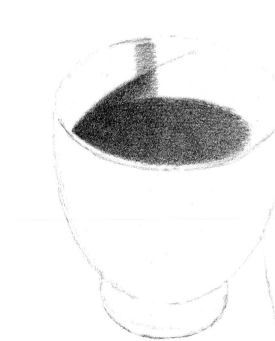

CONCEPT
The visual effect of **lost edges** happens where values of a subject's contour match those of the background and the two are seen as one shape.

4 Shade the lower interior of the cup with 70 percent value, then make it slightly darker at the left while keeping a shaded, not outlined, edge. Shade a small portion up the diagonal curve line.

Shade with short, overlapping, back-and-forth strokes.

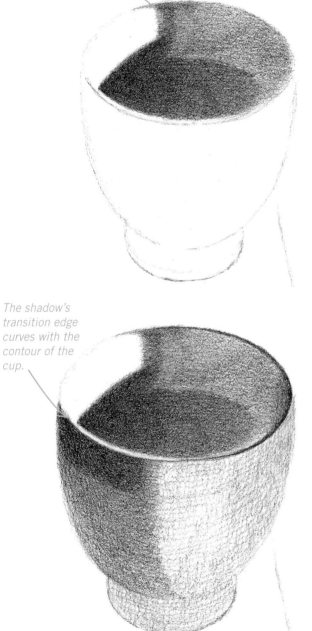

The shadow's transition edge curves with the contour of the cup.

5 Shade the area to the right of the vertical transition lighter than the lower area, yet close in value.

6 Shade the entire side of the cup with soft vertical strokes and then short cross contour strokes to create a 30 percent value base tone. Shade a second layer to create the left-side shadow shape, then begin a third, darker layer (visible at the rim, but incomplete) to create an 80 percent value.

Apply a dark shade to the interior of the right part of the rim.

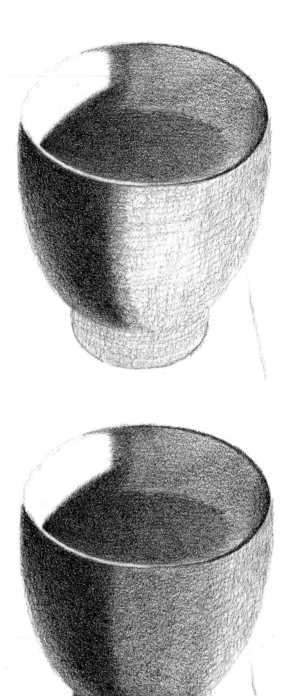

7 As you shade the shadowed side of the cup, allow the area at the lower left edge to be lighter to create the illusion of light reflected from the table.

8 Shade the foot with a layered process like the side of the cup, first covering the entire area. The lighter areas are created in the second layer by not shading midtone there. Darken the shadow in the third layer.

9 Create the highlight to the left of the interior vertical transition by shading the left area a 10 percent value, then lift off the horizontal teardrop-shaped highlight with a kneaded eraser.

Lift off the long highlight below the rim at the right. Then lift off the dot highlight at the recess of the foot and the highlight along the curving outer edge.

Shade the upper right area of the interior to continue the diagonal curve to the rim.

ADVANCED VARIATION

Shade the background, first with long, horizontal strokes with the side of the pencil tip and then with layers of darker, finer vertical strokes. Shade the table a 20 percent value with an HB pencil.

dog (3/4 view)

Steps: 9 **Difficulty:** ■ ■ ■ ■ □

This drawing presents the dynamic view of a dog from the front and side simultaneously, in three-quarter view. This, along with overlapping of the back with the chest, and rear leg with foreleg, helps establish the illusion of depth. The reward, as you will see, is visual excitement.

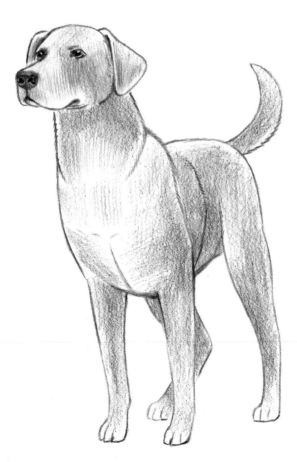

Draw the construction marks lightly—they will be erased later.

1 Construct the dog's head with a lightly drawn circle, about 1½ inches (4cm) in diameter. Use this as a unit for figuring the entire height of the dog, which is about four and a third heads (circles) tall. Make four construction marks below the circle.

Draw the shape contours with broken lines.

2 Continue constructing the head by using broken lines to avoid details while keeping it simple and blocky. Draw the general shape of the muzzle at the lower left of the circle. Construct the ear with a triangle and add two lines for the neck, as shown.

3 The shoulders hide much of the back and the hind end appears to curve right out of the neck, which is extreme, but possible with three-quarter view. Draw the two curving lines to the right of the neck and the two lines for the chest at the lower left. The width of the circle and triangle together should be equal to the width of the tail end.

4 The tail construction is made of two curved lines that point back to the head. The outside of the dog's right foreleg is straight and angled while the inside is slightly curved where muscles attach to the bones. Block in the foot also.

5 Block in the dog's left fore-leg and notice that the right contour is vertical. Draw a horizontal construction line to prepare for the placement of the rear feet in the next step. The width of the line to the right is the same as the diameter of the construction circle for the head.

6 The dog's left rear leg is a combination of gentle curves and straight parts due to muscle and bone. Generally, the upper part of all the legs is muscular and the lower part is bony. The belly line curves up and meets the leg. This leg looks compressed and narrow because it is viewed from the front.

The lower leg is vertical.

7 The sloping interior lines of the chest and the diagonal lines of the dog's right rear leg create depth and add contrast to the previous vertical lines. The slight curve of these lines and the overlap of the rear area by the front create volume, depth, and interest.

Curved transitions make the ears and jowls appear soft.

8 Draw the features of the face. The broken contours keep the eye from looking too heavy or flat. The eyes should be level with the ears and nostrils. Shade the muzzle and the undersides of the ears.

Use a kneaded eraser to lift off highlights of the nose and eyes.

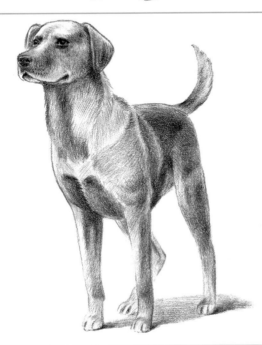

Cross contours show where a transition of a near and a far area occurs.

9 Refine the contours by connecting the blocked-in lines. Draw the cross contour lines of the back and midsection to emphasize the rounding of these areas. Refine the feet. Erase any visible construction marks. Cover the body with directional shading that is darker where parts turn to the right shadow side or under.

CONCEPT

Three-quarter view *is often used for portraits. More dynamic than a "mug shot," it shows off the front and the side simultaneously.*

ADVANCED VARIATION

Change the direction of the shading lines, and in some places, layer them to create darker values. Point a kneaded eraser to lift off highlights of the eyes and nose.

runner

Steps: 9 **Difficulty:** ■ ■ ■ ■ ☐

Running is all about the body's lung capacity and ability to oxygenate the blood. To the artist, however, a runner displays greater asymmetry and anticipation of movement compared to the standing figure. The complexities of the human form are more easily understood by abstracting the figure with combinations of 2D and 3D basic shapes.

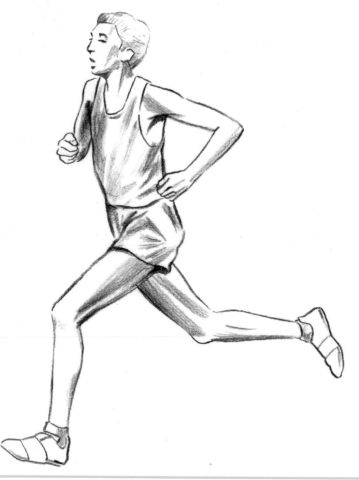

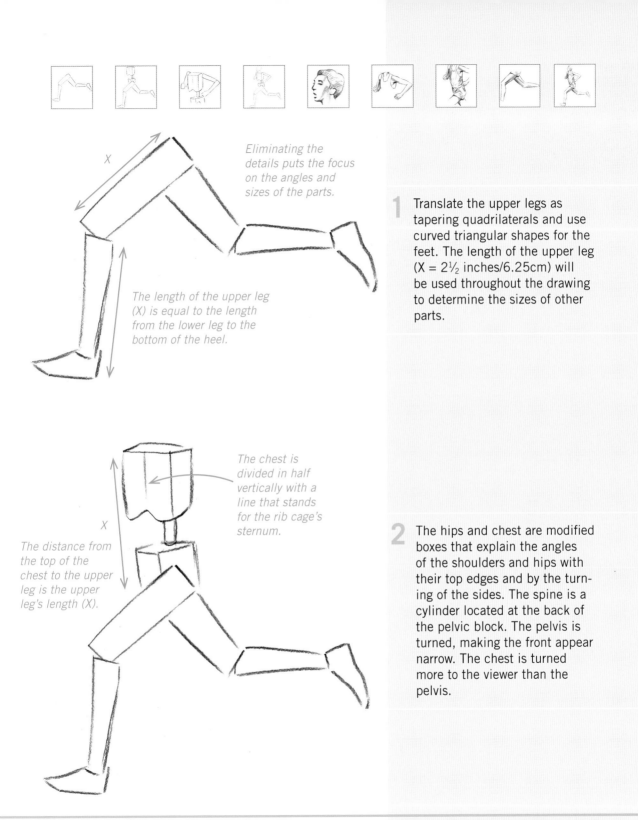

Eliminating the details puts the focus on the angles and sizes of the parts.

X

The length of the upper leg (X) is equal to the length from the lower leg to the bottom of the heel.

1 Translate the upper legs as tapering quadrilaterals and use curved triangular shapes for the feet. The length of the upper leg (X = 2½ inches/6.25cm) will be used throughout the drawing to determine the sizes of other parts.

The chest is divided in half vertically with a line that stands for the rib cage's sternum.

X

The distance from the top of the chest to the upper leg is the upper leg's length (X).

2 The hips and chest are modified boxes that explain the angles of the shoulders and hips with their top edges and by the turning of the sides. The spine is a cylinder located at the back of the pelvic block. The pelvis is turned, making the front appear narrow. The chest is turned more to the viewer than the pelvis.

Draw the left upper arm overlapped by the chest, then the hand overlapping the arm. The forearm is not drawn because it is pointed straight at the viewer and is overlapped by the hand.

Draw the right upper arm out to the elbow, then draw the forearm overlapping it.

Erase the extra lines where overlapping occurs.

3

CONCEPT

*A **shape figure** is a translation of the human body into basic 2D and 3D shapes. It reduces the distraction of surface details when determining size and positional relationships.*

Complete the shape figure by drawing the head and then the neck. The head is an oval that tilts to the right. The neck is a cylinder with an elliptical curve at its base.

4

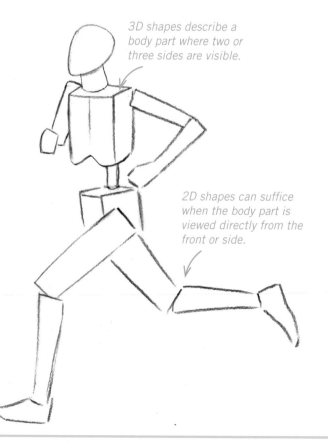

3D shapes describe a body part where two or three sides are visible.

2D shapes can suffice when the body part is viewed directly from the front or side.

Shade the hair darker at the forehead and neck.

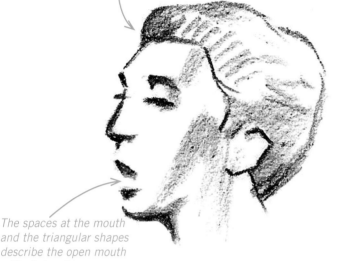

The spaces at the mouth and the triangular shapes describe the open mouth with abstraction.

Shade the angled line of the muscle that attaches to the clavicle and sternum.

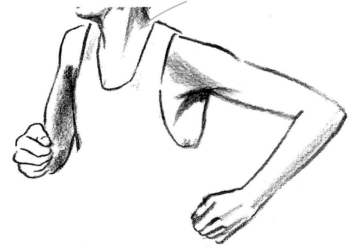

5 Lighten the entire shape figure with a kneaded eraser.

Mark the angled line of the eyes faintly at the horizontal midpoint of the head. Draw the near eye with an angled line and a bump for the eye. Draw the far eye's lashes, then both eyebrows. Continue with the forehead and hair, then the ear, nose, mouth, and jaw.

Shading at the temple and cheek and breaks in the contour add to the 3D illusion.

6 Draw the contours of the arms.

Before drawing the contours of the hand, notice that the thumb, index finger, and middle finger are angled downward and larger than the two smaller fingers.

Draw the contours of the torso, hips, and upper legs. Shade portions of the fabric with triangular shapes to indicate the draping of the fabric.

7

Notice the edges curving around the waistline and the leg that creates 3D illusion.

Draw the legs with the side of the pencil tip to create the thick-to-thin line and the soft shading. Turn the page to shade the angled muscles.

8

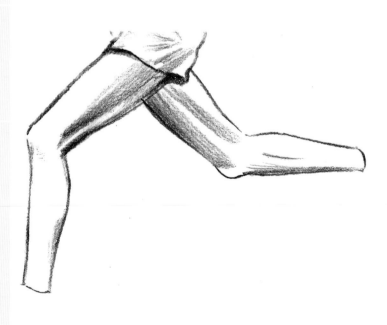

9 Draw the contours of the socks and shoes. Shade the grass underneath with the side of the pencil tip. Shade darker under the nearer shoe.

The band at the instep is tape to keep the shoe from coming off.

ADVANCED VARIATION

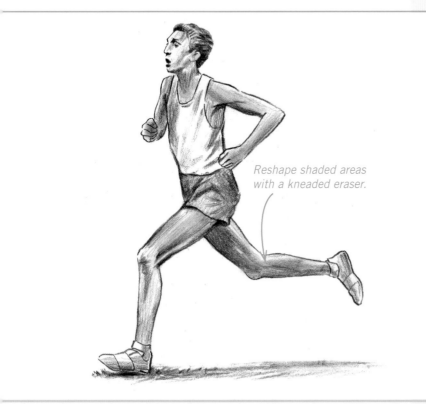

Reshape shaded areas with a kneaded eraser.

Refine the face with more naturalistic details. Shade the limbs to have more 3D illusion. Create gradations that run the length of the limb. Darken where the forms turn under or away.

S

Steps: 9 **Difficulty:** ■ ■ ■ ■ □

The *S* curve found in many art images is a symbol of elegance that flourished in ancient Rome. This letter *S* has a graceful slant and fine detailing of the serif ends. The thin-to-thick-to-thin pattern of the parts creates a visual rhythm. As with most letterforms, it's distorted slightly to appear balanced.

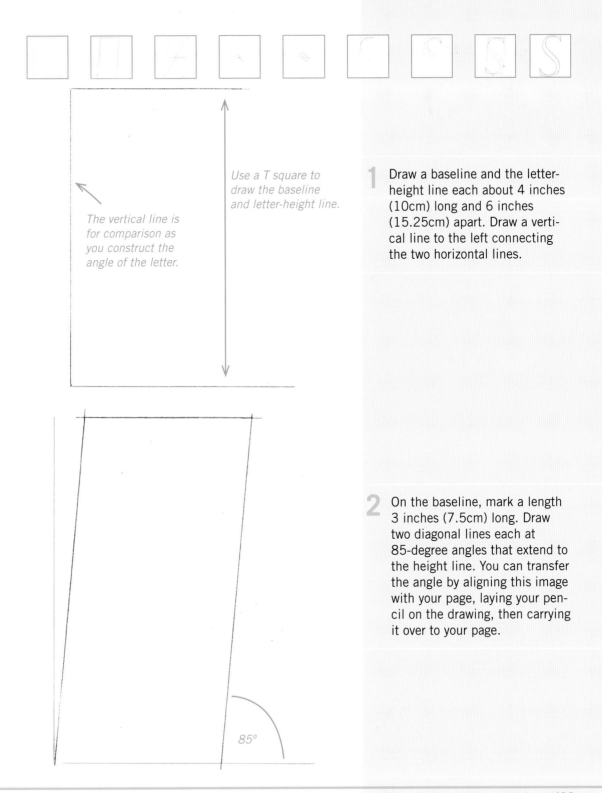

The vertical line is for comparison as you construct the angle of the letter.

Use a T square to draw the baseline and letter-height line.

85°

1 Draw a baseline and the letter-height line each about 4 inches (10cm) long and 6 inches (15.25cm) apart. Draw a vertical line to the left connecting the two horizontal lines.

2 On the baseline, mark a length 3 inches (7.5cm) long. Draw two diagonal lines each at 85-degree angles that extend to the height line. You can transfer the angle by aligning this image with your page, laying your pencil on the drawing, then carrying it over to your page.

Draw the diagonals connecting opposite corners to find the center of the parallelogram. Draw a horizontal line through this point.

3

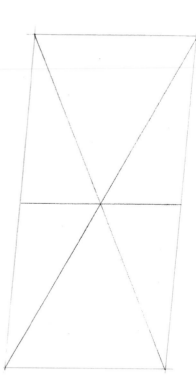

Erase the diagonal lines used to find the center of the parallelogram.

Draw a line 1 ½ inches (3.75cm) long at a 45-degree angle divided in half by the center of the parallelogram.

4

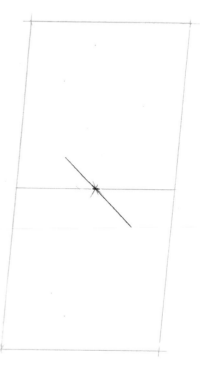

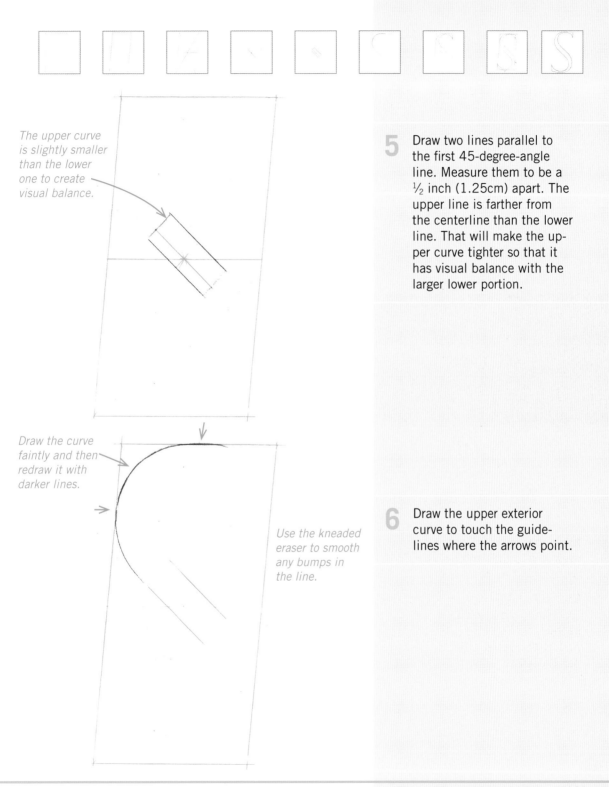

The upper curve is slightly smaller than the lower one to create visual balance.

Draw the curve faintly and then redraw it with darker lines.

Use the kneaded eraser to smooth any bumps in the line.

5 Draw two lines parallel to the first 45-degree-angle line. Measure them to be a ½ inch (1.25cm) apart. The upper line is farther from the centerline than the lower line. That will make the upper curve tighter so that it has visual balance with the larger lower portion.

6 Draw the upper exterior curve to touch the guidelines where the arrows point.

Complete the upper portion, the interior curve, and the serif. Draw the thinnest part of the line to be 1/8-inch (3mm) thick.

7

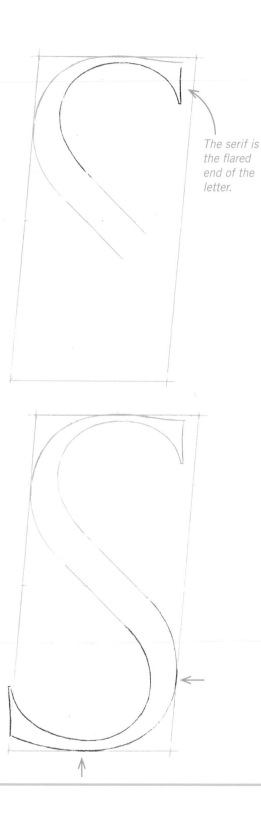

The serif is the flared end of the letter.

Complete the lower portion with the same process as the upper portion. Again, the apexes of the curves occur at the arrows. The lower curve and serif extend wider than the upper curve.

8

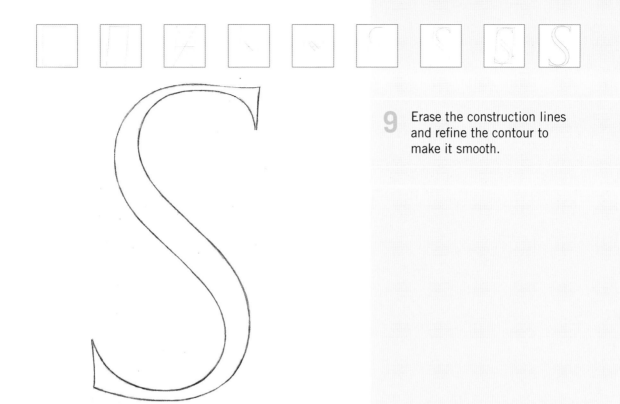

9 Erase the construction lines and refine the contour to make it smooth.

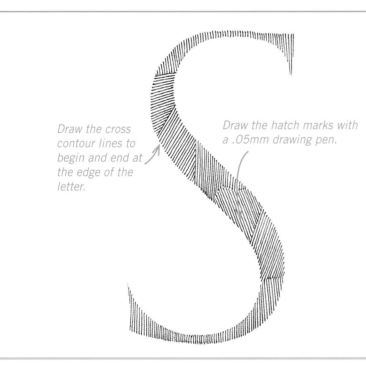

Draw the cross contour lines to begin and end at the edge of the letter.

Draw the hatch marks with a .05mm drawing pen.

ADVANCED VARIATION

Draw a penned version of the letter. Create an overlay by covering the preceding drawing with translucent paper and taping it down. Without drawing contour lines, shade the letter area with cross contour hatch marks. Space the marks evenly to create an even tone. Change the direction of the marks occasionally to create variety.

glass and fruit

Steps: 9 **Difficulty:** ■ ■ ■ ■ □

This drawing contrasts and compares two spherical objects in strong sunlight, one dense and the other translucent. The lemon has one light and one dark area of value, and the vase has one dark area containing several small light shapes. The lemon casts a simple dark shadow compared to the vase's, which is more complex with varying values and overlapping forms.

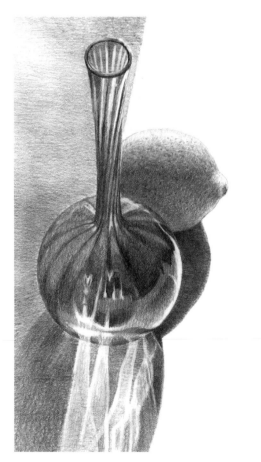

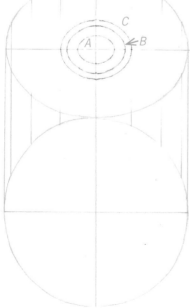

Use a 4B pencil to create a transfer of the circle and ellipse for the glass vase.

These marks on the circle and ellipse will determine the spacing of the vase's vertical stripes.

1 On translucent paper, draw a 3½-inch (9cm) diameter circle and its midpoints. Along the top half of the circle, make a tick mark every $^{11}/_{16}$ inch (1.75cm).

Draw two vertical lines 3 inches (7.5cm) starting at the ends of the circle's horizontal midpoints and a horizontal midpoint for the ellipse. Create the ellipse's vertical midpoint by extending the circle's vertical midpoint another $2^{5}/_{8}$ inches (6.5cm).

Draw vertical lines from the marks on the circle through the ellipse.

2 Draw three smaller ellipses positioned at the center of the larger ellipse. The smallest, ellipse A, is $^{9}/_{16}$ inch (1.5cm) tall and $^{3}/_{4}$ inch (2cm) wide. Ellipse B is $^{7}/_{8}$ inch (2.25cm) tall and $1^{1}/_{8}$ inches (3cm) wide. Ellipse C is $^{11}/_{16}$ inches (1.75cm) tall and $1^{3}/_{8}$ inches (3.5cm) wide.

D is the largest ellipse from step 1.

On a 9 × 12–inch (22.9 × 30.5cm) sheet of Bristol paper, draw a 7-inch (17.75cm) vertical axis for the vase 3½ inches (9cm) up from the bottom.

With the transfer turned drawing side down, align the circle's vertical midpoint with the vase's axis at the bottom of the line and tape it down. Rub the circle and its horizontal midpoint firmly with a blending stick.

3

Adhere the transfer in place with drafting tape.

Refine the contours of the transferred circle and ellipses to a 50 percent value, if necessary.

CONCEPT
*The **anatomy of light** is a model of the parts of light on a basic form consisting of a highlight, midtone, shadow, reflected light, and cast shadow.*

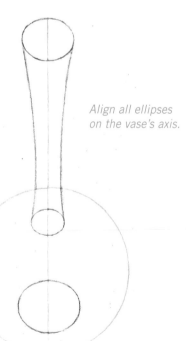

Align all ellipses on the vase's axis.

Position the top of ellipse B of the transfer sheet to the top of the vase's vertical axis and transfer it. Position the top of ellipse A ⁹⁄₁₆ inch (1.5cm) below the top of the circle and transfer it. Position ellipse C ⁹⁄₁₆ inch (1.5cm) up from the bottom of the circle and transfer it.

4

The rear stripes curve below the contour edge.

5 Position the horizontal midpoint of ellipse D on the horizontal midpoint of the circle and transfer it.

Draw the curves of the vase's stripes beginning at the points from the transfer to curve up to the base of the neck.

Create the contour of the lemon.

Start shading at the window drape's cast shadow at the top and include the vase's mouth.

The midtones of the vase are similar to lighter areas of the combined cast shadows at this point.

6 With short, overlapping horizontal strokes, create the gradations of the cast shadow to be darkest below the lemon.

Shade the vase's stripes following the guidelines. The lower half of the neck is darkest. In the upper half, long highlights are left between the stripes. Shade the rim dark and the mouth again to 70 percent value. Shade the left side of the vase globe with dark-to-light midtones.

Continue shading the vase's globe with a dark-light-dark value pattern, darkest below the lemon and lightest at the top and bottom. Lay in the lower elliptical base of the vase with short vertical strokes to make a soft, darker edge.

7

With an HB pencil, shade the top of the lemon to 20 percent value, and the dark side (lower part) to have a soft edge with a reflected light at the bottom.

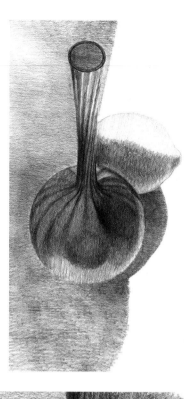

Shape a kneaded eraser to a rounded tip and drag it downward to create the sides of the highlights that stream from the bottom of the vase. Point the eraser and lift off the highlights of the top, right side, and lower part of the globe. Lift off the long highlights in the mouth area.

8

Point the eraser with a needle-small point to create the most delicate highlights.

The lower highlights overlap and have a light-dark-light interior value pattern.

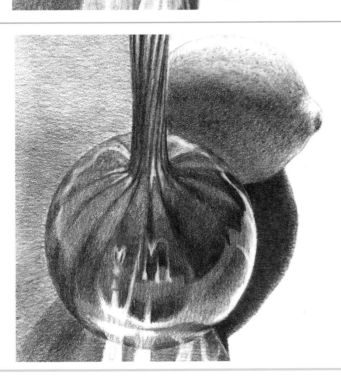

The pitted midtone of the lemon has tiny dark shapes paired with lifted-off highlights below.

The dark-light-dark patterns of the highlights' reflections on the lower globe are vital to the 3D illusion.

9 Shade the darkest areas cast by the globe and lemon. Increase the darkness of the edge of the vase's mouth, between some of the stripes at the neck, and around the delicate parts of some of the highlights.

Create the pitted texture of the lemon's peel by first shading small, uneven patches with an HB pencil, then add pitted areas with a 6B pencil. Create little highlights below some of the pits.

ADVANCED VARIATION

Soften the texture of the lemon peel. Tap the light area with the tip of a kneaded eraser to lighten and blend. Darken the shadow line separating the dark from the light side, but keep it soft. Have fun refining the vase's highlights even further with light touches and swipes with the tip of a kneaded eraser. Finally, with horizontal strokes, darken the shadow beneath the lemon to 100 percent value with an 8B pencil while leaving the right edge about 80 percent.

creature

Steps: 9 **Difficulty:** ■ ■ ■ ■ □

This imaginary creature's curvilinear form coils into the depths of the ocean. Multiple techniques are used to create its illusion of depth: light figure on a dark ground; overlapping, converging lines; change in detail; and change in size. The visual path is a broken figure eight, but the continuation leads back to the head, staring into its blind eye.

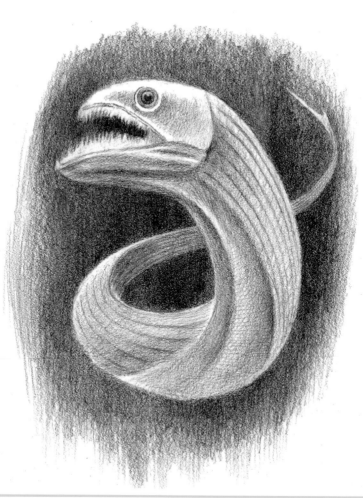

These dashed reference lines are for comparing the placement of other parts in relation to the head.

The dashed reference line is the midpoint of the head from this view.

1 Sketch the curvilinear action line in sections, beginning at the top with the slightly angled line for the head. Then draw the downward angling line of the body to the lowest point. From here, angle the line upward and to the farthest point left. Continue upward, angling to the right, and complete the line where it curves to the left.

2 Draw the boxlike head as seen from below. The horizontal line delineates the near jaw; the lower angled line delineates the far jaw.

The top part of the head is set farther back than the jutting jaw. Draw the mouth opening and the circle for the eye.

3

CONCEPT

*The illusion of depth is created with **diminishing size** when similar objects become smaller and smaller or a single object is depicted in a fore-shortened or angled view.*

Lay in the curving lines of the left and right sides and underside of the body.

4

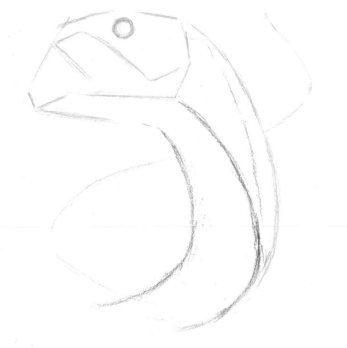

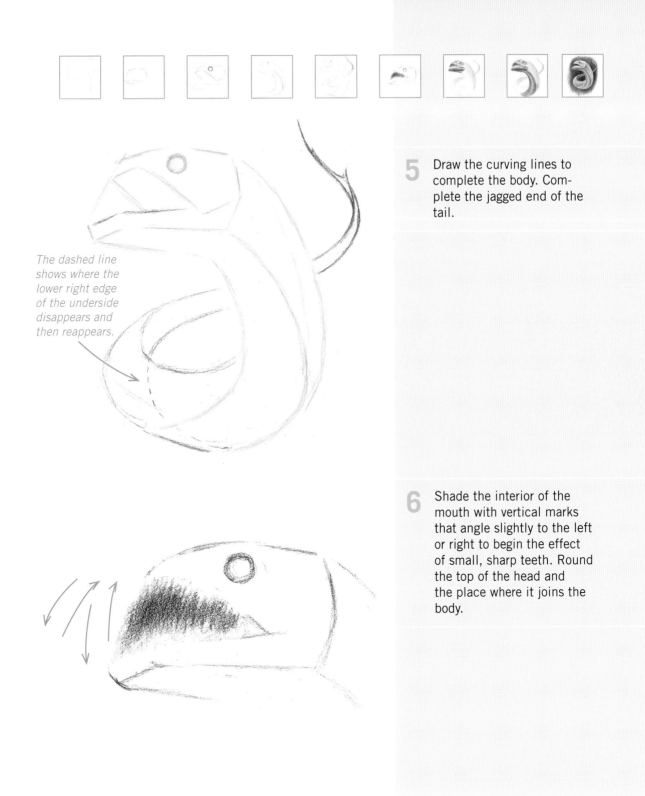

5 Draw the curving lines to complete the body. Complete the jagged end of the tail.

The dashed line shows where the lower right edge of the underside disappears and then reappears.

6 Shade the interior of the mouth with vertical marks that angle slightly to the left or right to begin the effect of small, sharp teeth. Round the top of the head and the place where it joins the body.

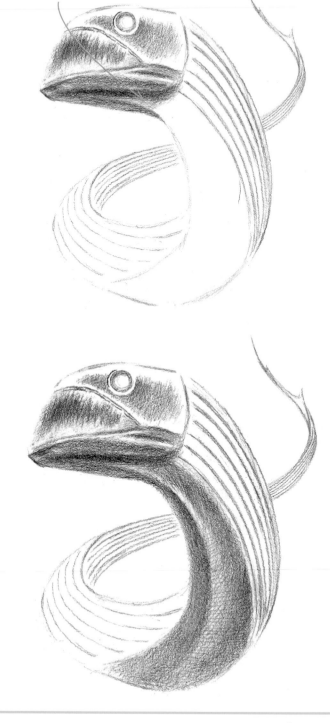

This lighter curving part is the medial center of the underside.

7 Shade the head, leaving highlighted areas at the edges and around the eye. Shade the jaw to have highlights and reflected lights in the shadow.

Add five evenly spaced lines running the length of the body that converge as the side narrows. These continue down the sides of the body and end before the jagged part of the tail. The underside is left unlined.

8 Continue shading the underside with a combination of back-and-forth shading and crosshatching to develop the surface from side to side. Leave the medial center lighter.

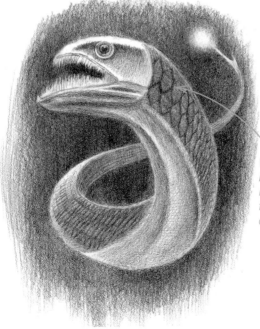

9 Shade the left side to be darker nearest the lighter edge of the underside. Shade the right side in the background to be darker near the light edge of the left side. Shade the tail up to the jagged part.

Shade the eye and leave a highlight. Darken the mouth interior.

Darken the background with vertical strokes from a 6B pencil. Leave the outer edge jagged and not shaded in the corners.

Shade the background to show a vertical light-dark-light value pattern with 80 to 100 percent value.

ADVANCED VARIATION

Create a surface texture on the creature with hexagonal scales. Use the lines on the right and left sides of the body as guidelines to create a pattern that diminishes at a consistent rate. Darken the hexagons' contours and shade the interiors.

Darken the shadow on the head. Then use a kneaded eraser to give the creature a glowing tail to put the finishing touch on this imaginary "Lantern Eel." Or can you imagine your own variation?

When the hexagons become extremely narrow, transition the pattern into cross contour lines.

hand

Steps: 9 **Difficulty:** ▦ ▦ ▦ ▦ ▦

The human hand is very versatile, and can be expressive even when it's working. This lesson shows a hand in the act of cutting with scissors. Three fingers are extended and two are contracted in a graceful pose. The scissors, too, have a design that is beautifully streamlined while performing an exacting task.

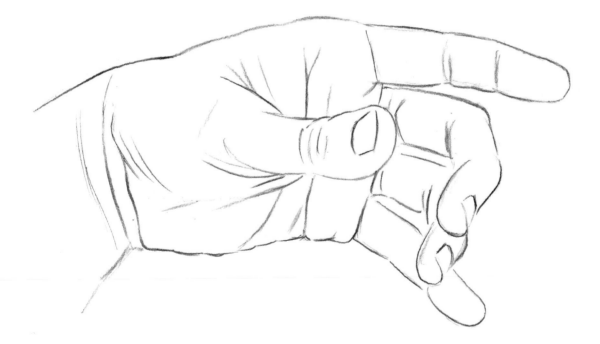

The dashed reference line indicates the start and end of the upper contour are level.

1 Draw a light rectangle 3 inches (7.5cm) tall and 6 inches (15.25cm) wide. Allow for 4 inches (10cm) above the rectangle if you will be completing the advanced step.

Draw a vertical midpoint in the rectangle and copy the broken-line contour from the illustration.

2 Draw the lower contour, then the vertical curve at the base of the fingers. Notice the angle of the tips of the two extended fingers and the distance X that shows how far the little finger goes below the rectangle.

The end of the thumb angles upward and overlaps the line of the upper palm.

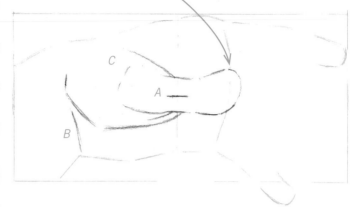

Mark the horizontal midpoint (A) and use it to position the lines of the thumb. The crease of skin at the bend in the wrist (B) angles upward to the base of the thumb. Point C marks the location of the second joint of the thumb.

3

CONCEPT

Where overlapping occurs, **draw the farthest parts completely, then the nearer parts over them** *to determine the continuation of contours with sections that disappear and then reappear.*

Draw the middle finger. Notice the underside of the middle segment aligns with the crease of the index finger and the joint of the first segment aligns with the bottom of the thumb.

4

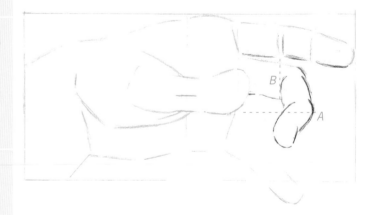

5 Draw the ring finger and complete the little finger.

6 Draw the nails of the middle and ring fingers. The end curve is a cross contour line that describes the lateral roundness of the finger.

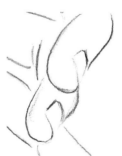

Draw the thumbnail. Notice how the sides are not parallel, the outer curve is wider and the narrow curve is not symmetrical.

7

Add the flesh folds and wrinkles of the wrist, palm, and thumb.

8

9 Erase all the construction lines; then lighten all the contours of the drawing and refine them to 80 percent value. Create lines with varied pressure and allow some breaks to keep the contour lively and light.

ADVANCED VARIATION

Draw scissors over the lines of the hand positioned as if they are being held. Begin by drawing a construction line at a 65-degree angle aligned with the side of the thumbnail, then draw the inside hole and work outward. This half of the scissors bends at the pivot. Create the top scissor with the same process as the first. Erase the overlapped lines to complete the drawing.

The underneath scissor is drawn first, with its overlapped contour indicated by the dashed line.

reclining figure

how to draw a

Steps: 9 **Difficulty:** ◼ ◼ ◼ ◼ ◼

This figure is in three-quarter view with eyes below the viewer's. This is determined from the line of her eyes slanting upward as it goes from near eye to far. Extend this imaginary line and other angled imaginary lines of the nose and mouth to meet at a point on the horizon that is level with the viewer's eyes.

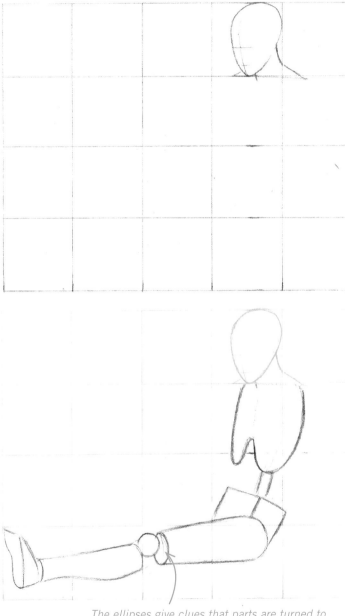

Construct a shape figure transfer.

1 On translucent marker paper, construct a 4 × 5 grid where each block is 1⅝ (4cm) squared. This is the same height as the figure's head and will be a unit of measure for placement of the various parts. Begin the shape figure by drawing the head at the right of the second block from the right of the top row. Add the line of the neck and shoulders.

2 Construct the torso and near leg of the shape figure. Follow the placement shown by the grid.

The ellipses give clues that parts are turned to the viewer.

The leg will eventually cover the palm and wrist.

3

Draw both arms, then the far leg. The hand on the far leg is drawn first to determine the correct placement of the fingers.

These lines will be transferred to the final drawing page.

4

Turn the transfer page over and redraw these portions of the lines from the other side.

Check your progress by lifting up the transfer sheet that has been taped down on one side.

5 Lay the transfer sheet, with the non-grid side facing down, over Bristol paper and tape it down with a book hinge mount. Transfer the lines by rubbing over the lines of the figure on the grid side with a blending stick.

Draw the centerline, the lines of the eyes, nose and mouth, and ear, and the soft beginning forms of the eyes on the head shape.

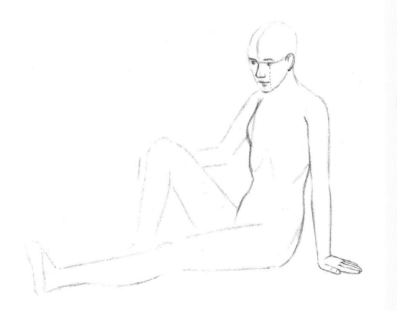

6 Draw the contours of the torso, the arm, and the near hand.

Draw the near leg. Lay in the contours of the far leg and leave a blank area where the fingers will overlap. Then add the fingers.

7

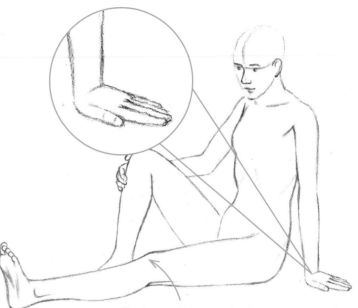

The knee of the near leg has a small rise that then angles downward to the shin.

Begin drawing the features of the face with very light touches with a sharp 4B pencil. When they are positioned correctly, refine them with darker touches.

Shade the hair in the direction that it is pulled back and then falling downward. Leave a lighter highlight that runs across the crown.

8

The outside of the left eyebrow is hidden as it wraps around the far side of the forehead.

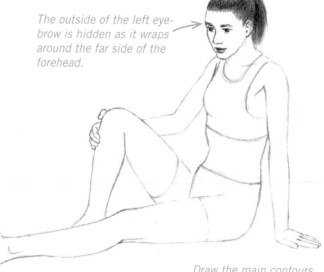

Draw the main contours of the clothing.

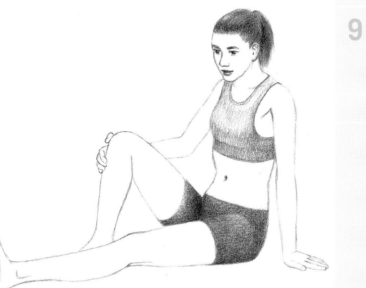

9 Lightly shade the shape of the navel with a darker recessed right side and a softer shadow at the left and above. Shade the clothing with dark local values.

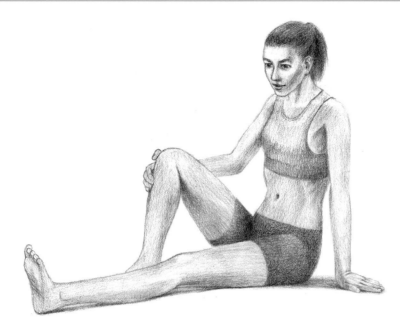

ADVANCED VARIATION

Shade the recessed areas of the flesh and tone the entire subject to 20 percent value with an HB pencil. Create the illusion of a light source at the upper left by lifting highlights on the brow, bridge of the nose, and clavicle. Add a cast shadow beneath her near leg that connects to her hand. Refine the edges of the shaded areas, mouth, and eyes with a kneaded eraser.

two-point perspective scene

Steps: 9 Difficulty: ■ ■ ■ ■ ■

Objects that can be constructed with two-point perspective have a near edge between two facing sides. Sometimes the top or bottom is visible if the view is from above or below the subject. In this view of the lighthouse, the eye level of the viewer is the same as the horizon line that is slightly below the distant sea level.

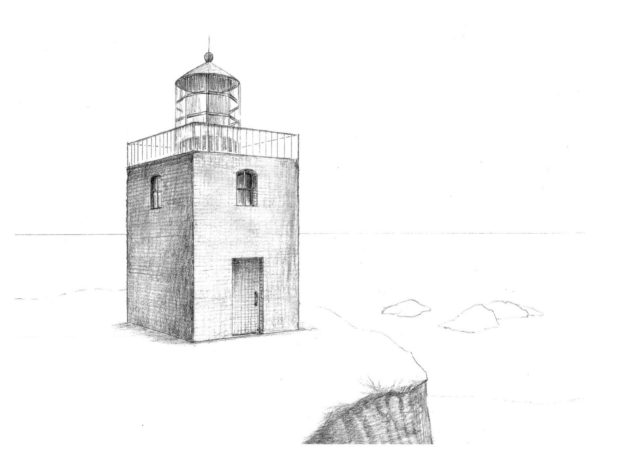

The midpoint will be the scene's
horizon line (HL).

VP1 | horizon line (HL) | VP2

1 Cut three pieces of paper
down to 8 × 11 inches
(20.5 × 28cm) and tape them
together end to end to make a
33-inch (84cm) long drawing
page. Align the page on a draw-
ing table or board and tape it
down. Draw a midpoint across
the entire area and on that line
draw a small point 8 inches
(20.25cm) from the far left
edge and another at the far right
edge. Label the left point VP1
and the right point VP2.

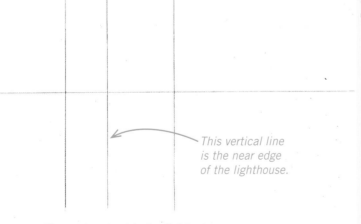

This vertical line
is the near edge
of the lighthouse.

The center sheet is the finished
drawing page and the side sheets
are extensions for the perspective
construction.

2 On the center sheet of the three
taped sheets draw a vertical
line down the entire page $3\frac{1}{2}$
inches (9cm) from its left edge
by aligning the T square head
to the top edge of the table or
board. Draw another line $1\frac{1}{4}$
inches (3.25cm) to the left of
it and a third 2 inches (5cm) to
the right.

Erase the vertical lines and
angled lines of convergence
indicated by the dashed
lines.

The center vertical is the near edge.

Draw tick marks on the near **3** **edge at 2 inches (5cm) above the HL, at 1½ inches (3.75cm) above the HL, and at 2 inches (5cm) below the HL. From each of these points draw two angled lines ending at VP1 and VP2.**

Erase excess portions indicated by the dashed lines.

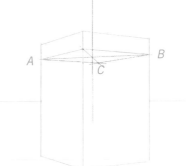

CONCEPT
Create depth in a drawing with **atmospheric perspective** *by placing darker objects with more detail in the foreground and lighter objects and areas with less detail in the distance.*

Draw a construction line an- **4** **gling downward from point A toward VP2 and a line angling downward from point B to VP1. The two lines will cross at C to create the hidden top of the lighthouse that will help determine the central axis of the lantern and lens. Draw diagonals to opposite corners of the roof shape. Where they intersect, draw a 2½-inch (6.5cm) vertical line upward.**

Turn the page to draw the ellipse with balanced curves.

Draw this construction lightly.

5 Draw the horizontal major axis of the ellipse that will be the lantern's cap 1½ inches (4cm) up from the bottom of the lantern's vertical axis and 1¼ inches (3.25cm) wide. Draw the ellipse ⅜ inch (1cm) tall. Draw the vertical sides of the lantern downward from the ends of the ellipse.

6 Erase the ellipse's construction lines.

Draw the vertical divisions of the lantern's glass panes, then the angled lines of the cap and the vent ball.

Find the centers of the two facing sides of the lighthouse by connecting diagonally opposite corners as in step 4. These will be used in step 8 to place the windows and door.

Sketch the cliff's edge, shoreline, and distant rocks.

7

Draw the sides of the window and door on the right equidistant from their centerline using a T square. Turn the T square face down to draw top and bottom edges to angle to VP2.

Extend the window's angled lines to the near edge. From these two points draw lines that angle downward to VP1 to determine the left window's height. Then draw its sides closer to the centerline than the window on the right.

8

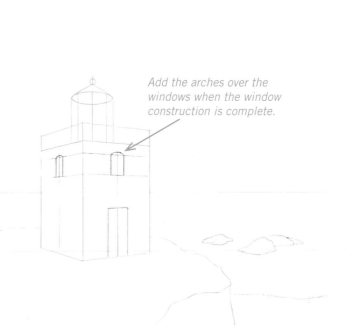

Add the arches over the windows when the window construction is complete.

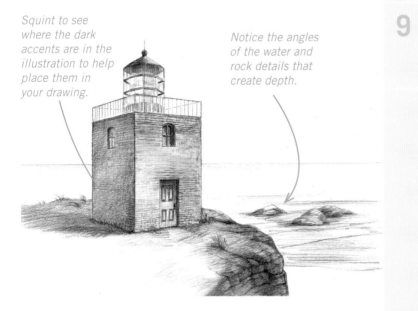

Squint to see where the dark accents are in the illustration to help place them in your drawing.

Notice the angles of the water and rock details that create depth.

Erase the window construction lines. Shade the right side of the lighthouse with 30 percent value and the left with 60 percent value, and then shade individual bricks in rows aligning with the corresponding vanishing points.

Shade the cliff darker than the distant rocks to create depth. Use directional shading, then create darker cross contour recesses. Shade the grass with directional shading and draw clumps of grass. Create a cast shadow at the left.

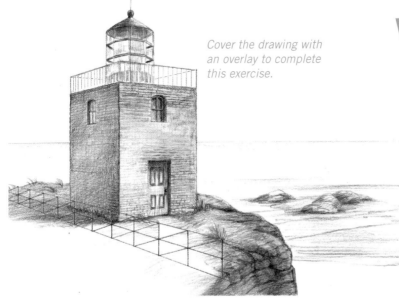

Cover the drawing with an overlay to complete this exercise.

ADVANCED VARIATION

On an overlay, rule three equally spaced angled lines that converge toward VP1. Place a vertical line at the far right and then another to its left to create the desired distance between posts. Draw a diagonal line from the top of the far right post through the point where the second post and the center converging line intersect and on down to the ground line. Repeat this process moving one post to the left each time.

complex abstraction

Steps: 9 **Difficulty:** ■ ■ ■ ■ ■

Extreme close-ups, like this fragment of a shell, take a subject out
of context and turn it into a strange terrain to explore. This composi-
tion contrasts curvilinear and rectilinear shapes that resemble land
formations in some areas. Begin constructing the spiral with accurate,
well-placed contours, then block in the midtone and shaded areas.
The delicate gradations are created before the final dark values.

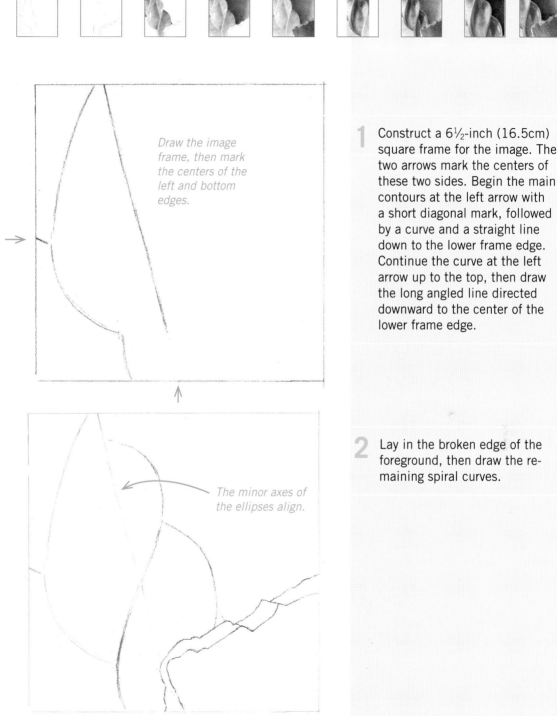

Draw the image frame, then mark the centers of the left and bottom edges.

1 Construct a 6½-inch (16.5cm) square frame for the image. The two arrows mark the centers of these two sides. Begin the main contours at the left arrow with a short diagonal mark, followed by a curve and a straight line down to the lower frame edge. Continue the curve at the left arrow up to the top, then draw the long angled line directed downward to the center of the lower frame edge.

The minor axes of the ellipses align.

2 Lay in the broken edge of the foreground, then draw the remaining spiral curves.

Lay in the main value shapes of the spiral. Though the edges have definition, keep them soft without outlining. Note the directions of the gradations and shading.

3

This gradation goes from 60 percent to 30 percent value and requires two layers of shading at this stage.

Shade the lower left corner shape with an HB pencil and the darker area to the right of the spiral with a 4B pencil.

4

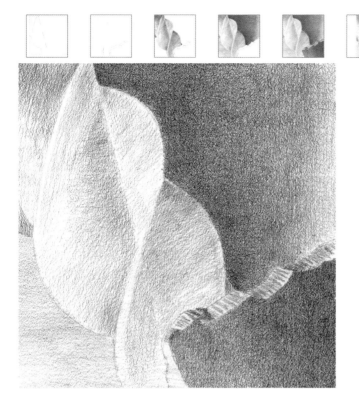

5 Shade the foreground fragment edge with 10 percent value, then add the cross contour marks. Create a 40 percent to 60 percent value gradation on its facing side.

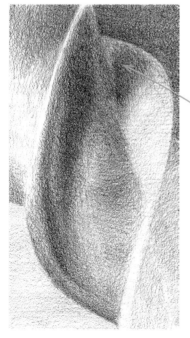

Maintain the light upper edge and the reflected light in the shadow.

6 Shade the middle turn of the spiral with midtone, then add the deeper shadow tones with small back-and-forth shading strokes.

7 Continue shading the lower turn of the spiral. Again, shade the midtone, then lay the deepest shadow over it.

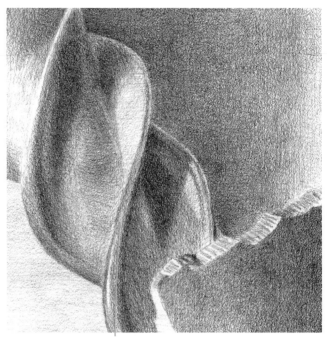

Maintain the reflected light.

Sharpen the pencil often as you shade the darkest values.

8 Refine the spiral's surface gradations and edges. Lift off the delicate highlights and reflected light edges with a shaped kneaded eraser.

Deepen the gradation of the large shadow at the right to 100 percent at the left and 80 percent at the far right. Carefully define where it meets the top edge of the near fragment without a hard outline.

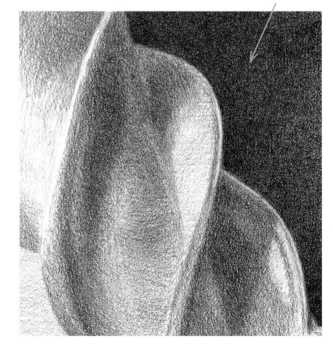

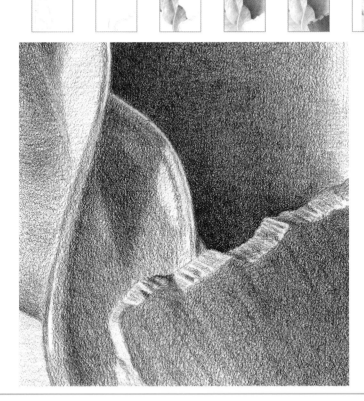

9 Darken the shadows of the nearer fragment. Add the diagonal streaks in a random pattern.

Lean back and squint to judge the effect of the values.

Take the overlay off to refer to the pencil version while creating the pen drawing.

ADVANCED VARIATION

Create a pen version of a section of the composition with crosshatching. Begin by sketching the main contours on a translucent paper overlay with an HB pencil. Then, based on the drawing, build the value shapes on the overlay sheet slowly with vertical strokes for all areas 20 percent value and above, horizontal strokes for all areas 40 percent and above, 45 degrees right for areas 60 percent and above, and 45 degrees left for 80 to 100 percent value areas.

vanitas still life

Steps: 9 **Difficulty:** ▣ ▣ ▣ ▣ ▣

Symbolic objects arranged to tell a story date to ancient history. The wine glass, skull, and old book are central to the vanitas, or *vanity*, still life. Though a macabre and sober reminder of the transience of life, it also combines the skeletal anatomy of the human figure, the reflective effects of glass, and two-point perspective for closer inspection.

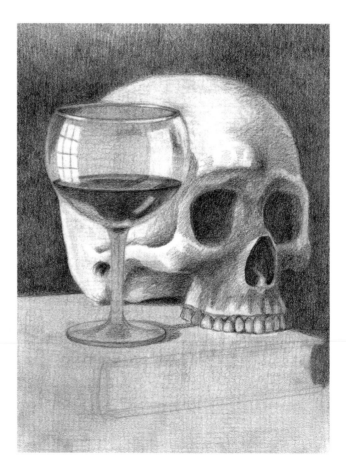

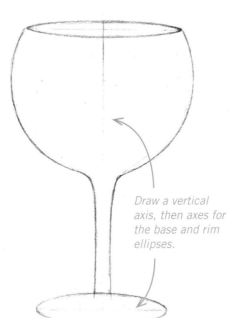

Draw a vertical axis, then axes for the base and rim ellipses.

The center of the page is to the left of A.

← A

B ↓

↑ B

1 Draw a rectangular frame 10¼ (26cm) inches tall by 7¾ (19.75cm) inches wide on a 9 × 12 inch (23 × 30.5cm) drawing page. Construct a wineglass that is 2¾ inches (7cm) up from the bottom of the frame and ¾ inches (2cm) from the left side of the page, and is 5¾ inches (14.5cm) tall and 3⅝ (9cm) wide.

2 Draw the broken line outside contours of the skull. Notice that the skull's vertical midpoint is tangent with the right side of the wineglass, making the skull about twice the width of the wineglass. Then draw the guidelines B that angle upward slightly to the right. Draw the dashed midline that follows the contour of the center of the skull to help determine placement of the features.

Draw the outside contours of the book, copying the angles from the illustration. Notice the thickness of the book's pages is nearly half the height of the entire book in this foreshortened view.

Refine all the contours to about 70 percent value.

3

Drag the eraser to lift off a little and push the eraser onto the page to create lighter areas.

Use the contours as a guide while you draw with the kneaded eraser.

Shade the entire image area with a 4B pencil in a vertical direction and then a second time in a horizontal direction creating a 50 percent value with a texture that appears woven.

4

Gently blend the entire area with a folded paper towel, wiping in horizontal and vertical strokes to create an even 50 percent gray value all over.

Drag and touch a kneaded eraser on the page to lift off the skull's light side.

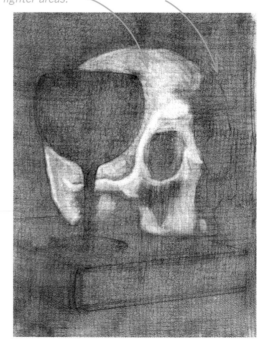

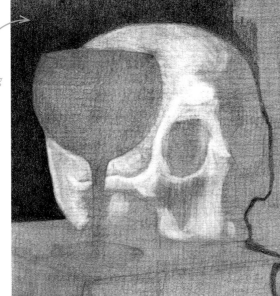

Shade with short overlapping back-and-forth strokes.

5 Shade the background lightly with a 6B pencil around the skull, then with vertical strokes over the main area.

The light shapes are created by lifting off tone and then shading to refine the light shapes' edges.

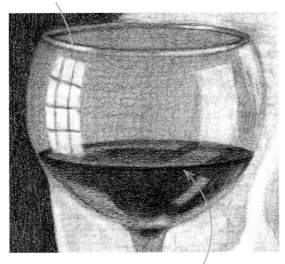

Check that the ellipse of the wine is level.

6 Draw the darker lines of the rim, then lift off the highlights. Also lift off the curving rectangle highlights of the wineglass, then lightly redraw the muntins of the window in the left-side reflection. Draw the dark line of the ellipse and then the ellipse shading, followed by the lower area of the wine.

Shade the eye sockets and nasal cavity and notice where the edges are hard or soft. Use the kneaded eraser to refine the edges, if necessary.

7

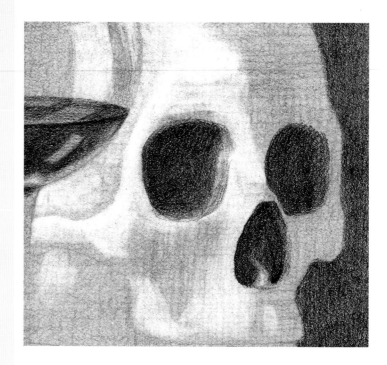

The zygomatic bone and arch.

Shade the maxillary area above the teeth to have a light-dark-light value pattern to create the undulating surface. Sketch the teeth individually with shapes unique to molars, bicuspids, canine, etc., as shown. Shade the deep pierced area behind the zygomatic bone and the auditory hole to the left of the wineglass stem.

8

After sketching the teeth, touch them softly with the kneaded eraser to create a porcelain quality.

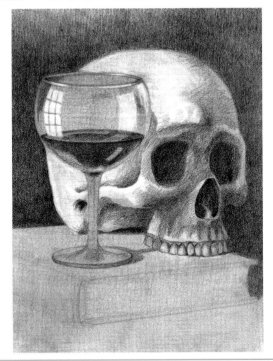

9 Create the shadow of the wineglass beginning at the base, following up the molar, maxillary, orbital cavity, nasal bone, and brow. Increase the shading on the right frontal side of the head.

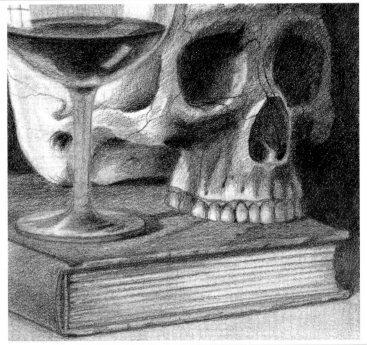

ADVANCED VARIATION

Shade the background to 90 percent and 100 percent value near the right zygomatic bone. Darken the wine and skull gradations. Add cracks in the bones that follow the form. Shade the entire book to 60 percent value, then even darker at the corner by the teeth to create a torn area. Darken the pages, then lift off rows of highlights and add thin shadows to emphasize the gathered sections of pages. Add small shadows under overhanging areas of the cover.

feather

Steps: 9 **Difficulty:** ■ ■ ■ ■ ■

This hawk feather has an eye-catching shape, fascinating texture, beautiful irregular pattern, and a range of details. Its structure is branching, with the barbs growing from the shaft of the quill. From the barbs grow even smaller barbules, and from these, barbicels. Drawing is a way to enjoy nature's details through observation.

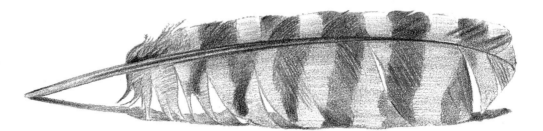

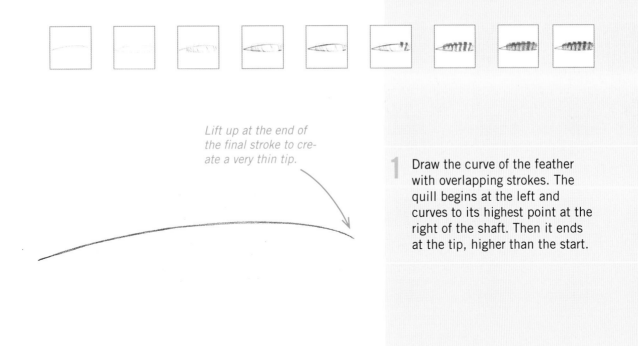

Lift up at the end of the final stroke to create a very thin tip.

1 Draw the curve of the feather with overlapping strokes. The quill begins at the left and curves to its highest point at the right of the shaft. Then it ends at the tip, higher than the start.

2 Draw the upper outer contour with a broken line that anticipates separations of the barbs. Then draw the lower contour that includes the shadow cast from the quill.

Draw the separations of the
barbs. Take care to copy the
widths between them and the
range of spaces they make.

3

*Be aware of the spaces of the
separations and draw them to
match the image.*

*Some of the lower tips touch the
shadow contour, some don't.*

Begin the shading of the
shaft to be darker at the
sides and lighter in the
middle. Shade the shadow
shape between and beneath
the barbs.

4

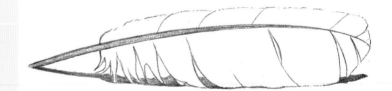

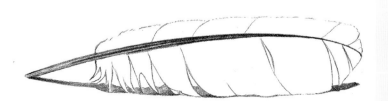

5 Intensify the illusion of the shaft by adding a thin cast shadow and darkening the center and sides. Darken the cast shadow near the quill tip and where the barbs touch the surface beneath it.

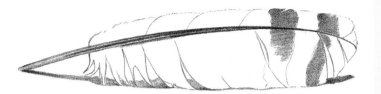

6 Lightly draw the shape of the first two bands and shade them in with a back-and-forth motion.

Draw the contours of the remaining bands and shade them in.

7

Some of the banding is staggered at the shaft.

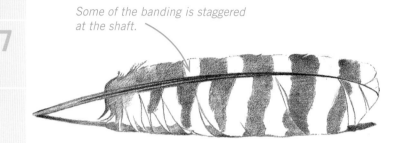

In a much lighter tone than the bands, shade over the entire barbs area, leaving the top area a bit lighter.

8

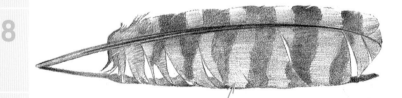

Shade with soft back-and-forth motions and very little pressure.

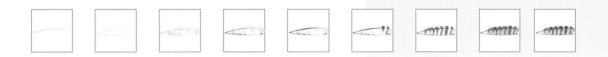

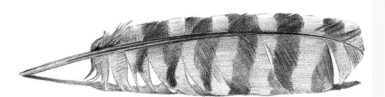

9 Darken the bands and add some marks that make some of the barbs stand out. Shade some of the barb area in the direction of the barbs to create the undulation of the surface.

ADVANCED VARIATION

Drag the flat-edged eraser in these directions to highlight the shaft and barbs.

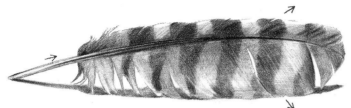

Softly shading with a 2B pencil, blend and darken slightly the center of the feather in the direction of the shaft to intensify the lateral rounding of the feather. Stroke the kneaded eraser in the direction of the barbs between the shading of step 9 to further develop the undulating surface. Create highlights along the shaft.

foreshortened face

Steps: 9 **Difficulty:** ◻ ◻ ◻ ◻ ◻

To draw this unusual view of the face requires your mind to trust
your eyes. The mind knows an individual's facial features are easiest
to distinguish by viewing the face directly. In this oblique view, the
cross contours are critical landmarks to understanding the features'
positions and knowing that the midline, because this head is slightly
turned, is not a straight line.

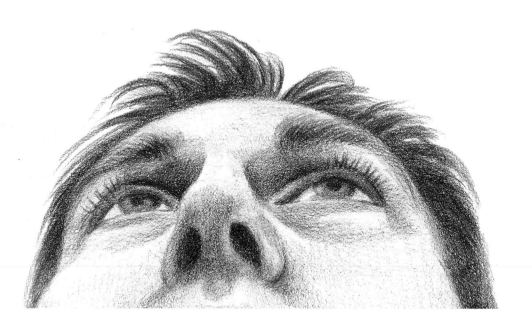

Draw this construction very lightly to easily erase it later.

The level line is a reference line only to make plain the angle of the line of the eyes.

1 Draw a 4-inch (10cm) long construction line that angles upward to the right at about 4 degrees. Then lay in the two lines for the individual eyes. The eye on the right is $1\frac{1}{8}$ inch (3cm) wide. The one on the left is 1 inch (2.5cm) because the eye turns out of view at the outside.

The curves of the eyelids peak at the arrows where the raised corneas will be directed.

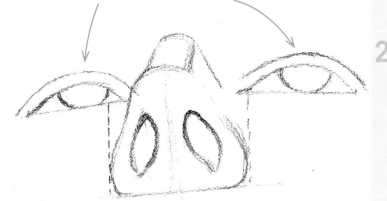

2 Draw the main contours of the upper eyelids and the irises. Lightly sketch the vertical alignment lines and then position the contours of the nose in relation to them. Sketch the angled bridge of the nose lightly to be incorporated into the shading later.

Draw the curving contours of the lower lids and the cross contours of the sides of the nose.

3

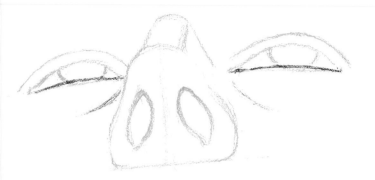

CONCEPT
*Create **depth** by changing the values with gradations and by shading a midtone, then adding dark areas, and then adding the darkest darks of the image's value range.*

Erase the construction lines of the eyes. Draw the curving lines of the sides of the brow and then sketch the hatch marks of the eyebrows. Draw the top of the forehead to peak above the right nostril.

4

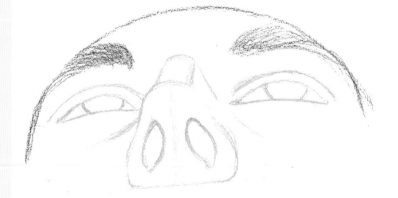

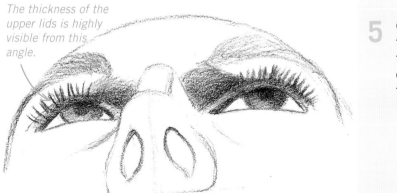

The thickness of the upper lids is highly visible from this angle.

5 Create the shadows around the eyes, draw the irises, then draw the curving lines of the eyelashes. Add the thin shadow where the upper lids meet the eyeballs.

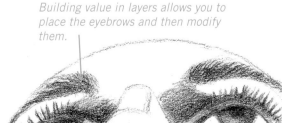

Building value in layers allows you to place the eyebrows and then modify them.

6 Darken the eyebrows with lines that angle outward from the sides of the face. Increase the value of the shadows of the upper eyelids and the eyelashes.

7 Shade the nostrils with very small strokes and then shade the underside of the nose. Lay in the subtle gradations of the underside of the nose.

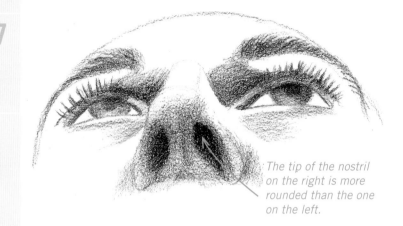

The tip of the nostril on the right is more rounded than the one on the left.

Shading lightly over an entire complex value area helps create unity.

8 Shade lightly over the entire face from the upper forehead down to the underside of the nose with an HB pencil.

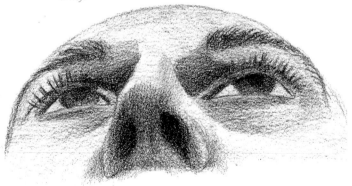

Lift off the high-
light of the eye with
the pointed tip of a
kneaded eraser.

Because of the low point
of view, the forehead
curves back out of view
to the hairline.

9 Intensify the darkest darks
of the nostrils and eyes and
lower eyebrows to 90 per-
cent value with an 8B
pencil. Continue to shade
the hair with soft shading.
Then gradually define some
of the individual hairs and
strands. Finish by darkening
a few of the individual hairs
and shade a little darker at
the base of the hairs near
the hairline.

The ear at
left is lower
and partially
overlapped
by the side
of the face.

Shade the
values lighter
in the lower
area to keep
the focus on
the eyes.

ADVANCED VARIATION

To place the features of the
lower face, notice the follow-
ing:

The length spanning the
outside corners of the eyes is
equal to that from the top of
the head to the indentation
below the lip.

The length from the forehead
to the shadow of the chin is
equal to the width at the eyes
from temple to temple.

The ear at the right is just
below the level of the corners
of the mouth.

brick wall

Steps: 9 **Difficulty:** ▣ ▢ ▢ ▢ ▢

A carefully arranged path of details directs one around this image. The viewer's gaze enters at the left area of bricks connected to the lower-left corner of the window. After viewing the illusion of the shadows falling on the panes, the viewer is directed to the bricks on the right, around the arch where a small crack reaches back to the entry.

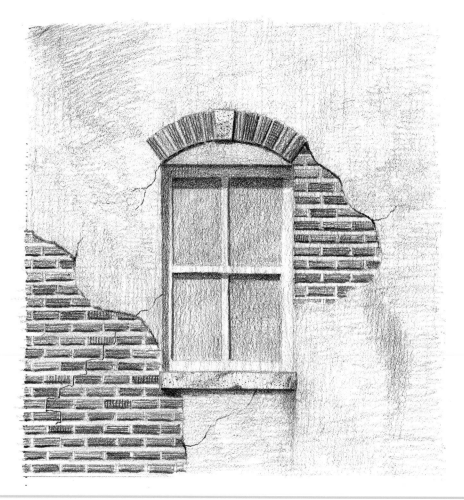

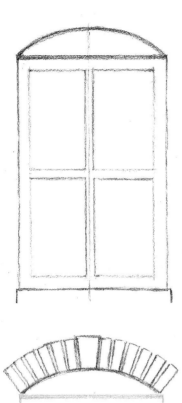

1 Draw a rectangle that is 3 inches (7.5cm) tall and 2 inches (5cm) wide. Create a four-pane window out of this with an arch at the top and a base.

2 Above the arch, draw a keystone and brick detail. Draw the bricks to be ⅛-inch (3mm) by ⅜-inch (1cm).

Draw a wavering edge of the plaster and brick wall at the right of the window and a diagonal one at the left, creating small and large exposed brick areas.

3

These irregular lines will be the rough edge where exterior plaster has cracked off.

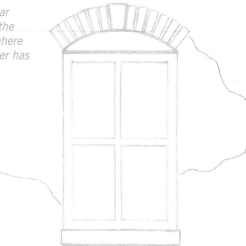

CONCEPT

*A **visual path** is a form of continuation where visual clues guide the viewer through supporting parts of an image to a main area of interest called a **focal point**.*

At the left of the page, mark ⅛-inch (3mm) then ¹⁄₁₆-inch (1.5mm) spaces with a ruler repeating down the left of the image area.

Position the head of a T square along the left vertical edge of a rectangular table and align the bottom of the page with the horizontal ruling edge of the T square. Tape the drawing to the table, then draw a horizontal line at each mark only in the brick areas. Do the same in the brick area to the right of the window.

4

Draw these light guidelines with a sharp 4B pencil.

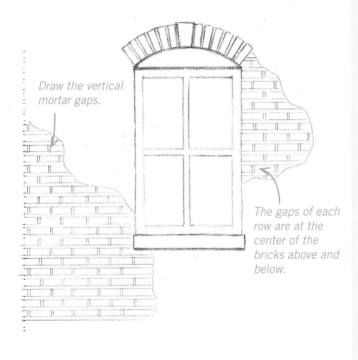

Draw the vertical mortar gaps.

The gaps of each row are at the center of the bricks above and below.

5 Measure out from the window (either brick area) a full brick width of ⅜-inch (1cm) and draw a mortar gap. Then draw the gaps every other row above and below aligned with that first one. Then draw the rows in between starting at the center of the first bricks. Continue across both brick areas.

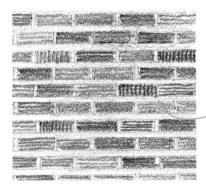

The pattern should have variation with unity.

Look at the drawing at arm's length to assess the pattern of bricks.

6 Shade the individual bricks with three or four horizontal marks each. Then darken some bricks with vertical crosshatching.

Shade the plaster covering with an HB pencil, making horizontal back-and-forth strokes and then vertical ones to create unified texture with some value changes. Shade over the brick areas lightly, too.

7

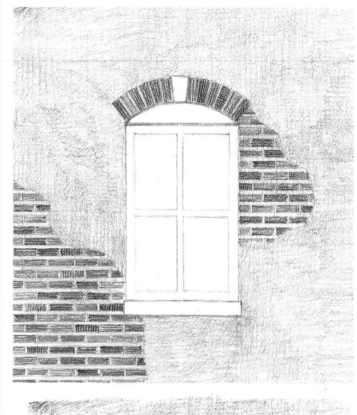

Create even tone with back-and-forth shading.

Shade the windowpanes with a 2B pencil. Then shade the entire window, keystone, and base with an HB pencil.

8

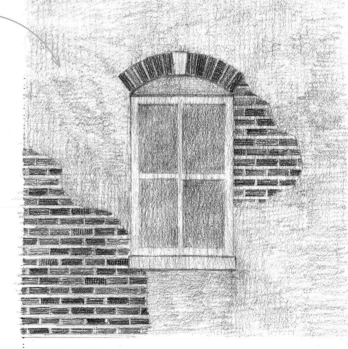

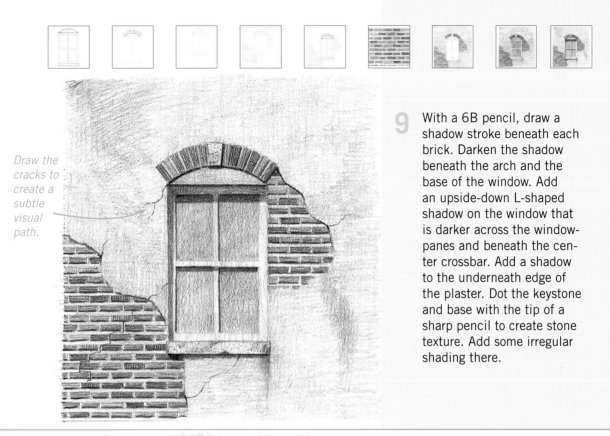

Draw the cracks to create a subtle visual path.

9 With a 6B pencil, draw a shadow stroke beneath each brick. Darken the shadow beneath the arch and the base of the window. Add an upside-down L-shaped shadow on the window that is darker across the window-panes and beneath the center crossbar. Add a shadow to the underneath edge of the plaster. Dot the keystone and base with the tip of a sharp pencil to create stone texture. Add some irregular shading there.

ADVANCED VARIATION

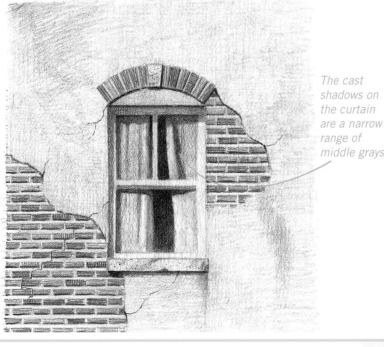

The cast shadows on the curtain are a narrow range of middle grays.

Add a curtain in the window by shading the curving, dark gap between the flutter-ing curtains. Draw the lower window sash to be pushed up by shading over the central muntin and adding shading underneath the horizontal part of the upper sash. Create the cast shadow from the window onto the curtain. It angles to the right or curves down-ward the farther the curtain is from the window.

wood

Steps: 9 **Difficulty:** ▣ ▣ ▣ ▣ ▣

Distressed natural forms are exciting challenges with the graphite pencil medium. This driftwood tree trunk is a matrix for organic shapes and textures. The remains of the roots have a dynamic quality. To fully capture the beauty of this form, draw the general shape and depth, then the medium-sized shapes of the depressions and hollows, and finish with the cracks.

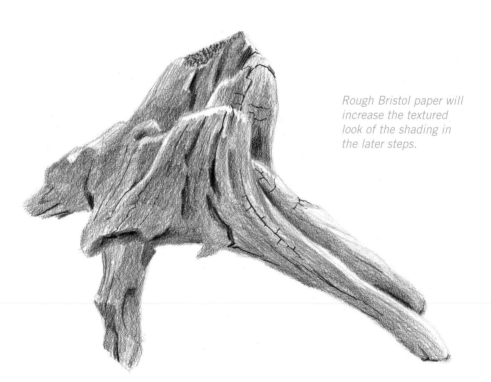

Rough Bristol paper will increase the textured look of the shading in the later steps.

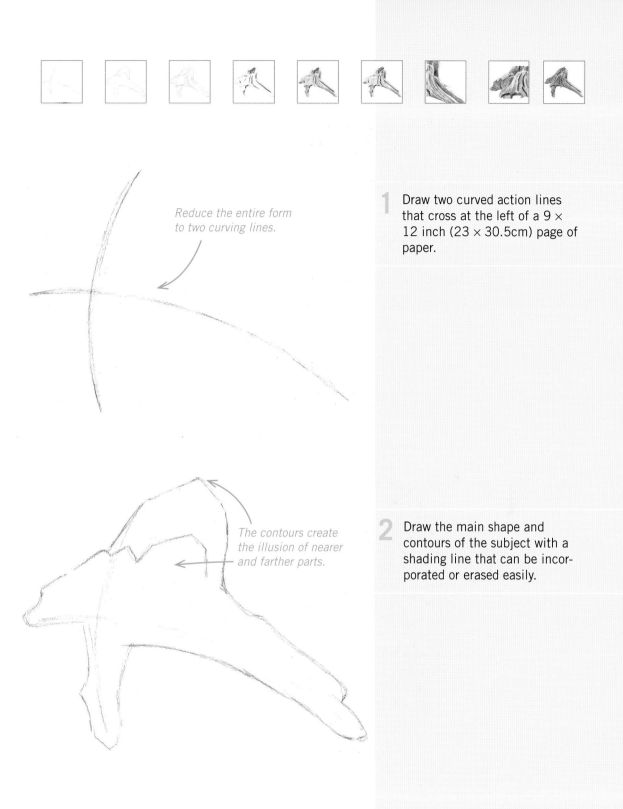

Reduce the entire form to two curving lines.

1 Draw two curved action lines that cross at the left of a 9 × 12 inch (23 × 30.5cm) page of paper.

The contours create the illusion of nearer and farther parts.

2 Draw the main shape and contours of the subject with a shading line that can be incorporated or erased easily.

Draw the interior contours that define the main surface changes and depressions.

3

The depressions follow the grain of the wood.

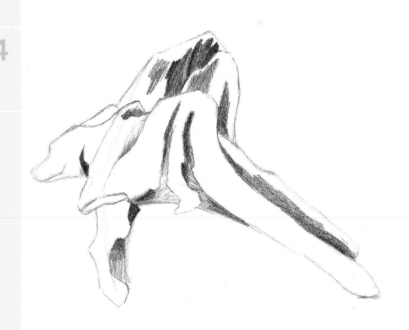

Shade the shapes of the darkest recessed areas of the form with 50 to 70 percent value.

4

5 Shade the 40 percent value midtone all over except the lightest edges at the top of the parts of the wood. Shade with the side of the pencil tip and follow the changing direction of the form.

Shade with back-and-forth strokes in the direction of the wood's grain.

6 Increase the value of parts of the deepest recessed areas to create levels of value within the shadow shapes.

Add the dark surface cracks with a varied line and create the end grain texture at the top with very short marks where the pencil tip lifts away from the paper at the end of the stroke.

These marks are made with a lot of pressure and a sharp 6B pencil. Grip the pencil closer to the tip.

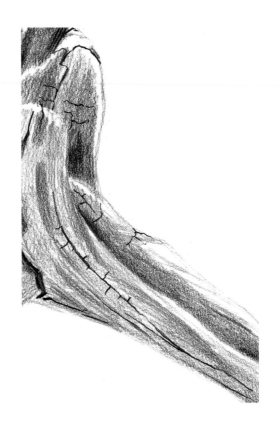

Draw more splits and cracks in the right portion of the wood with lines of varied thickness made with a sharp pencil. The main split follows the long direction of the form and the shorter cracks dip and rise as they follow the cross contour surface. **7**

Intensify the illusion of depth on the left side with darker shading that follows the form. The very tops and sides of the sections are lighter while the recessed and turning areas are darker. **8**

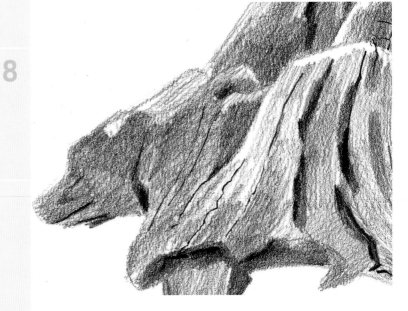

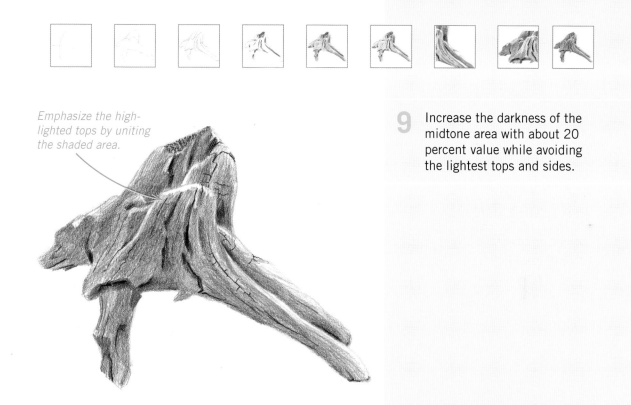

Emphasize the high-
lighted tops by uniting
the shaded area.

9 Increase the darkness of the
midtone area with about 20
percent value while avoiding
the lightest tops and sides.

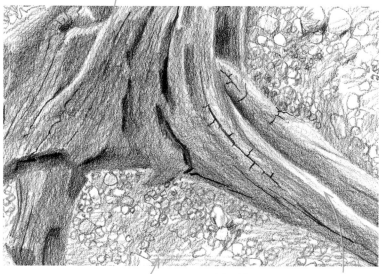

Add more grain texture to the wood.

ADVANCED VARIATION

Create a background of pebble
and sand texture with a 4B
pencil. First draw several
larger pebbles with different
round and oblong shapes.
Then, with a soft line of vary-
ing thickness, draw small oval
shapes combined with back-
and-forth shading to create
the sand texture.

Draw the sand with a
flexible wrist.

Add 20 percent value shading to the
highlight areas with an HB grade pencil.

waterfall

Steps: 9 **Difficulty:** ◻ ◻ ◻ ◻ ◻

It might seem challenging to apply the laws of perspective to most nature scenes, but the lines of the rim and base of this waterfall converge as they angle toward the horizon. The angles hint that the viewer is off to the right with an eye level about half the height of the falls.

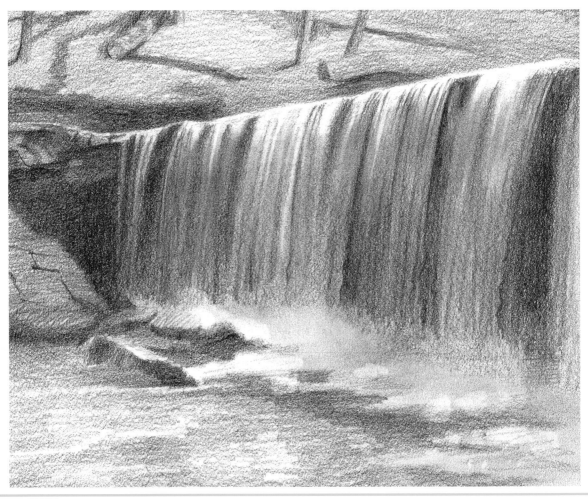

Shade these lines to be soft to integrate with the later values of the drawing.

1 Draw a frame 7½ inches (19cm) tall by 10 inches (25.5cm) wide. Make a soft dot (indicated by the arrow) marking the point 2 inches (5cm) to the right of the left side and 2 inches down from the top. Sketch a shaded line that angles upward and over to the left and another that angles upward to the right. Shade a lower line that starts below the dot and angles downward to the right.

2 Draw the shapes of the fallen rocks with very little detail. They are left of the vertical midpoint of the scene and aligned along or below the lower diagonal line from step 1.

The rock's shapes are mainly made of cubes and triangles.

The horizontal strokes are indications of the water's surface.

3 Draw these soft and irregular shapes of the foam and whitewater.

These shapes have repeated horizontal parts that follow the flow of the water.

Shade these lines and clean up the edges with a kneaded eraser.

The hill converges down to the right in contrast with the falls.

4 The logs and trees beyond the falls are a secondary area of interest. The trees are cylindrical and the end of the larger fallen one on the left is nearly a circle, indicating that it points more directly at the viewer than the log on the right. Draw these shapes softly with the side of the lead.

Mainly shadows placed around or on the shapes define them. Very few lines are used.

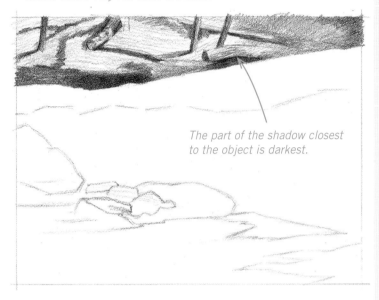

The part of the shadow closest to the object is darkest.

5 Shade the upper area beyond the falls with soft shading strokes to a 30 percent value. Then lay in the main shadow shapes.

Shade the far left of the rim with dark, irregular shadows.

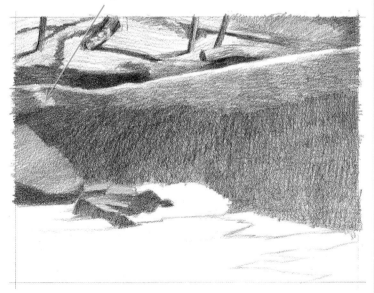

6 Leaving a thin, irregular strip beneath the background trees area white, shade the rim of the falls from the left edge of the paper to the right with horizontal back-and-forth strokes. Shade the large shape beneath the rim to 70 percent value with a layer of vertical strokes, then a layer of horizontal strokes. Shade the shadow side of the fallen rocks 70 percent value and their tops the value of the rim.

Begin the water texture by
dragging the tip of a kneaded
eraser down from the top
of the rim. Create slightly
curved streaks in a random
pattern. Drag the eraser
about three times before
kneading it. Some of the
marks will blend the graphite
instead of taking it off and
will create the effect of the
transparency of the water.

7

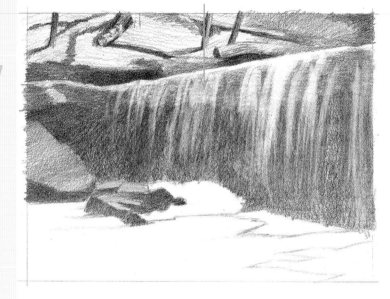

Shade the water beneath
the falls with horizontal
strokes and diagonal breaks
between the sections. Allow
some sections to overlap.

8

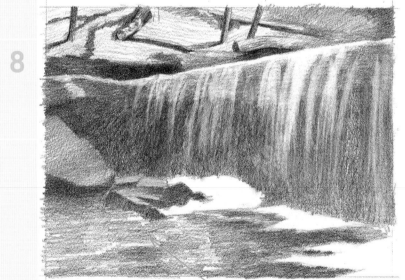

*Diagonal lines and shading patterns
increase the illusion of depth.*

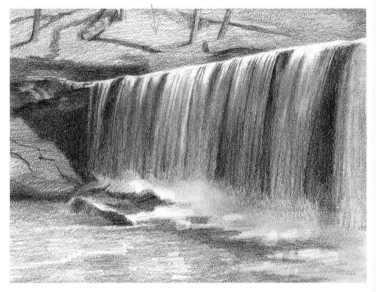

Shade 10 percent value over the entire background to make the top of the falls pop.

9 Refine the shapes between the sections of falling water. Gently blend the shaded area of the falls with a rolled paper towel or tortillion using vertical strokes. Then blend the whitewater at the base with soft, circular strokes. Drag a pointed kneaded eraser down the curving water to create a few highlights. Lift off some from the whitewater next to the dark rocks.

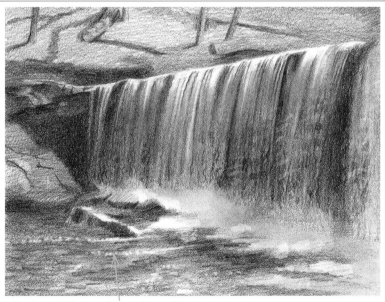

Create bubbles on the surface with repeated touches from a pointed kneaded eraser.

Darken the water and add reflections of the darker rocks.

ADVANCED VARIATION

Falling water has a rhythmic waver that begins at the rim and increases the farther it falls. Create the illusion of this effect by adding some wavering lines at the top. Add rows of parallel lines farther down and then repeated highlight touches with the kneaded eraser between them. Draw wider wavering lines farther down as a guide to shade up to, leaving a thin, wavering, lighter line.

appendix A glossary

2D Having the illusion of two dimensions: height and width.

3/4 view A dynamic view of an object or figure where the front and side can be seen simultaneously.

3D Having the illusion of three dimensions: height, width, and depth.

abstraction The intentional distortion of the appearance of objects from life in a composition to isolate the essential shapes of the subject without naturalistic proportions or detail. It also can refer to a composition with no reference to natural objects (nonobjective).

alignment The lining up of parts of a drawing—vertically, horizontally, or diagonally—which can help to place them correctly.

analyze To break something into parts in order to better understand the whole.

anatomy of light, the A model of light with a light side, highlight, midtone, shadow area, reflected light, and cast shadow.

art gum eraser A tan-colored crumbly eraser for lifting off lines that has a tendency to smear shaded areas.

asymmetry Non-reflective placement of elements where an object on one side of a composition is not balanced by a corresponding object on the opposite side.

atmospheric perspective The illusion of depth created where objects and areas that are a great distance away are paler and have less detail than near objects.

axis An imaginary centerline of both 2D and 3D shapes.

background The area around, and implied as behind, a main object or figure of a composition.

basic shapes The triangle, square, and circle (2D); and the cone, cube, sphere, and cylinder (3D) are primary shapes used to understand and construct more complicated forms, such as the human figure.

bilateral symmetry A form of balance where an object can be imagined as divided in half with equal and reflective parts.

blending stump A stick made of paper fibers with pointed ends for blending graphite shading.

block in To lay in or draw forms with straight lines in the beginning stage of a drawing that avoids details.

bond Paper made of wood pulp commonly used for electronic printers and copiers. It is a less permanent but useful drawing paper.

Bristol A kind of premium drawing paper or board available in 1-ply or multiple layers and surfaces that range from very smooth (plate) to slightly rough (vellum).

broken line A construction line that defines the outer contour of a shape with mostly straight lines and spaces between and no details.

chamois cloth A soft, pliable leather used for blending graphite and charcoal.

compact fluorescent lamp (CFL) An energy conserving light bulb that comes in a range of lighting colors from natural sunlight to pinkish.

comparing measurements The process of observing the size of an element and determining its relationship in length to another element.

composition The design of a drawing or a designed image and the placement of its elements; a drawing.

cone A tapering 3D form with a cylindrical base.

construction Preliminary marks and shapes on the drawing page to determine the orientation and placement of elements.

construction lines The beginning marks and lines used to place objects in a drawing. These include tick mark, reference line, guideline, axis, centerline, midline, midpoint, broken line, and line of convergence.

continuation Elements within a composition that align and appear to be an obvious or subtle line.

contour An edge line.

contrast Usually a difference in value, but change of texture, size, shape, etc. also can create an interesting variety in an image.

convergence The effect of parallel lines appearing to be closer together the more distant they become.

cover sheet A piece of copy paper or printer paper that can be laid over the drawing page where the drawing hand can rest to avoid smudging or transferring oils from the hand.

cross contour A line that stretches across a shape that describes the surface.

crosshatching Rows of parallel marks that are crossed by other rows of parallel marks and are perceived as tone.

darkest dark and lightest light The extreme tone in a composition, usually applied at the very end.

depth The illusion of space created by overlapping forms, diminishing size, converging edges, diagonal lines, and atmospheric perspective.

directional shading Tonal marks that follow the changing surface of a form and support the 3D illusion.

drafting board A heavy wooden board with metal edges made to be used with a T square.

drafting lamp A lighting fixture that is easily positioned and clamped to a drafting table to provide light for drawing.

drafting tape A less sticky tan-colored masking tape that can be easily removed from paper without tearing it.

drawing from observation A drawing translation of a scene or object from life.

element A part of a drawing.

ellipse A circle seen at an angle.

eye level Corresponds with the horizon and determines the look of objects and angles in a drawing; a drawn scene can be constructed to imply the viewer's eye level is higher or lower by the placement of the horizon.

field board A portable drawing board made of compressed wood.

figure The human form; also an object that has primary placement in a composition when describing its relationship to the background.

foreground The nearest area in a composition; understood in relation to the middle ground and background.

form Another name for a shape, especially a 3D shape.

freehand drawing Drawn by hand without rulers, templates, or guides; this kind of drawing has a casual, energetic, and wavering line quality.

gesture drawing Made with very energetic, spontaneous lines that capture the essence of an object or scene.

gradation Continuous value that changes from dark to light.

graphite pencil A traditional drawing tool made of a shaft of wood with a small diameter encasing a lead of clay and graphite.

grid A pattern of equally spaced vertical and horizontal lines that divides an image area into blocks or rectangles which simplify placement of elements, especially when copying it.

grip The way a pencil is held to produce various effects.

ground The background in contrast to the figure(s) that is the main object(s) of the composition.

hachure A short mark that is part of an area of shading or crosshatching.

horizon The place where vanishing points align in linear perspective construction, corresponding to the viewer's eye level.

kneaded eraser A gray, malleable, tacky eraser that can lift off dark values by pressing down onto them or dragging across them. You clean it by pulling it apart and folding into its center the areas that are dark with graphite. It can be pointed to create very small highlight effects.

layer Darker shading is created in stages; each layer is shaded in a different direction to create even tone.

level Horizontal, at 90 degrees to the sides of the paper.

lift To take away tone with a kneaded eraser by pressing it into a shaded area.

linear perspective A method of constructing the observable effect in life where parallel edges appear to lead to one point on the horizon.

local value Every object has a natural tone due to its ability to absorb and reflect light.

main shape The outline of a form or object.

midline A reference line that follows the changing surface of the center of a form, such as the face, as an aid to determine placement of features.

midpoint The vertical and horizontal midpoints are lines that divide a shape in half to analyze or copy the image.

midpoint grid The combined horizontal and vertical midpoints together that divide an image into quadrants.

modeling A kind of illusionistic shading where nearer parts are lighter and farther parts are darker.

negative space The space around a figure or object in a composition; the background.

nonobjective A composition made of basic shapes and tones having no reference to natural objects.

one-point perspective The method for constructing the illusion of angled, receding edges where a rectilinear object directly faces the viewer, requiring one vanishing point.

orthogonal lines Converging lines of a perspective construction.

pencil grade Graphite pencils are marked on the side of the casing with a number 2 through 8, combined with a letter H or B. H is for *hard* (lighter marks) and B is for *black* (darker marks). H, HB, and B are the middle three grades of the total range of pencil grades.

pencil measurement The pencil can be used as a measuring tool by laying it along the edge of an object and using the thumb and index finger to grasp it at the end of the measurement. This can be transferred to the drawing page or merely compared to another measurement.

plumb Vertical, at 90 degrees to the bottom and top edges of the paper.

profile A view from the side.

proportion A relationship of one size to another.

realism Relates to a drawing that depicts subjects with proportions and detail similar to those found by direct observation from life.

reference line A construction line that is used only to help determine the placement of elements and then is erased.

refine To add more definition and final details to a drawing.

refined drawing A carefully constructed drawing with accurate measurements and proportions complete with atmospheric effects of light and shadow.

shading Tone applied to a drawing in a variety of strokes or manipulations of the pencil.

sketch A kind of drawing that looks casual with less value refinement.

sphere A ball; a 3D circular form.

square At 90 degrees to another element; also a basic shape.

stroke An individual mark; it can be similar to other marks or have a distinct character.

stroke shading Grouped rows of individual lines used to create tone.

symmetry Balance in an image, where one side is a reflection, near reflection, or visual equal of the other side. Drawings that display these qualities are *symmetrical.*

tick mark A short line that designates where the end of a line or edge of a shape will be.

tonal drawing A drawing that uses tone to describe form instead of line.

tone Value; lightness or darkness in an image.

tooth Texture of the paper surface.

tortillion A small, rolled paper stick with a pointed tip for blending shading, and handy for rubbing tracing transfers.

tracing paper A thin, fairly clear paper for copying detailed work.

transfer sheet Usually a sheet of tracing paper or translucent paper on which an image has been traced and can then be transferred to another page by laying it with the graphite down and rubbing it with a firm yet smooth tool like a tortillion or a guitar pick.

translucent marker paper A thin paper that is useful for tracing overlays, allowing most of the image underneath to be seen, yet opaque enough to clearly see the tracing lines.

two-point perspective The method for constructing the illusion of a rectilinear object with a near edge and two visible facing sides, and with two sets of angled receding edges that converge at two different vanishing points.

unity and variety Unity is sameness and variety is change. A composition is improved when the elements appear to go well together (unity) and where there is also some change or difference (variety).

value Tone; lightness or darkness in an image.

value pattern The way the values of an area or shape change from light to dark in a rhythmic way to describe depth or texture, i.e., light-dark-light; also, the general look of the values of an image.

value scale A range of values that goes from white to black in stepped increments.

value shape Areas of dark and light in an image best seen when squinting.

visual balance When each element of a drawing has a unique texture, shape, position, or size that complements the others without being overwhelmed.

visual integrity When care is taken to be consistent with textures and the lighting source, the image has believability.

visual path Elements of a composition can be arranged to guide the viewer's eye around the image to the various lesser and greater focal points.

Resources

Light and form are pivotal to illusionistic drawings from life and naturalistic subject matter. While you can make a lot of discoveries by simply making lines and shading, a mastery of drawing skills begins with deliberate consideration of techniques and topics known for centuries as vital to art and drawing. The multitude of details you can observe when you set out to create a drawing will be greatly simplified with a little knowledge of value, perspective, and the effect of light on form.

Following are three important references for artists. You will refer to them often as you strive to add realism to your drawings.

Value Scale

The value scale displays a full range of value in 10 percent steps. Learning to recognize the darkness of elements in your drawings helps when developing tonal strategies. With value you can emphasize a point of interest, create 3D illusion, create the illusion of light, and develop expressive value patterns.

0%	10%	20%	30%	40%	50%	60%	70%	80%	90%	100%

One- and Two-Point Perspective

Linear perspective is a method for creating the illusion of depth by accurately constructing receding angles. It's most effective to determine the shape of cubic objects and angles of parallel edges. One-point perspective uses one vanishing point on a horizon line where an object has one side that directly faces the viewer. Two-point perspective requires two vanishing points where an object has no direct facing side, but instead presents two sides oblique to the viewer.

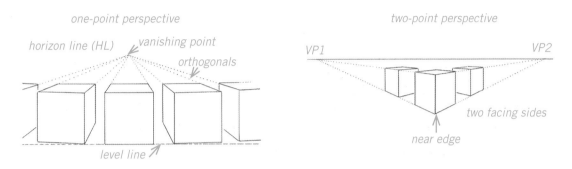

The Anatomy of Light

Every surface that can be observed and drawn is affected by direct light from a source and indirect light reflecting from other surfaces. The anatomy of light is a model of what to look for in every object you draw. Begin drawing objects with plain surfaces where you can see the definite parts of light of this model. When you understand it, you will be able to draw even highly patterned cloth, glass bottles with labels, or animal fur to look real.

When you draw objects, blur your vision by squinting to see a light and a dark side. Observe the speed with which the light side turns into shadow, either gradually or in a sharp line. Try to see the parts of this model in any object you draw and you will strengthen your ability to see nuances that are often overlooked.

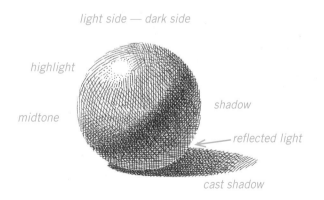